LOVIS CORINTH
A Feast of Painting

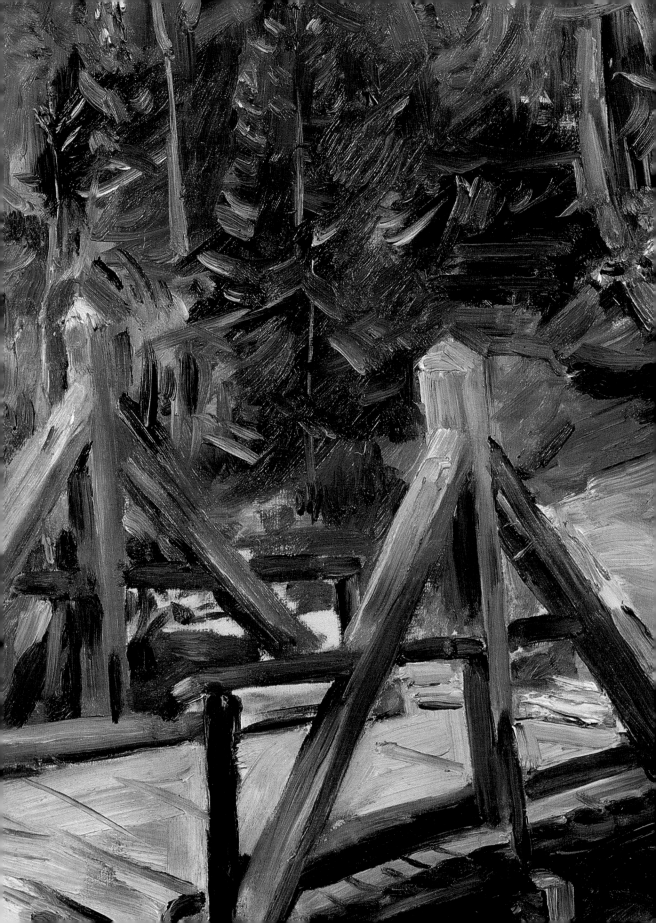

LOVIS CORINTH
A Feast of Painting

Edited by Agnes Husslein-Arco and Stephan Koja

belvedere

PRESTEL
Munich · Berlin · London · New York

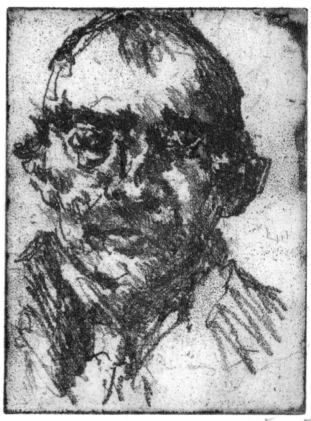

Self-Portrait, 1920/21
Etching, 12 x 9.3 cm
Belvedere, Vienna

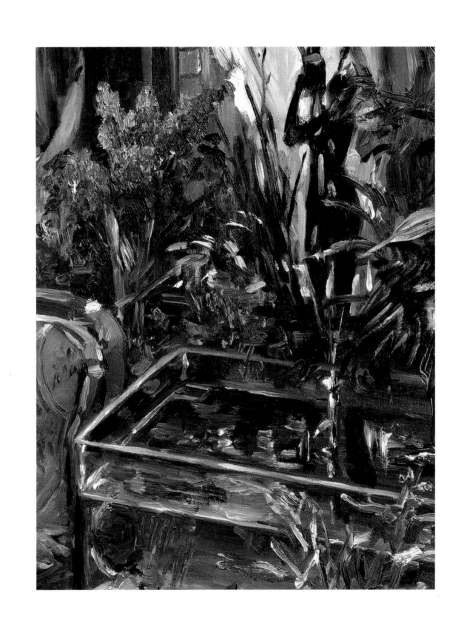

Agnes Husslein-Arco

Preface

Closely scrutinizing the way museums operate today leads to the impression that many institutions are placing increasing value on large-scale, temporary exhibitions that are popular with the public. Of course, generating a large number of visitors is an important aspect in times when museums are pressed to think and act economically. However, museums are also obliged to concentrate on their real assets: their collections and how best to preserve, expand and present them. This is one of the considerations behind the Belvedere's newly conceived series of exhibitions called *Masterpieces in Focus*. Twice a year, we will focus on thematic areas, individual artists, or outstanding masterpieces from the collection. Although the presentations will be integrated into the permanent exhibition in the Upper Belvedere, they will be architecturally spotlighted, thus focusing on the importance of the chosen works in the context of the collection and in connection with the art and culture of their time. Carefully chosen loans will underline the high quality of the holdings that we have been able to so judiciously acquire over the years. The series of books accompanying the exhibitions will include contributions by renowned experts on the most recent findings in research and attempt to cast new light on the selected works of art in an interdisciplinary analysis and, in this way, provide new insights. These carefully produced publications will also provide the art lover with a catalogue of the masterpieces in the Belvedere.

Lovis Corinth—A Feast of Painting is initiating this new series of exhibitions. This will be the first time that the ten paintings and one etching by this exceptional artist in the Belvedere's collection are shown together. The works, which were created between 1896 and 1924, provide an extensive overview of Corinth's creativity from his beginnings in Munich, over his period as a painter of Berlin society, and as an artist and president of the Berlin Secession. At the same time, they impart an outstanding impression of the restless and creative character of this artist who attempted to overcome the after-effects of a stroke through an excess of creative power.

The Corinth holdings in the Belvedere were acquired under the two directors Franz Martin Haberditzl (1916–1938) and Bruno Grimschitz (1938–1945). The first must be merited with courageously purchasing the most modern art of his time—including *The Herzogstand on Walchensee in the Snow* and, even more excessive, the portrait of *Herbert Eulenberg*—whereas his controversial successor must be thanked for not only assuring that these works by an artist who was condemned during the National Socialist era were not lost but augmented by additional purchases from earlier phases in Corinth's career which make it possible for the Belvedere to provide such a remarkable overview of the artist's œuvre.

This "Feast of Painting" provides us with a brilliant opportunity to open our exciting new series of *Masterpieces in Focus* and we hope that this new project will meet with an enthusiastic response from the Belvedere's friends and visitors from all over the world.

Stephan Koja

Introduction

It is undisputed that Lovis Corinth is one of the major figures in German painting of the nineteenth and twentieth centuries, less on account of his herculean appearance than as a result of the intensity of his creativity, his passion for the pictorial, and for the mysterious creation of the picture out of an obsessive process of painting. His enthusiasm for the act, the material aspect of painting, stimulated Corinth throughout his life. His paintings were always executed with the utmost vehemence, which ultimately culminated in an almost brutal, seemingly unbridled, attack on the canvas in his late work.

Corinth was a painter who celebrated the sensual, an artist with nothing less than an explosive love of life. His creative powers were enormous. He left close to 1,000 paintings in all possible genres: allegoric pictures, depictions of mythological, biblical and literary themes, portraits, still lifes, interiors and landscapes, from work in the studio to plein-air paintings flooded with light. Many of the subjects of his pictures originated in the canon of German culture—reflecting on his solid education at school and then the art academy in Königsberg as well as during his further training at the art academy in Munich.

Even the stroke he suffered in 1911 (most likely followed by others) did little to slow him down; it even seemed to increase his hunger for life and his desire to appropriate the world through his art.

Corinth was also a crafty market strategist who knew how to expertly take advantage of the mechanisms of the cultural business. In addition, with his activities as a supporter of modern art on the board of the Berlin Secession he proved to be an important figure in cultural politics and, in this way, fostered the internationality of Berlin as an artistic metropolis.

His lifestyle was quite bourgeois—he was ultimately so successful as to be able to extend his studio and apartment to cover three floors of a residential building on Berlin's Klopstockstraße and to have as many as six people working for him.

In this way, Corinth's life and work reflect all of the values—as well as the flaws and discrepancies—of German art and culture at the end of the Empire and beginning of the Weimar Republic.

At the same time, his work was always highly individual; to this day he has remained—as he was during his own lifetime—uncomfortably anachronistic, he could never quite be categorized because he always appeared to be at odds with the prevalent movements.

His artistic approach was much less romantic, less determined by idealism, than that of his contemporaries in the land of poets and philosophers where a painter could quickly develop into a painting philosopher. Corinth was always, and above all, a painter concerned with sound work, with painting logically developing from a fine technique, and not with superficial effects or an ideological superstructure that smothered everything.

This is also why Corinth cannot be described as being a salon painter, not as an Impressionist or Expressionist; he remains much more in a class of his own.

In his later works, such as the pictures of Walchensee and the floral still lifes, Corinth finally liberated himself from the figural without completely forsaking it as the basis for his pictures. He thereby completed the transition to Classical Modernism, already underway in Central European painting, with all of its consequences for his own art.

What makes Corinth so modern is his tendency to probingly question reality. Even when he used literary models, or attempted to deal with mythological or religious subjects, he could not distance himself from the reality of the visible world. This was the fundamental question of modern art—especially in France. The open-minded interpretation of visible reality should determine the understanding of the world, and not values or canons that had been handed down.

While many German painters were prepared to question the real character of the visible world in the sense of idealism, Corinth discovered his new artistic approach by way of this material world, by way of feasting the eyes on the visible.

Gradually the artistic means of which he availed himself became increasingly independent, ultimately liberating themselves by and large from the original models found in nature. It has often been claimed that Corinth's new, freer style was connected with the after-effects of one or more strokes, even though the causes are undoubtedly more complex.

Especially during the National Socialist era, when "modern" was equated with "sick", the pictures from this creative period were denounced as being "degenerate"; many were removed from public collections, sold abroad at auctions, or locked away in storage.

It is precisely these questions—the artistry, the craft and the technical brilliance, on the one hand, and the handicap resulting from the stroke and trembling of the right hand as possible triggers for a stylistic change, on the other, that have found such great resonance in the literature on Lovis Corinth and which still give rise to heated discussions today. In the hope of creating a sound basis for future discussion, we had them investigated for this publication by two specialists from the fields of painting technique and medicine.

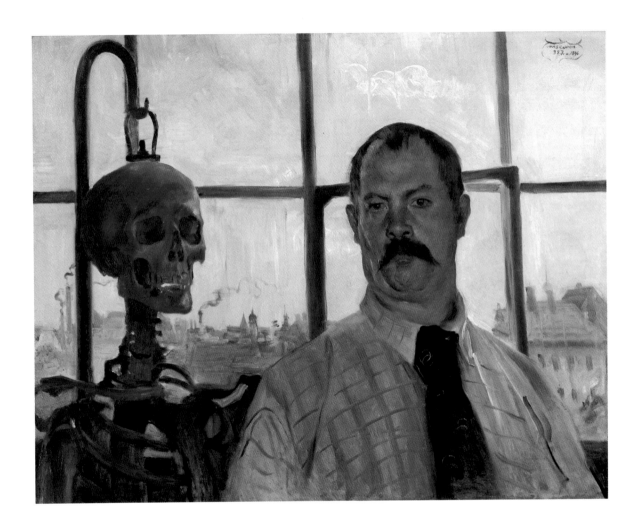

Fig. 1
Self-Portrait with Skeleton, 1896
Oil on canvas, 66 x 86 cm
Städtische Galerie im Lenbachhaus, Munich

Stephan Koja

"... Struggling with Art as Jacob Struggled with the Angel"[1]
Lovis Corinth's 'Painter's Paw'

In his 1896 painting *Self-Portrait with Skeleton*, Corinth depicted himself as a massive figure looming in front of the window of his studio, that provides a view of the city behind him. The artist makes absolutely no attempt to appear elegant—he knows that he comes from the hinterland of East Prussian a petit-bourgeois background, and a rural environment.

At the same time, his gaze is penetrating, forceful and completely self-assured.

Hanging alongside him on an iron rod is a common studio prop of the period—a skeleton. Its head appears at almost the same level as the artist's—as if two people were standing next to each other. This almost equal juxtaposition invests the *momento mori* with considerable intensity, despite the naturalism of the depiction.

It is clearly modeled on Arnold Böcklin's *Self-Portrait with Death Playing a Violin* from 1872. Yet, Corinth found a completely different approach to the subject.

Everything in the picture is shown with naturalist sobriety, the silhouette of the city in the background shows smoking chimneys, the skull of the skeleton hanging on the hook is depicted with great attention to detail, the reinforced corners of the open studio windows are represented accurately. The concurrence shown in the painting as a symbolic message appears almost as an aside, and the mercilessness with which Corinth depicts himself—with a face and massive body that have obviously been ravaged by the excesses of bohemian life—is startling.

Thus it is not surprising that here—in spite of all the energetic machismo—the image of death is included in the self-portrait. He was plagued by uncertainty throughout his life, suffered from depression that, on occasion, resulted in his realizing the abysmal senselessness of his activity. Corinth understood the fragility of human existence and the vanity of worldly—and artistic—aspirations.

The self-assured, expansive physical presence can be interpreted as a statement on the role the painter had created for himself in Munich as a city of art.

The highly successful composition of the portrait and its extremely memorable pictorial concept are consciously located in the concretely depicted studio in Munich—and, in this way, can be seen as making a universal statement on Corinth as artist and a person at that specific moment in his life.

"I enjoyed swimming along with the current, proud that my voice was highly regarded. And, I also had the instinctive feeling that I would go far in this clique."[2]

Years of Training

Corinth began his studies at the Königsberg Academy under Otto Günther in 1876, before moving to Munich where he initially took lessons in Franz Defregger's class and later under Ludwig Löfftz. They offered no training in new tendencies in painting, such as Delacroix's innovations in the use of color, Courbet's realism, or even the tremendous modernity of the unique romantic tradition of Friedrich and Blechen, but instead cultivated a virtuosity that was intended to make naturalistically painted historical pictures even more effective. He also became acquainted with the sound

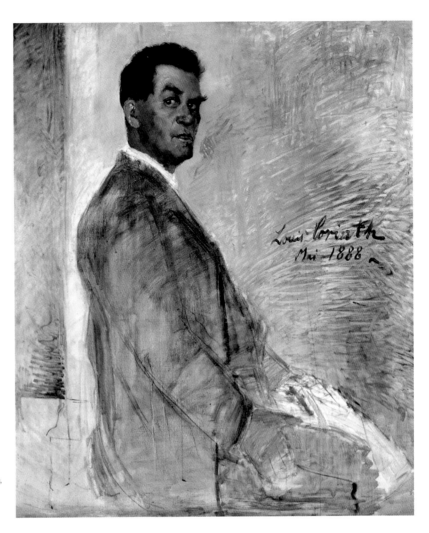

Fig. 2
Portrait of his Father Franz Heinrich Corinth,
1888
Oil on canvas, 118 x 110 cm
The Saint Louis Art Museum

tradition of Flemish genre art and Dutch tonal painting in the classes held by Wilhelm
von Diez's pupil Löfftz.

Subsequently, he spent three months in Antwerp in 1884 in order to perfect his art
under Paul Eugène Gorge.

Finally, he decided to try his luck in Paris, where he enrolled in the Académie Julian. This
decision is especially surprising since he obviously must have reckoned with some hard
feelings in the French capital after the Franco-Prussian War of 1870/71. In Paris, he stud-
ied under the salon painters Tony Robert-Fleury and Adolphe-William Bouguereau—two
pupils of Ingres'—who introduced him to the art of the perfect drawing, and figural com-
positions precisely prepared with sketches, thereby influencing Corinth's method for deal-
ing with multi-figured compositions for many years to come. However, Corinth never
succeeded in officially achieving success at the Salon—as he had intended—and returned
to Germany, initially settling in Königsberg, where his father was living. He had recog-
nized his son's artistic talent at an early age and offered him all the support he could to
further his development. Thus, Corinth and his father always had a very close relationship.
The portrait of Franz Heinrich Corinth that was painted in Königsberg in 1888, when his
father was already seriously ill, is clear evidence of this and also of the talent as a portrait
painter that lay dormant in him. Corinth kept the portrait until his death and had it hang-
ing in his studio so that he could always see it from his chair.[3]

12

It appears that Corinth had no direct contact with French Impressionist art before the turn of the century and only became acquainted with its objectives through the art of other painters. The French Impressionists left absolutely no mark on Corinth during the period he spent studying at the Académie Julian in Paris between 1884 and 1887. "As a simple person, living humbly, who nobody had made aware of the modern art of Impressionism, which was only appreciated by a few, I was forced to look for what was good by myself, no matter where I found it."4 Courbet's art became increasingly important in Munich. In his first years in Munich after 1880, Corinth came into contact with Courbet's realism via Wilhelm Leibl's work and, above all, that of Wilhelm Trübner.

More than a decade earlier, the French art of the masters of the Barbizon School (including Corot, Daubigny, Dupré, Millet, Rousseau and Troyon) and Edouard Manet, and especially Gustave Courbet's realism, had made a great impression at the Munich International Art Exhibition of 1869. In addition to the elder Eduard Schleich, the driving force behind the exhibition, Wilhelm Leibl had become a particularly fervent defender of this new form of realism. The eight months he subsequently spent in Paris, which were abruptly ended by the outbreak of the Franco-Prussian War in 1870, not only brought him a gold medal at the 1869 Salon and Courbet's admiration for his *Portrait of the Pregnant Frau Gedon*, but also a deeper understanding of the art of Courbet and Manet. Frustrated by life in Munich art circles, Leibl first moved to Graßling near Dachau in 1873 and then, later, to the countryside near Ammersee. But, his legacy and the influence of Courbet's painting remained alive in Munich; in addition to some of his works to which young artists were exposed, this was mainly due to the influence of Wilhelm Trübner whose art played an extremely important role for Corinth in these formative years. He became acquainted with Leibl's alla-prima painting technique, which he combined with open brushstrokes in the style of Courbet. Later, Trübner also introduced him to the intellectual world of late Realism and Impressionism—but this was more of a theoretical nature. This was the case when Trübner doggedly argued, "Only art that remains independent of the object is lasting art... The aim is to paint as well as possible and ignore everything else that was formerly regarded as being the main objective (namely, the representational) to the extent that it stands in the way of achieving the utmost goal of painting... Each and every subject is interesting and even the most insignificant can provide sufficient interest for painting. Yes, the simpler the object is, the more interesting and complete it can be made to appear through its artistic treatment and coloration. It all depends on how I show something and not what I show."5

Trübner's own painting from the 1870s, organizing the object of the picture using short brushstrokes with individual colors that were applied to the canvas—unmixed— alongside each other, was already a step in this direction; although in the following decade—when Corinth became aware of him—he strayed under the influence of Böcklin for a short time. It is significant that Corinth was mainly interested in his early works.

Corinth's relationship to visible reality was essentially determined by his contact with Leibl's—and, indirectly, Courbet's—art. This, and the integration of the alla-prima technique, created the foundation for his stronger pursuit of plein-air painting and the further development of his own work. When writing about this period, Corinth stated, "It must have been around the eighties, the period of plein-air painting. I have often ... mentioned that, with his beggar, Bastien-Lepage was one of the many trumps at the Glass Palace in 1883, and was praised to the skies. Then, all Munich painted plein-air; one discovered a new Barbizon in nearby Dachau, along with quite a few fields of cabbages..."6

As Corinth was always striving to make progress in the areas of History and genre painting, the rural subjects of post-Millet art also made a certain impact on him during the same period. They were exhibited while he was studying in Munich and were

heatedly discussed—especially, the tone-in-tone painting by Jozef Israel and the beginnings of Liebermann's plein-air painting with its depictions of the life of simple people.

The second, quite decisive source of inspiration for the painter came from his introduction to the works of Peter Paul Rubens, Franz Hals and Rembrandt in Antwerp in 1884. During his three-month stay in the city, Corinth's palette became considerably lighter under the influence of the Belgian colorists. But, above all, he became acquainted with the pictures of those great masters whose creations were to remain models throughout his life. During his years in Paris, he also studied the works of Hals, Rembrandt, Rubens and Velazquez at the Louvre with great care.

He recognized his own concerns in their creations. Later, under the impact of Impressionism, he wrote, "The three greats: Velazquez, Rubens and Rembrandt are seductive. They saw their figures with light flowing around them while the surroundings had a comparable influence on the tonal values in the form of reflections. Local colors were not painted on the panel, instead the color of the object changed and took on all the hues that light, shadow and reflections give rise to. In their way of seeing things in color, these artists not only reproduced the muscles and structure of the body, they also made you believe that you could poke at the flesh with your finger and see the blood pulsating beneath the skin."[7]

After Corinth's return to Königsberg in 1887, Walter Leistikow, whom Corinth had met in Berlin in the winter of 1887/88 and who became a close friend in Königsberg in 1890, encouraged him to once again investigate the possibilities of plein-air painting and landscapes. *The Grothe Bathing Establishment, Königsberg* from 1890 is a painting completely characterized by this pleinairism and bright coloring.

Corinth had considered attempting to launch a career in Berlin but then, intimidated by the big city and discouraged by the lack of positive reactions to the portrait of his father he had shown at the 1888 Berlin Art Exhibition at the Lehrter Bahnhof, he settled on Munich, the city to which he returned in 1891.

Fig. 3
Grothe's Swimming Establishment, Königsberg,
1890
Oil on canvas, 97 x 118 cm
Location unknown

Munich. Years of Eclecticism

"I was no longer the greenhorn I was ten years ago. I had friends, not only from those days, and these connections made it possible for me to be admitted to the most distinguished club, the Allotria. An Allotrian was …, a priori, an individual with a higher standing than one's fellow creatures."[8] He moved into a studio on the third floor at Giselastraße 7 in Schwabing, which can be seen in the background of his *Self-Portrait with Skeleton*; he painted the view from this window several times. The poet Josef Ruederer lived in the same building and Max Halbe only a few houses away on at Giselastraße 16.

At the time, Munich was rampant with artistic activity and a stylistic melting pot. There were Realists, Naturalists, *Jugendstil* painters and Symbolists, and the preferences and fads appeared to be continually changing. Corinth described the stylistic fashions of these years ironically: "1875 old masterly, 1879 plein air or Munkácsy style, 1883 Dutch, 1888 Scottish, 1892 Impression or Böcklin, 1896 Neo-idealism and Allegorism, 1900 Posters."[9]

The eclecticism of the late nineteenth century was in full swing and Corinth's art was a part of it. Hence, we find everything in his work: figural paintings of historical, mythological and biblical subjects, portraits and landscapes painted in styles either dense or diffuse, heavy and wet or dry, dark and bright painting, nuanced tonal values and dazzling colors, extreme detail and works painted with flowing, dancing brushstrokes.

In addition, Corinth, who remained a role player throughout his life, not only showed himself in numerous disguises and identities—in pictures that occasionally crossed the borders of good taste—but also seems to have enjoyed trying out new styles and

14

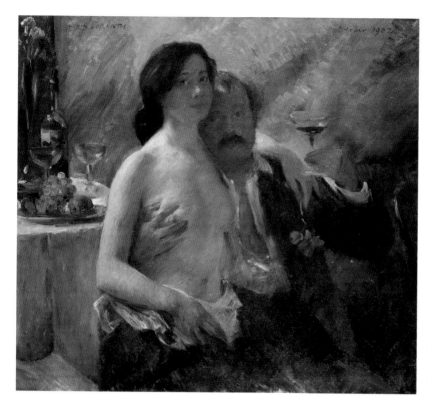

Fig. 4
Self-Portrait with his Wife and Champagne Glass, 1902
Oil on canvas, 97 x 107 cm
Private collection, Zurich

different pictorial languages and forms of expression. (Sometimes, the role playing was not limited to literary or biblical subjects but covered a much wider field including works he admired from the history of art, as in the *Self-Portrait with his Wife and Champagne Glass* from 1902—showing the artist in the role of the sinner—that is clearly inspired by Rembrandt's 1636 painting of *Rembrandt and Saskia in the Parable of the Prodigal Son.*

Corinth therefore confuses us somewhat, his œuvre thwarts the expectations we have of a continuing, logical development of an artistic talent as well as our notions of a compelling artistic signature. "He seems to oscillate between value and worthlessness" according to Julius Meier-Graefe. "Parisian virtuosity, Munich carnival, schmaltzy History painting, wild genre and, alongside and within all this, strokes of amazing strength. It often seems that the academician is only playing with recipes as if the trite was making use of exaggerated triteness to make fun of his time."[10]

Corinth stood on the side of the innovators when he joined the Munich Secession, which had been founded in April 1892, along with Otto Eckmann, Thomas Theodor Heine, Max Liebermann, Hans Thoma, Wilhelm Trübner, Fritz von Uhde and others and, one year later, founded the "Freie Vereinigung" (Free Association) with those who were disappointed by the Secession (including Eckmann, Schlittgen, Strathmann, Slevogt, Trübner and Behrens). Many of them were driven by the desire for greater realism in painting and to incorporate light and its effects. In 1876, Liebermann painted the *Dutch Sewing School* followed, in 1882, by his famous painting of *Playtime at the Amsterdam Orphanage* and, one year later, *The Bleaching Ground.* Fritz von Uhde, impressed by Liebermann and the light of the Dutch coast, followed suit with his *Fisher Children in Zandvoort* in 1882 that was to develop into *The Organ Grinder* one year later. Corinth now became personally acquainted with Wilhelm Trübner and they spent quite a bit of time together; he met Max Slevogt in his studio. In his later essay on Wilhelm Trübner's art, Corinth praised his painting that developed from the

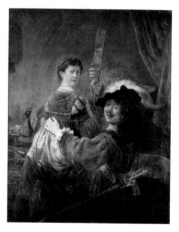

Fig. 5
Rembrandt Harmensz. van Rijn
Rembrandt and Saskia in the Parable of the Prodigal Son, c. 1636
Oil on canvas, 161 x 131 cm
Galerie Alte Meister,
Staatliche Kunstsammlungen Dresden

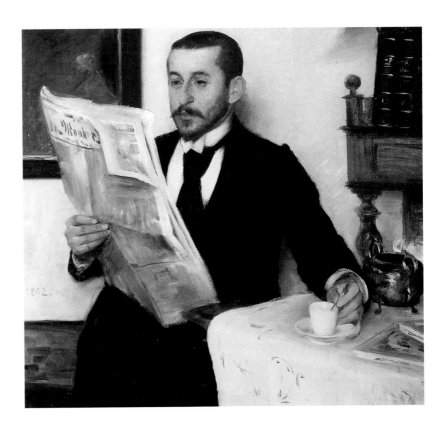

Fig. 6
Portrait of the Painter Benno Becker
(The Newspaper Reader), 1892
Oil on canvas, 87 x 92 cm
Von der Heydt-Museum, Wuppertal

simplest models such as "everyday street scenes" and "through his innate feeling for tone and color ... were ennobled to become genuine works of art."[11] Inspired by Trübner's work, he turned more and more to rural subjects—without neglecting interiors and landscapes—that demonstrated a further development in his painting as shown in the *View from the Studio Window* (1891) and *The Inner Forest near Bernried* (1892).

In 1892, his portrait of his colleague, the landscape artist Benno Becker, who was two years his junior, showed that he was already able to express the feelings of modern life in his pictures with great ease. The palette is reminiscent of Trübner but the naturalness of the posture, the conscious anchoring in the modern, the stressing of the situational, goes much further. (It is not by chance that one is reminded of Manet whose works were well known from reproductions at the time.)

A few years later, in the painting *In Max Halbe's Garden* from 1899, the moment makes itself felt even more strongly as something fleeting, even though the coloration is once again completely based on earthy tones in this case. The picture shows four people having a late breakfast one morning; the laundry has been hung out to dry in the background. Halbe looks up from his newspaper, while his wife smilingly—maybe even teasingly—offers their guest (the Viennese comedy playwright Carl Rößler) a peach; he appears to be grinning. A young woman with a doll-like face and an empty cup in her raised hand looks on, amused. In his autobiography, Halbe described the creation of the picture. "With the exception of myself, only one of the others worked. It was Lovis Corinth. As was his custom, he picked up his motifs from here and there; at the beach, in a farm garden, in a rocking boat on the lake. And, after a few morning hours, the large, quickly painted picture "at the breakfast table," with the laundry behind it and my wife offering a vagabond-like chap a peach, was finished."[12]

16

The overlapping now considerably effects the objects in the picture, increases the abrupt detail and, in this way, the sense of reality. This is particularly true of the figure of Rößler, with his back turned to us on the left, as well as Halbe's wife and the clothesline in the background. The brushstrokes of the group portrait are extremely open, broad and brisk; some objects—such as the woman's blouse and the clothesline and trees in the background—have completely lost their materiality and become moving fields of color. The immediacy of the view and the low observation point, at the eye-level of the figures and close up, indicate some knowledge of French painting. In addition, the strong contrasts of black, dark brown, and white, as well as the flat colors (especially in the green of the background) remind one of Manet's painting, which Corinth could have become acquainted with in Berlin in the winter of 1898.

The Parisian art dealer Durand-Ruel had already shown the first public exhibition of works by the French Impressionists at the Fritz Gurlitt Gallery in Berlin in 1883; it had been dealt with cruelly by the critics. One year previously, Carl Bernstein presented the ten Impressionist paintings he had purchased in Paris to a group of friends. Max Liebermann also came into contact with French Impressionism at Bernstein's. He wrote, "In 1885 or 1886, I became acquainted with the Bernsteins. The Bernstein's home was decorated in keeping with Parisian taste … of course, I was most interested in the Impressionist paintings that Bernstein had purchased through his cousin Charles Ephrussi (the later director of the *Gazette des Beaux-Arts,* and a friend of Manet's, Degas's, and Cl. Monet's) … The collection included some of Manet's most beautiful still lifes including the white lilac that Frau Bernstein bequeathed to the Nationalgalerie, the red poppies, a really lovely Degas and, especially, wonderful Cl. Monets, including the famous *Champs de Coquelicots* that Frau Bernstein left to me because I had always admired it so much."[13]

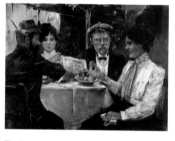

Fig. 7
In Max Halbe's Garden, 1899
Oil on canvas, 75 x 100 cm
Städtische Galerie im Lenbachhaus, Munich

In the early 1890s, Liebermann began collecting pictures by the French Impressionists himself. There had been a Monet exhibition in Weimar in 1890 followed, one year later, by a show with works by Manet, Monet and Sisley. In 1893 Gurlitt showed pictures by Pissarro, Degas, Monet, Renoir and Sisley in Berlin. In 1896, the year of his appointment, Hugo von Tschudi—together with Max Liebermann—purchased Manet's 1879 painting *In the Winter Garden* for the Nationalgalerie in Berlin. Two years later, Bruno and Paul Cassirer opened their art salon in Berlin with works by Liebermann, Degas and Meunier and, in 1899, they hung works by Degas and Manet alongside pictures by Slevogt.

Despite the impact they made, these French stimuli were received in Germany with restraint. The sturdy foundations in their own tradition of painting made it impossible for German artists to adopt impulses readily and completely. French Impressionism had been created out of a breach with tradition and saw itself in that light, whereas German art was based on the tonal painting and suggestive brushstrokes in the footsteps of Frans Hals and Dutch painting of the seventeenth century.

Throughout his life, Corinth was most strongly inspired by Frans Hals, Rembrandt and Velazquez. He found their work timelessly modern and significant,[14] and by attempting to anchor himself in their tradition, he hoped to also attain their importance.

That is why he repeatedly called for being aware of the importance of one's own tradition. Later, in Berlin, he reproached the young Expressionists, as well as the Fauves and Picasso, for having severed the vital umbilical cord connecting them with their own tradition. "A person who does not honor the past also has no hope for the future," he was to conclude. "It would be better for a person who disdains his own ancestors to take a millstone and go where the water is deepest."[15]

He repeatedly studied the art of the great masters of the past. A remark that Corinth made in a letter written to his wife in 1907, after he had just copied a painting by Frans Hals in Kassel, is particularly revealing: "Frans Hals, that chap, painted exactly as I do."[16]

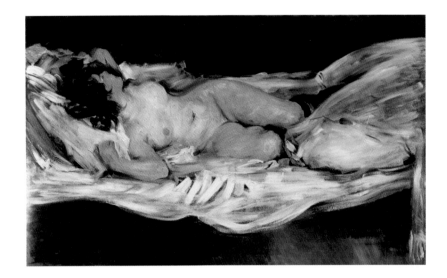

Fig. 8
Reclining Nude, 1899
Oil on canvas, 75 x 120 cm
Kunsthalle Bremen—Der Kunstverein
in Bremen

(On the other hand, this does not mean that Corinth rejected modern art—he repeatedly declared his admiration for Manet, Cézanne and Munch.)

Corinth's famous *Reclining Nude*, painted in the same year as *In Max Halbe's Garden*, shows how models of that kind could be applied to subjects of a picture with a modern outlook on life. What is shown with the unprecedented openness of the stroke—especially in the bed sheet—is tonal painting, the spirit and virtuosity of Frans Hals' brushstrokes, the living tradition of Dutch figural painting. The coloration of the picture remains very subdued and coherent, there is not a great variety of color or lighting effects and he mainly depicts the plasticity and heavy fullness of the body. The lighting is well composed and implemented with careful consideration. The nude achieves its sensuality and physical intensity not from warmly gleaming colors but from its plasticity and accentuated contours and their contrast to the open, immaterial structure of the brushstrokes on the light-colored sheet.

The depiction of a concrete person is not the most important aspect, there are no psychological intentions, Corinth is dealing with the attractiveness of this female body, with the posture, the fully developed physicality, and the warm glow of the skin. Asleep, the young woman has pushed the sheet down and now, unconsciously, presents the sensual shape of her accentuated body. The linen is only hinted at with a few incredibly open, sweeping brushstrokes. Its disordered, ragged appearance stresses this as does the tousled hair and lascivious posture of the portrayed woman and the sensual force of her physical appearance. It is certainly also a picture about the power of Eros that fascinated Corinth at the time, completely staged, full of effects and studied coincidence.

In other, later, pictures—such as *Magdalena*, *Descent from the Cross*, *Potiphar's Wife*, *Salome*, or *Temptation of Saint Anthony*—the artist deals more intensely with the historicity of the flesh, its conditioning through human destiny, its aging and decay, as well as its inscrutability, the sometimes senseless power of sex that makes one forget everything and the confrontation with asceticism, the clash of sensuality with self control. Here, however, we see only beautiful vitality and blossoming, the sheer fullness of life, with no danger of transience.

In Munich, Lovis Corinth soon discovered the strategies that lead to success. He repeatedly tried to provoke because he realized that a scandal could be beneficial to a career. In 1892, all of Germany's eyes were riveted on Berlin when Anton von Werner had an exhibition with works by Edvard Munch closed on account of its immoral

Fig. 9
Salome, 2nd version, 1900
Oil on canvas, 127 x 147 cm
Museum der bildenden Künste Leipzig

18

content as well as questionable artistic merit. The effect was, however, quite the opposite. Corinth wrote pointedly, "… the young were able to increase their hate of reaction and draw even more attention to themselves as martyrs of art, and the one who was to blame, Edvard Munch, profited the most. He suddenly became the most famous person in the German Empire."[17]

And, he attempted to benefit from this attitude himself. The second version of *Salome* (1900) was created completely with this in mind. She opens the broken eye of John the Baptist with the thumb and index finger of her heavily bejeweled hand and, in this way, forces him to look at her after his death. "Lift up thine eyelids, Jokanaan! Art thou afraid of me, Jokanaan, that thou wilt not look at me? …Well, thou hast seen thy God, Jokanaan, but me, me, me, thou didst never see."[18]

Many artists of the fin-de-siècle were attracted by the clash between the worlds of spirituality and sexual desire that Oscar Wilde showed in his drama.

The drastic picture is constructed sophisticatedly, everything is concentrated on the center of the picture where the bloody sword, the feet of the corpse, the severed head of the Baptist, the heinous hand of the princess, her voluptuous breasts and her blasé look are assembled one over the other. At the same time, the arms of the naked slave and Salome's leaning-forward posture create a circle with the saint's head at the center.

Fig. 10
Susanna in the Bath, 2nd version, 1890
Oil on canvas, 159 x 111 cm
Museum Folkwang Essen

Salome's breast almost brushes against the beard of John's severed head. This detail of closeness, which comments on the relationship of the woman to the man she loved or desired, can already be found as a motif in Paolo Veronese's *Venus and Adonis* from 1580 (Museo del Prado, Madrid) where the goddess's naked breast, similarly, almost touches the hair of her sleeping lover.

In any case, in *Salome* Corinth's burning desire for vitality leads to that "unusual mixture of an orgiastic scene and the psychological interpretation of the story. His Salome is also a woman of the late nineteenth century and his picture also depicts the abyss of human nature that Wilde described in his extravagant language." In this work, Corinth "disguises a matter that was current at the time in a biblical story."[19] History and mythology became a "means to express private experiences … Precisely the connection of the private with the mythological, the inclusion of the feeling of the time with the traditional content, was enough of an innovation and provocation."[20]

20

To Corinth's great disappointment, the painting was rejected by the jury of the Munich Secession. His friend Walter Leistikow—who, in the meantime, had founded the Berlin Secession together with Max Liebermann and Paul Cassirer—advised him to show the painting in Berlin. "He expected the picture to be an enormous success. And it was. I became a leading figure in Berlin."[21] The picture was shown at the Second Berlin Secession Exhibition along with *Susanna and the Two Elders* (1897) and *Crucifixion* (1897). This success was one of the reasons why Corinth turned his back on Munich and moved to Berlin. "In many respects, I have had enough of Munich and no interest in playing up to any of the blockheads in any one of the groups there; but nothing is possible without that. And, apart from that, my life has become boring; on the other hand, Berlin: tails, patent-leather shoes -..."[22]

Fig. 11
Portrait of Walter Leistikow, 1893
Oil on canvas, 124.5 x 100 cm
Stadtmuseum Berlin

Life in the Metropolis of Berlin

Walter Leistikow was the one who suggested that Corinth move to Berlin, as he needed support for those renewing the artistic life of the city, the Secessionists. Leistikow made his impressive studio on Klopstockstraße available to Corinth and suggested that he open a painting school for women to provide him with a steady source of income. He introduced him to important personalities in Berlin's cultural life and, in this way, helped him get his first portrait commissions in the capital city. Among those who Corinth met at Leistikow's were the playwright and writer Gerhart Hauptmann, the director of the National Gallery Hugo von Tschudi, and the painter Edvard Munch. He had personal friendships with the writer Arno Holz, as well as the painters Ludwig von Hofmann and Emil Orlik; all of them, in their fields, innovators of German art.

Berlin's abundant cultural life was characterized by a great willingness to take risks, intellectual debates and stimulating conflict. At the same time, the horizon for the fine arts had become increasingly international—especially through the efforts of the Berlin Secession and Hugo von Tschudi.

Corinth became involved with the Secession and saw it as a springboard for his own career. He joined as a member in 1901, and by 1902 he was already on the board as second secretary alongside the president Max Liebermann, Paul Cassirer as chairman and Walter Leistikow as first secretary. August Gaul, Ludwig von Hofmann, Fritz Klimsch and Max Slevogt were also members of the board. Essentially, this group of men represented the spearhead in the battle for modern art in Berlin.

However, Corinth was mainly looking for recognition and he made conscious use of his power when he felt it necessary to defend his own position. In 1910, he took advantage of the situation when Emil Nolde and other young artists felt that they were not receiving enough attention and demanded Liebermann's resignation. As a result, the entire board displayed solidarity and indignantly resigned—only Corinth remained and he was chosen to be the new president.
A few years later, in 1912, Paul Cassirer was elected chairman and the incompatibility of his private business interests with those of the office caused Liebermann, and most of the other important figures in the Secession, to leave the organization in 1913 and establish the "Free Secession." Corinth remained in the old Secession and was once again elected president in 1915; a position he held until his death. He understood that—even though it was no longer so important—the institution offered him a wealth of options for fostering his own fame and keeping him in the public eye. Thus, Corinth soon became a respected member of Berlin society; a party animal whose activities were regularly covered by the newspapers that even reported when he was out of town.

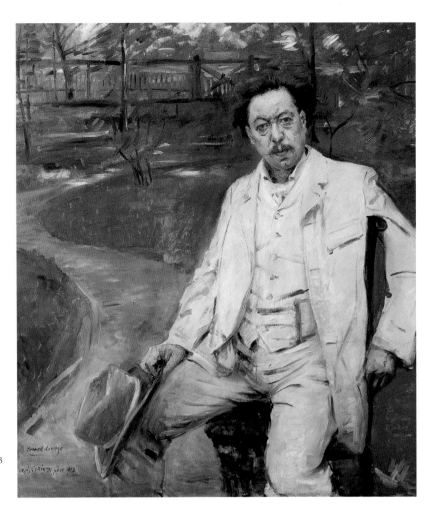

Fig. 12
Portrait of the Pianist Conrad Ansorge, 1903
Oil on canvas, 141 x 125 cm
Städtische Galerie im Lenbachhaus, Munich,
On loan from the Secessions-Galerie Munich

A stylistic change also gradually made itself felt in the painter's work after his move to Berlin—it was not abrupt; these developments always took place gradually in Corinth's work. Sometimes, after taking two steps forward, he took one step back into familiar territory. This can be clearly illustrated by Corinth's increasing interest in plein-air painting, which became much more important for him in his Berlin years.

After Blechen and Menzel had made major innovations—comparable with those of Corot—in the area of plein-air painting in Berlin, this tradition hardly developed any further during the second half of the century and was edged out by an increased interest in History and—especially—salon and genre painting. The intellectual narrowness of official cultural politics also increased continuously. In particular, Anton von Werner, director of the Berlin Art Academy and painter of History pictures, a man who articulated the Wilhelmian notion of art and took an active part in the public debate, was a red rag for the progressive artists. The foundation of the Berlin Secession, that Walter Leistikow so emphatically promoted, was a declaration of war and an attempt to open up new paths. Liebermann, its president after 1898, was particularly involved in confronting the officially endorsed artistic taste with French Impressionism and expanding the artistic horizon through international exhibitions. Cultural chauvinism was taking on an increasingly militant character and even led to the ban on purchasing modern French art for the Nationalgalerie.

Pictures by Bonnard, Cézanne, Gauguin, van Gogh, Munch, and others were then

shown in an exhibition in the Berlin Secession in 1903. In 1904, there was a Cézanne exhibition in Cassirer's gallery and one of Vincent van Gogh's work a year later. In 1906 a Manet exhibition opened and Corinth visited it several times;[23] this was followed in 1907 by a Delacroix show. Paintings by Cézanne, Matisse and Munch were also frequently on display until exhibitions of French art became more common and the important German museums started to collect such paintings.[24] The path for French Impressionism in Germany was also paved journalistically. As early as in 1883, Julius Meier-Graefe wrote about Pierre-Auguste Renoir; in 1902, he published *Manet and his Circle*, in 1904 *Modern Impressionism* and the first edition of *The History of the Development of Modern Art* (which was to be a great success when it was released in two volumes in 1908), and *Vincent van Gogh* in 1907. In addition, Paul Cassirer's contributions to *Pan* magazine played a major role in introducing French art to Germany.

In 1903, Corinth's *Portrait of the Pianist Conrad Ansorge*, which was painted entirely outdoors, devoted more attention to the depiction of the reflexes in the soft green tones of Ansorge's light-colored clothing. Here, the recognition of the fact that light, its reflexes, brightly-lit, strongly colored objects closeby, and their reflections, could all change the local color of objects, was now visually manifest. Subsequently, in his painting manual Corinth wrote, "The change in the local colors must be followed in the details. The darkness of the hair must be lightened by reflexes. They are tinted green when the figure is standing under leaves; the darkest eyes are foreseen with sparkling reflections. The color of the entire figure is determined by the surroundings that reflect it… The light, as well as the shadow, is of the most dazzling luminosity and colorfulness. The sky often produces blue highlights directly. One can never do enough with color."[25] This text, published in 1908, no longer includes any thought about tonal painting, no attempt to balance cold and warm hues. The efforts to depict materiality also radically take second place to the power of light, which no longer appears as illumination but instead as radiant colors.

On the other hand, Corinth's *Blossoming Farm Garden* of 1904 shows how difficult it was for him to give up his naturalistic approach. He was interested in new things but,

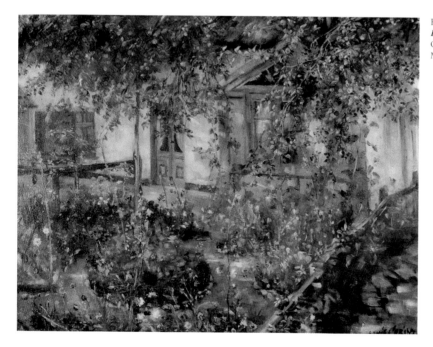

Fig. 13
Blossoming Farm Garden, 1904
Oil on canvas, 76 x 100 cm
Museum Wiesbaden

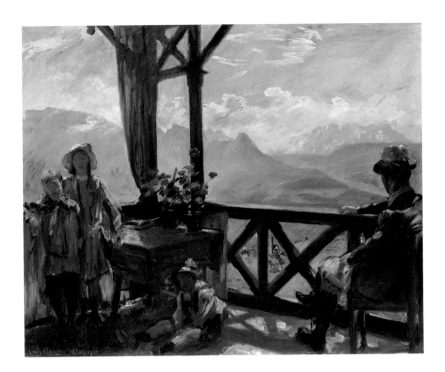

Fig. 14
Terrace in Klobenstein, Tyrol, 1910
Oil on canvas, 80 x 100 cm
Hamburger Kunsthalle

at the same time, trapped by what he had learned in Munich. All of the details of the garden in front of the house in Dievenow (Dziwnów) on the Baltic that Corinth painted in 1904—such as the flowers in the tidy beds and the apples hanging on the trees—are reproduced with great care and create a sense of cheerfulness. Although the section appears to have been chosen spontaneously and is somewhat open, the picture remains naturalistic. The various techniques and precise execution observed in works of the same period in Corinth's œuvre never cease to amaze.

Only a few years later, the *Terrace in Klobenstein, Tyrol* (1910) shows a picture inundated by light, which does without detail and indulges in the glow of the sunlight that flows into the veranda and magically transforms everything. The back of the man seated in the foreground draws us into the depths of the picture. Following his gaze, we look out into the vastness of the valley going as far as the mountains. But, the real main actors in the painting are the reflections of light that play on the various objects, hats, hair and clothing brightly illuminated by the sunshine.

Isolated examples of these characteristics can be found in the pictures with a religious, mythological or historical theme, which leads to tension in the pictures, to pronounced breaks between a modern and traditional understanding. One example of this is the apparent focus on detail, the close-up of the subjects despite the carefully arranged composition of the figures and the unvarnished realism in *Salome* or the lack of distance in *Sampson's Capture* where the viewer has the feeling of "being involved in an unforeseen manner … and being made a witness to the actions."[26]

As Corinth always approached his work from reality, the composed figural pictures were all painted in the studio after models. However, he was unable to capture "the tension between history and life and resolve it within a style"[27] as had been possible in European painting up to the eighteenth century, but became more problematic in the nineteenth. "The inner split" of the century that "no longer had the strength to be able to grasp reality and its superelevation with the twist of a calipers"[28] also made it impossible for him to pictorially grasp everything in one fell swoop.

Corinth's *The Weapons of Mars* (1910, fig. p. 75) is a particularly good example of this.

The timelessness of the mythological statement and the commonness of the figures shown simply cannot be rectified with each other, despite all of the technical quality of the painting.

This, although "the radicalism and absoluteness of the commitment are the same in both the early and late works. The movement of the permanent stylistic and thematic change in works by the young Corinth later settled to form a style, in the permanent actions of spontaneous painting. The violent and high speed stagings of the powerful young genius come from the same urge as the later improvisations. ... He was also definitely a commercial opportunist who rode the nineteenth century to death, accelerated its liquidation through shocking exaggerations and by over-winding the artistic carousel. With his excessive gifts and productivity, Corinth is a kind of super Makart."[29]

However, he not only produced extremely dubious pieces but also frequently pictures of exceptional quality.

Rudolf Rittner as Florian Geyer (1906) is one of these; a successful synthesis of portrait and History painting. Gerhart Hauptmann's drama had been premiered in Berlin in 1904 and Rudolf Rittner was magnificent in the title role.

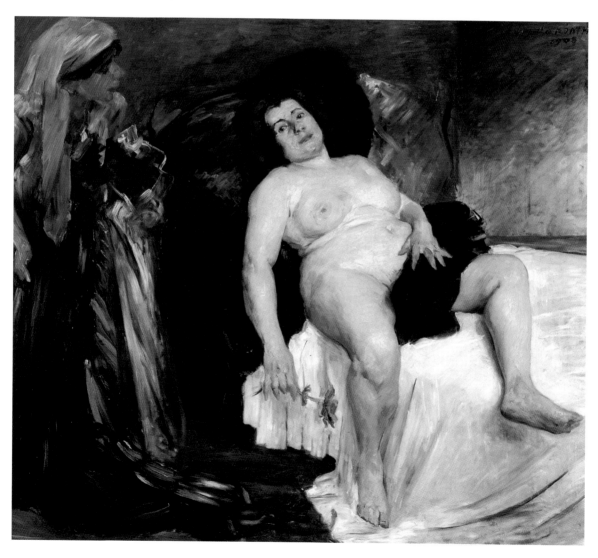

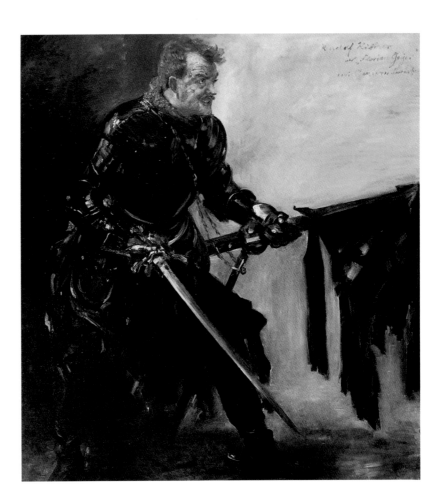

Fig. 16
Rudolf Rittner as Florian Geyer,
1ˢᵗ version, 1906
Oil on canvas, 180.5 x 170.5 cm
Von der Heydt-Museum, Wuppertal

Fig. 17
Portrait of Uncle Friedrich Corinth, 1900
Oil on canvas, 98 x 79 cm
Ostpreußisches Landesmuseum, Lüneburg

Its coloration is extremely restrained; the picture plays entirely with the drama of light and dark. The powerful appearance of the Frankish knight enters into the dazzling light of the stage from the gloom on the left edge of the painting and stands waiting for his enemies with the stump of the banner in his left hand and his drawn sword in the right. Corinth did without any other props and demonstrated the energy and inner strength of the man through the vehemence of his brushstrokes.

This makes the painting one of the most important portraits of an actor in a role from the period and brought Corinth a major success at the 1907 Secession exhibition.

Corinth's production increased tremendously in Berlin; he worked very quickly and many paintings only took a few hours. Even though some of the portraits (especially of women) that were created then are just pleasantly superficial, he attempted to show the characteristics of the person and sometimes displayed their physiognomy without mercy. It is much more that the graphic portrayal of his figures makes a statement about their personality. In addition to the self-portraits, this is shown impressively in the vagabond-like appearance in his *Portrait of Peter Hille* (1902, fig. p. 70) where, with limited means, he depicts the interior of the studio Hille had come to visit and the impression made by the bohemian. In the *Portrait of Uncle Friedrich Corinth* from 1900, we are confronted with the dignity of old age, looking at us out of alert eyes in an already frail body. The portrait of the writer *Count Eduard Keyserling* shows the permanently ailing Baltic poet, who was suffering from a progressive illness of the spinal cord and became blind eight years after this picture had been completed, as a quiet, gentle storyteller.

26

The magnitude of Corinth's production in those years and the wealth of subjects were too much for some of his contemporaries. In 1918, a critic reporting on the thirty-second exhibition of the Berlin Secession wrote, "When he arrived in Berlin, people were infuriated by his ruthlessness... The atmosphere changed, when one instinctively felt that he was not a preacher in the wilderness but a gourmet... It is as if his art always wants to take a bite out of the flesh of life... His world is made up of figures of Christ, the Apostles, henchmen, naked saints, armored warriors, exotic beasts, expensive fabrics, flowers, fruits and landscapes, perverse Miss Salome from Berlin West, Susanna and the two elders, Odysseus as a scabby beggar, actors in their roles, butcher's lads, the bourgeois and bohemians, costume models and the artist himself in all the conditions of his existence; he paints exotic improvisations, motifs from the Old Testament alongside mythological allegories, Peter Hille, Hagenbeck, Eduard Meyer and elegant society ladies, things from far and near, ancient and from yesterday—and, above all, nudes, nudes time and time again."[30]

Fig. 18
The Great Martyrdom, 1907
Oil on canvas, 250 x 190 cm
Kunstforum Ostdeutsche Galerie Regensburg

Yes, the woman was definitely the subject of his life with nudes playing a major part. The aspect Corinth most looked for was reality and, connected with it, he did not hide ugliness. But we also find paintings such as *The Big Garter* or *Rococo* and—to a certain extent—*Matinee* where the pleasure of showing something superficially coquette predominates. However, they are mostly mediocre pictures where the taste of the period seems put-on and not really in keeping with Corinth's artistic desires; his own sensuality and vital view of life are far removed from these artificially "spicy" pictures.

Corinth's statement is much more direct, his affirmation of the pleasures of human life much more open and, at the same time, straightforward. There is nothing coquette about the way he stresses the stimulating effect of a woman's body, portrays orgiastic and Dionysian subjects (*The Youth of Zeus, Returning Bacchants*) or praises sensual pleasures (*Self-Portrait with his Wife and Champagne Glass*). At the same time, other pictures point towards the depths of his being (*Fall of Man, Temptation of Saint Anthony* and *Joseph and Potiphar's Wife*).

Many of his nudes were created as a reaction to a moment—these include *Matinee* and *Relaxing Nude* and, although not a pure nude, *In the Corset*—but most were the result of thorough study because, even when born in a moment, Corinth's art usually goes beyond this initial impression and, especially in the portraits, overcomes the coquette, titillating, politely-delicate or only Impressionist (in the sense of a sophisticated, superficial manner).

In his book *Das Erlernen der Malerei* (Studying Painting), Corinth writes, "Modern motifs, by distancing themselves from classical figural paintings, differ in showing direct, positive situations rather than an intellectual expression. They are depictions of life, everyday occurrences, based on other artistic circumstances. In the former subjects, if one acts at will with the psychological expression, with the brilliance of the nude, with any kind of lighting, reality becomes a sensation and the depiction subservient to this."[31]

Fig. 19
Portrait of Count Eduard Keyserling, 1900
Oil on canvas, 99.5 x 75.5 cm
Bayerische Staatsgemäldesammlungen,
Neue Pinakothek, Munich

The *Reclining Female Nude* (1907, fig. p. 73) in the Belvedere's collection is unquestionably one of Corinth's masterpieces. This is not merely because it is only the figure that gives the picture its depth and fills it completely with its presence to such an extent that the space almost explodes, but also because the relief of this body, the nature of the flesh and various tones of the skin under the different lighting conditions with gentle red, brown, gray, blue, and green values is so masterly reproduced. There is no sense of uncertainty with the proportions, nothing clumsy about the positioning and, simultaneously, there is the utmost concentration on the pure nude lying on the light-colored simple cloth on the table and the even more restrained background. Nevertheless, this is powerful, unsparing art that does not shy away from ugliness.

In pictures like this, Corinth was not looking for an ideal but rather the depiction of

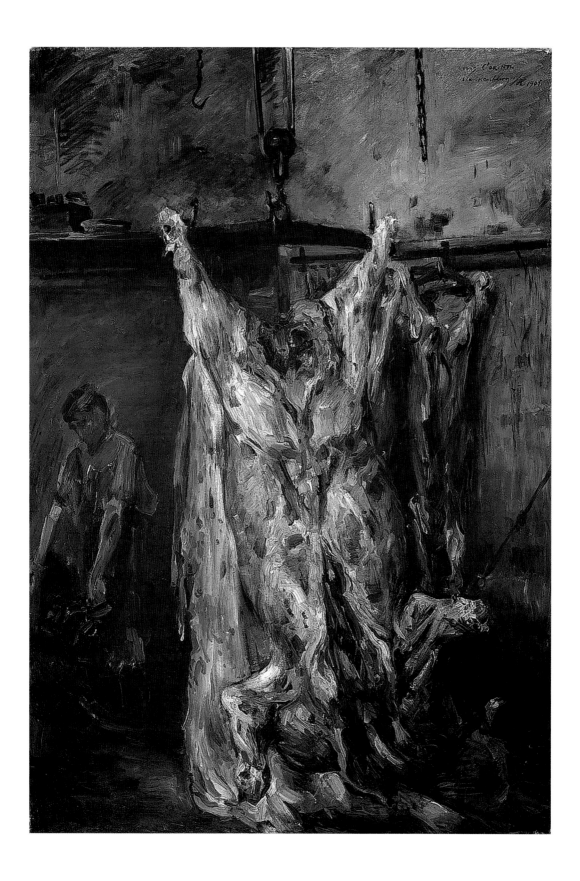

realistic bodies and postures. The painter liked passive, voluptuous bodies, heavy, bulging flesh, translucent, shimmering, pale or reddened skin. In this case, it is the almost indecent presence of the female figure that characterizes the painting, a dosing, almost shallow presence, but one full of vital physicality and depicted with unparalleled intensity.

The radical modernity of the portrayal results from the fact that it really does not show a person but a piece of flesh on a table!

Here, we are addressing an aspect that is valid for all of Corinth's art: his sensuality, his eroticism, is always invested with overtones of transience; finiteness makes itself heard as part of this magnificent material. Thus, it is not surprising that this fascination for the flesh made it possible for him to approach the subject much more directly.

With his pictures of slaughter and raw meat, Corinth stands in the tradition of a genre that dates back to the early sixteenth century. Annibale Caracci dealt with the subject as early as in 1580 in his *Butcher Shop* (Christ Church Library Collection, Oxford). Rembrandt's *Slaughtered Ox* was created in 1655 and this provided the inspiration for Corinth's first version of a *Slaughtered Ox* in 1862, since he had seen the painting in the Louvre during his stay in Paris. It is also possible that Liebermann's paintings of slaughtered animals from the late 1870s and some of Millet's pictures played a role. Corinth, who was used to such things from his father's farm in Tapiau, seems to have been somehow fascinated by the work of a butcher.

In *Slaughterhouse in Schäftlarn on the Isar* (1897, fig. p. 62), particular attention is paid to the effects of light on the individual pieces of meat, the feeling of space, and the butcher's helpers; both atmosphere and genre are in the foreground. Here, we no longer see entire carcasses but pieces of meat, pure in their constitution, without any connecting structure, organic or organized system. The shimmering, even dazzling, red meat still appears to be warm, just torn away from life. In this work, Corinth is no longer tied so closely to materiality and can investigate the pure effect of color values on each other.

On the other hand, in *The Slaughtered Ox* from 1905, the monumental depiction of the animal's carcass forms the middle point. It stands out in the light while the rest of the room remains in semi-darkness; the butcher in the background is also only hinted at with the fewest possible fleeting brushstrokes. Although the ox has already been slaughtered, its limbs are spread wide apart, its body cavity opened, and is shown hanging by its rear legs, it is still quite massive and makes a powerful impression—the viewer stands completely under the impact of the heavy weight of the flesh. Just skinned, this shines in many nuances of color ranging from red and pink to blue and green. The background is rather restrained but the chromatic variety is concentrated on the flesh so that it appears to mirror a multitude of reflected hues from its surroundings in addition to its own materiality. The challenge of capturing the inner structure, and the attraction of the surface, caused Corinth to repeatedly deal with changing aspects of this subject.

In Corinth's work, colors as such always have substance, they are not merely applied as spots, points and color values as the French did to represent a shimmering, flickering light, a glow and the reflection of color. That is why von der Osten speaks of a "sign of dampness"[32] in these Berlin year; a dampness of the heavy material that underlines the vitality of what is shown as an individual stimulus. In the *Slaughterhouse in Schäftlarn on the Isar*, this quality also invests the pieces of meat with an astonishingly sensual presence that gives the viewer the impression that they have been freshly butchered and are still steaming. Later, in pictures such as the *Woman Reading near a Goldfish Tank* from 1911 (fig. p. 79), the colors develop an inner force as well as a severity in their interaction, which goes beyond the optical impression.

In his colorful language, Julius Meier-Graefe found a fitting characterization for this fundamental talent of Corinth's: "He is a realist without realism; intellectually, with-

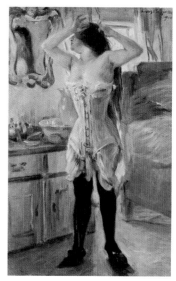

Fig. 21
In the Corset, 1910
Oil on canvas, 75 x 48 cm
Private collection

Fig. 20
The Slaughtered Ox, 1905
Oil on canvas, 160.5 x 110.5 cm
Kunstforum Ostdeutsche Galerie Regensburg

out any upbringing of the spiritual kind. He is a dreamer like Böcklin. An atmosphere of alcohol becomes the background of the fairytale… He has something in his brain, in his fingers, that probably makes him an artist in spite of all this. He is not refined, no less than that; but he has strength, unprecedented vitality. The physical power pours out of some of Corinth's paintings and hits the viewer with the force of an animal in heat. Sometimes, one would prefer not to look, believing that one can smell what is meant for the eye."[33]

It has become clear that the major subject in Corinth's art is the depiction of women. One of his favorite models was his own wife and he painted around eighty portraits of her—in addition to the countless other pictures she modeled for. Frequently, private situations originating in the closeness of the couple inspired the pictures. Charlotte Corinth often reported on her husband's rapid decisions to capture situations that appealed to him on canvas or paper as soon as possible.

This makes Corinth's pictures of his wife so full of intimacy, warmth, and sensitivity. It is quite astonishing that this physical artist was able to compose these pictures using such tender tones.

The portraits appear to be renewed assurances of his love for his young, attractive—and so devoted—wife.

Corinth's initial attempts to have closer contact with Charlotte Berend—one of his first pupils, who enrolled in his "Painting School for Women" at the age of 21—were by way of the portrait: *Portrait of Charlotte Berend in a White Dress* was created at the end of her first year of training. "The teacher soon showed a conspicuous attentiveness to me, praised me, and told me I was making good progress in the fine art of drawing, but I could feel that a personal interest was becoming ever more apparent. This reached its culmination at the end of the semester in June with his question: 'Miss Berend, I would like to paint your portrait. What do you think of the idea?' That is how the first portrait of me—*Portrait of Charlotte Berend in a White Dress*—came about. He gave it to me and signed it 'The teacher, for Miss Charlotte Berend.'"[34]

In many of the pictures, the closeness of the two is almost glaringly obvious. The *Woman Reading near a Goldfish Tank* (1911, fig. p. 79) shows one of his wife's favorite places in their conjugal apartment, which she had decorated with an aquarium and plants and where she liked to retire in the afternoon to read. Corinth reports on all the furnishings and plants with a great love of detail—everything is important, because it is important to his wife. The view from above also contains something loving but, at the same time, reveals something of the spontaneity of the decision to capture this situation.

The painting *Donna Gravida* (1907) is even more intimate. The portrait of Corinth's pregnant wife takes its title from Raphael's *Donna Gravida* in Florence's Palazzo Pitti and was created shortly before the birth of their daughter Wilhelmine. Charlotte Corinth's "heavy" figure rises up in front of a completely plain background of a curtain or cloth. She leans back in an armchair, relaxed, her head tilted a little to the side. The right hand holding the cloth against her breast appears to be an attempt to capture the fullness, while the left is propped up on the armrest at the side. With the exception of the fine, greenish headscarf and the light-blue fabric on her lap, the colors are restricted to her face and body. A little bit of red at the lower edge of the painting repeats the reddish tones of the face and, in this way, invests the painting with an additional sense of unity and formal stability.

While working on the painting, Corinth assured his wife that pregnancy had made her particularly beautiful; her face was blossoming and full of life. Especially the warm red tones that gently make themselves felt in the face and skin and create an effect of pulsating vitality, the glowing eyes, and the relaxed smile of her wide mouth contribute to this. The fertile, enveloping body is characterized by the wide expanse of the breasts. Charlotte looks so happily distant, and her facial expression is so content that

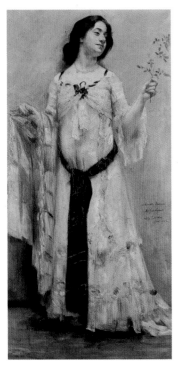

Fig. 22
Portrait of Charlotte Berend in a White Dress, 1902
Oil on canvas, 105 x 54 cm
Stadtmuseum Berlin

Fig. 23
Donna gravida, 1909
Oil on canvas, 95 x 79 cm
Staatliche Museen zu Berlin, Nationalgalerie

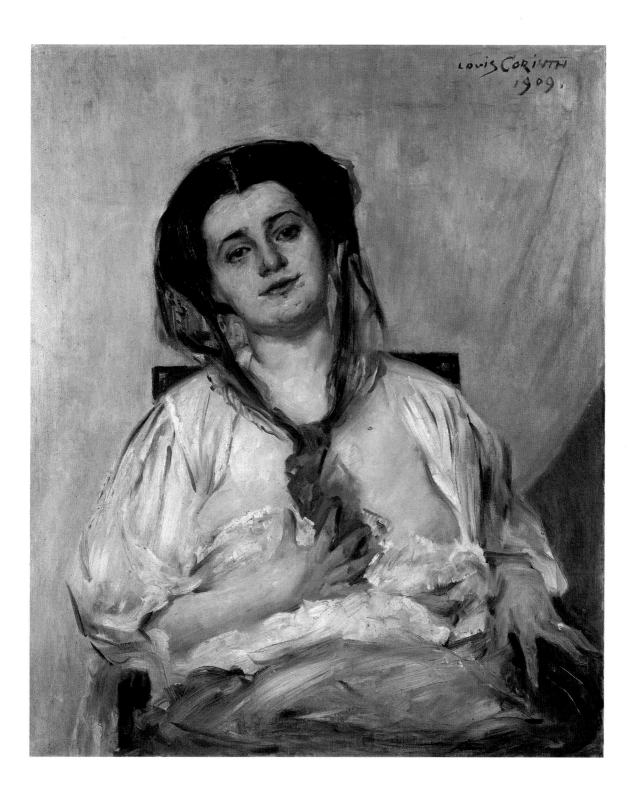

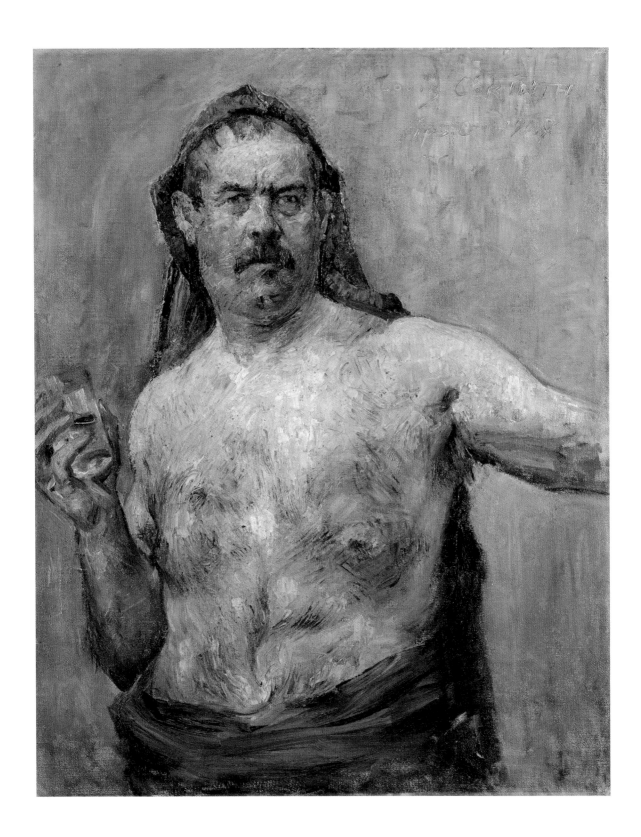

she pays no attention to her appearance and seems not to notice that she is not completely dressed (in an open blouse, scantily covering her nakedness by placing a cloth over her breast) while sitting for the portrait, giving the painting its intimate character. The relaxed unfolding of the wide body is collected by the right hand and centered in the middle of the picture. This forms the heart of the composition—not only physically and spiritually, but also formally—so that the viewer's gaze repeatedly makes its way from her face and eyes to her hand and back again. The game of hiding and revealing, shown in the face and body, gives the picture its high quality and expands the statement made by the picture going far beyond that of a simple portrait.

His self-portraits provided a possibility for Corinth to define his own position, to convince himself of his own value and analyze his own artistic will anew. The painter dealt with his own appearance—sometimes, completely spontaneously—in more than 40 paintings and around 80 drawings and, after the turn of the century, painted himself at least once a year, usually on his birthday. These depictions were sometimes prompted by a graphic stimulation, sometimes a psychological condition and occasionally by high spirits. In addition to the varied portraits in disguise, with mythological or historical allusions, we must pay attention to those that were created on the spur of the moment. This was especially the case with drawings, etchings and lithographs.
"In their immediacy and spontaneity of the moment, these self-portraits—a great number of them signed with a single date—reflect the atmosphere or situation as a reflex of a visual perception. Even more clearly than in a painted self-portrait, one's attention is concentrated on the fleeting changes in expression and the material appearance of the over-proportioned form of the head (in relationship to the body), modeled through the dramatic contrast between light and shadow."[35] A moment in time here, developing from the impression of the moment, even when this means no lingering in the appearance of the surface.
In the painted self-portraits, Corinth appears to observe his own figure objectively and without mercy, as it were. For example, in the *Self-Portrait with a Glass* (1907) he must have suddenly felt the desire to exhibit his massive body, half nude, and increase the effect by adding a neckerchief (or hood) similar to that used by laborers. This is a picture from those years when Corinth felt himself to be in complete control of his powers and was extremely involved in the culture-political activities of the Secession. Despite the staging—the slightly turned stance with the glass in one hand and the other arm stretched out and cut by the edge of the painting—the work creates the impression of showing of a person who tackles things head-on. Above all, Corinth finds an equivalent for his physical coarseness and strength in the overall roughness and patchiness of the painting's structure. The numerous tones of gray, brown, blue, yellow, pink, red, etc., in small, nervous, energetic, short brushstrokes, on his body vibrate and amalgamate with the omnipresent red to create a feeling of pulsating vitality. There is a close connection between the coloration of the figure and ground. "The rhythm of a polar bear with little red eyes glided over Berlin's parquet. He saw some bankers, and some bankers' wives, swaying in front of him in his lecherous eyes: bacon, ready for the slaughter! Watching him dance was one of the joys of winter in Berlin. He always had two carafes in front of his plate at dinner. They discussed Impressionism and emotions with him. Corinth was… Florian Geyer, Sampson, Armin the Liberator, the tamed Hun. With half-closed eyes, one could see the naked limbs stirring beneath the matted fur. One young woman fainted."[36] Meier-Graefe's amusing description is not far removed from the picture the artist had of himself. In those years, he liked to compare himself with Rembrandt and how he flaunted his own success. But, his pictures also clearly revealed that his way of living centered on worldly pleasures.
Almost as if he wanted to judge his own progress, he repeated the same composition two years later; this time, from much closer and almost entirely eliminating the arms in his *Self-Portrait with Red Scarf.*

Fig. 24
Self-Portrait with a Glass, 1907
Oil on canvas, 120 x 100 cm
Národní Galerie, Prague

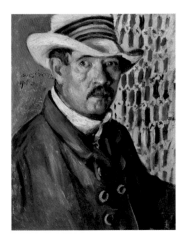

Fig. 25
Self-Portrait with Panama Hat, 1912
Oil on canvas, 66 x 52 cm
Museum of Art Lucerne

Fig. 26
Self-Portrait as Standard Bearer, 1911
Oil on canvas, 146 x 130 cm
National Museum, Poznan

Fig. 27
The Blinded Sampson, 1912
Oil on canvas, 130 x 105 cm
Staatliche Museen zu Berlin, Nationalgalerie

In 1912, once again inspired by a piece of clothing, he found his path to absolute colorfulness (cf. *Self-Portrait with Panama Hat*). And, in later self-portraits such as *Self-Portrait with Hat* (1923) and *Large Self-Portrait in Front of Walchensee* (1924, fig. p. 45), the "tension between the Impressionist detail and academic faithfulness to the model of the earlier self-portraits" that had previously existed "has been replaced by an artistic imparting of all the contrasts in the medium of light and air."[37]

The 1911 Stroke

On 11 December 1911, Corinth suffered a severe stroke that led to a partial paralysis. The shock of having narrowly escaped death went deep. "In the night, my departed often appear and seem to be waving to me while a force from above pushes me down, ever deeper."[38] The slowness of his recovery was excruciating, the hardship humiliating. From one moment to the next, the painter became aware of the finite nature of his own life, the fragility of his existence. "My whole life passed by me, a life that now appeared more valuable in my lonely struggle than in youthfulness and strength. It forced me to take account. A lifespan—it appeared so miniscule to me."[39]

He had just painted himself as the armed *Victor* (1910) who receives the beauty of a woman as his prize, and as a standard-bearing knight (*Self-Portrait as Standard Bearer*, 1911), but now Corinth saw himself as the captive of his physical infirmity, abused by destiny, "blind" on his future artistic path, like *The Blinded Sampson*. It is like a despairing outcry resulting from the experience of helplessness, his loss of strength, the feeling of complete uncertainty, and the collapse of his self-confidence. The muscular man, whose powerful physique seems to explode out of the picture, comes out of a narrow door, steps hesitantly, blinded and in chains, with his face contorted with pain and the bloody eye bandage, his arms spread wide open, fumbling for a world he no longer knows. It is witness of a profound existential blow, the expression of sheer terror.

The physical and psychological after-effects of the stroke were to remain. The drawings created in the first year of his recuperation show phenomena that are clearly a result of the stroke and did not exist in his work before 1911. Even though Corinth soon found it possible to work with his hands (particularly, to be able to control the trembling of his right hand)[40] and continue as before his illness with the creation of powerful pictures, some limitations obviously persisted. "I would like to defend myself with an expression the press accused me of: virtuosity; illnesses, paralysis of the left side, like a monstrous trembling of the right hand … prevents a skilled calligraphic style in my work. The continuous striving to reach my goal, that I never succeeded in as I wanted, has soured my life and all work ends in depression over having to continue with this life!"[41]

Above all, Corinth's approach to his work changed as a result of these experiences. On the one hand, after having recovered his strength, he must have reflected on what he had created during the difficult period and become aware of new possibilities of expression. But, on the other hand, the physical experiences, as well as his psychological condition, now made it possible for him to investigate the possibilities of modern artistic tendencies, such as Expressionism, with a new openness.

As a result, the subjects of his pictures became increasingly private. History painting, which had previously been so important to him, became less significant. Corinth had finally begun to divorce himself from being a nineteenth-century painter.

First of all, Corinth was sent to a spa to recuperate with his wife. In Bordighera on the Italian Riviera he not only rediscovered his lust for painting but also the pleasure of

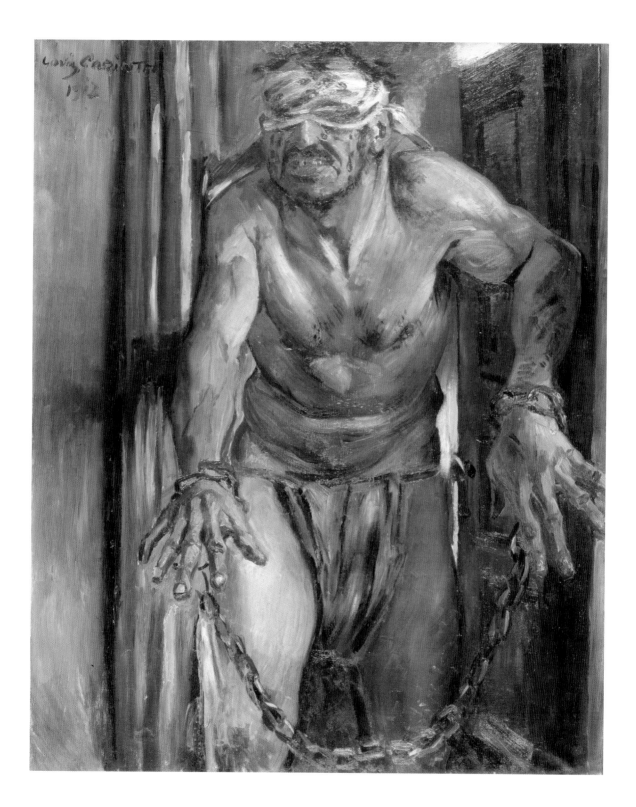

beautiful objects. In light of the fact that Corinth's identity was virtually painting, his convalescence and recovery came about through his artistic work.

On the Balcony in Bordighera from 1912 (see also fig. p. 108) tells of this new cheerfulness. As with many other artists, the southern light led to a liberation and change in Corinth's palette towards pure colors. The radiance of the clear air and glaring light of the south becomes visible in almost pure white tones, alongside the dark, saturated, rich colors of the succulent green of the vegetation, the orange-red roofs and, above all, the dark blue of the vibrating sky. The brushstrokes now become shorter (Corinth's physical state may have been responsible for their being applied in streaks) and the objects in the pictures—especially the mountains and plants—are characterized by a rhythm of spots of pure color and short strokes of paint, quite independent of their representational form (it is no surprise that we are sometimes reminded of Cézanne) and now the works come much closer to French Impressionism than any created before.

At the same time, this led to a radical acceleration of a development that had made itself felt in previous years but which was still tied to the virtuosity of his brush style: the conception of the picture as a surface and the development of depth and composition out of pure color values; the autonomy of the pictorial media with their inherent relative strengths and conditions. This was a decisive step: the discovery of the medium as an individual reality. In the words of Hermann Broch, "Painting must repeatedly be reduced to the medium of light and spots of color, because everything that can be said visually about the reality of the world takes place exclusively between, and at,

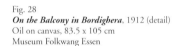
Fig. 28
On the Balcony in Bordighera, 1912 (detail)
Oil on canvas, 83.5 x 105 cm
Museum Folkwang Essen

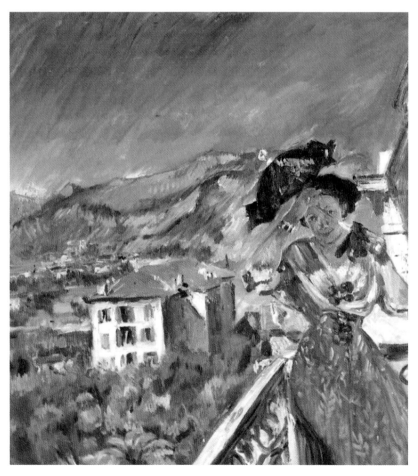

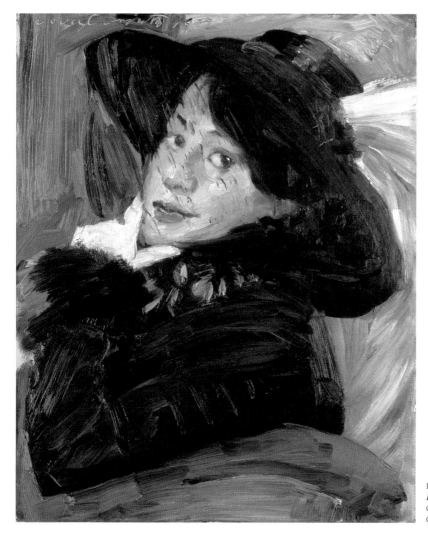

Fig. 29
Portrait of a Lady with a Lilac Hat, 1912
Oil on canvas, 64 x 50 cm
Germanisches Nationalmuseum, Nuremberg

these two medial levels, and such a reduction of the process of painting to its ultimate nakedness, to its most naked primeval principles, will reopen the entrance to those spheres from which the primeval symbols of art, and their new truths, will arise."[42] Corinth then followed the path that the French Impressionists had also taken—that, of increasingly making the pictorial media subjects in their own right—however, in a completely different manner that can be explained from the point of view of his own German tradition and the uniqueness of Corinth's development. In addition to the expressive value of color, he also understood the intense power of the subjective brush style; and, above all the vibrating stimulation created by hastily positioning them next to each other.

In these years, Corinth created portraits of amazing intensity in what had now become a more expressive style. The verve and, supposed, disorder of the open brush strokes and the color paste that seemed to be thrown wildly onto the canvas, resulted in pictures that not only showed a physiognomic similarity to the portrayed person but also an impressive personality whose gaze we have to withstand, whose aura becomes astonishingly tangible. Paradoxically, this dimension is more strongly reinforced, the freer the artist is in dealing with the portrayed subject.

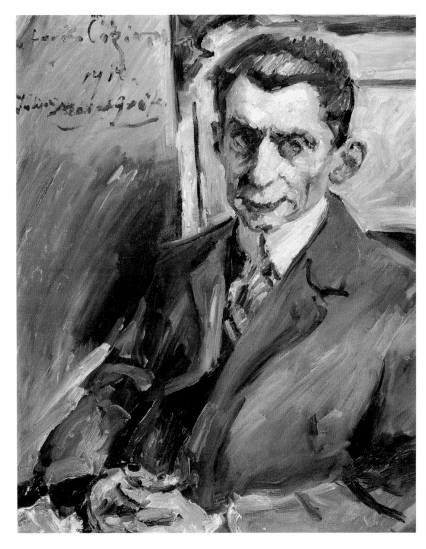

Fig. 31
Portrait of Julius Meier-Graefe, 1917
Oil on canvas, 90 x 70 cm
Musée d'Orsay, Paris

The cosmopolitan, alert, highly cultured Meyer-Graefe appears before us as if he wanted to observe the painter critically; the astute poet Herbert Eulenberg (fig. p. 95), whose piercing gaze reveals something of the spirited intellect and passionate esprit of this person who was so uncompromising in the National Socialist period.

Wolfgang Gurlitt—Corinth's agent after 1913 when the painter had fallen out with Paul Cassirer and separated from him—was painted in all of his urbane elegance in his gallery. The sheet of paper in his hand is an indication that he published Corinth's graphic works and was one of the co-editors, with Karl Schwarz, of the book *The Graphic Work of Corinth* in 1917. The display case and the pedestal of the pilaster behind him give an impression of the sophisticated ambience of his showroom.

In his later years, Corinth repeatedly questioned the innermost regions of his being in a series of increasingly intensive self-portraits. In them, the brushstrokes express Corinth's no-nonsense, highly aware, inwardly agitated condition as do the fierce, energetically sweeping, strokes of the palette knife. The color is impasted—applied almost "juicily"—sometimes only hastily spread, grimily mixed with traces of other colors at their edges. The inner doubts resulting from the repeated depressions, as well

Fig. 30
Portrait of Wolfgang Gurlitt, 1917
Oil on canvas, 113 x 90 cm
Lentos Kunstmuseum, Linz

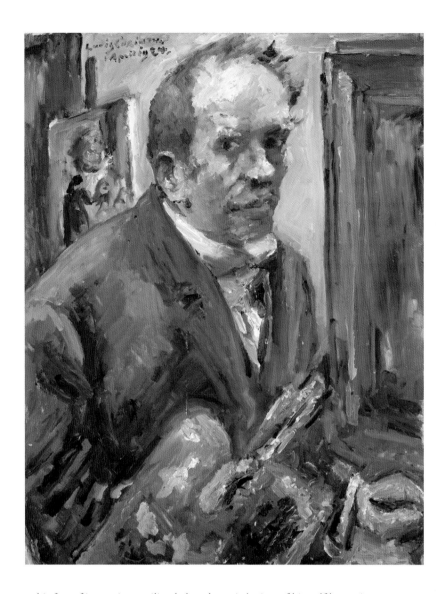

as his fear of increasing senility, led to the artist's view of himself becoming ever more uncertain. However, he countered all of that with the picture of his artistic potency and determination.

Towards the end of the war, the depressive tendencies in Corinth's character increased. The hitherto unimaginable atrocity of this war, the defeat and final collapse of the German Empire, were a heavy blow to him. In its stifling monumentality and symbolism, the painting *Cain* explores the problem of the fratricide between the peoples of Europe. *Pieces of Armor in the Studio* (1918) shows one of the props Corinth had liked to use for his pictures for many years (and which was also the epitome of his virile understanding of life)—the suit of armor, with its individual pieces strewn in resignation over the floor (fig. p. 77).

The *memento mori* now appears regularly in his works—with changing faces.

For example, in an etching from 1916, Corinth once again takes up the pictorial idea he had developed in his 1896 painting *Self-Portrait with Skeleton*. Now, death no longer stands alongside him but dominantly in front of him. On several sheets from his

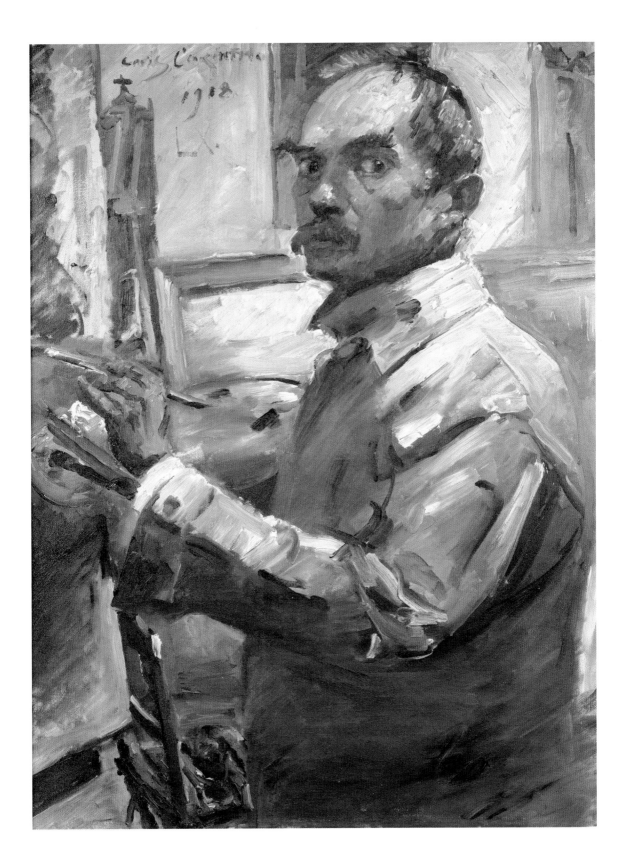

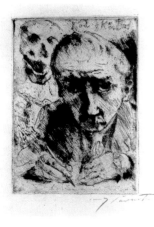

1922 *Dance of Death* portfolio, with the dramatic contrasts of its vernis-mou and cold-point etchings, Corinth shows himself, close relatives and friends, face to face with death.

On the other hand, the landscape pictures of his later years always originated from an atmosphere, the changing character of the landscape, the variation between familiar and new stimuli.[43] All of the pictures of fresh snow on Walchensee, where one can feel Corinth's surprise at the sight just after waking up, the moonlit nights, views across the lake in autumn, in winter, at Easter and so on, the self-portraits in the summer sun in the foothills of the alps, result from this renewed enthusiasm—and the coloration of many of them is more convincing than those previously created; they are more daring and concise in the dissolution of forms so that, if one squints slightly, one has the feeling of being directly in front of the landscape.

In 1919, Corinth bought a piece of land on Walchensee and his wife had a wooden house built there for the family. Urfeld increasingly became a refuge from the stress of the big city of Berlin for Corinth. Sixty paintings showing the changing atmosphere of the lake have been preserved. (A comparison with Cézanne's Mont Saint Victoire that was a repeated source of inspiration and challenge for the French artist suggests itself.)

Corinth wrote, "The lake itself changes its colors and atmosphere mysteriously. Sometimes it flashes like an emerald, then it is as blue as a sapphire, and suddenly as dazzling as amethysts in a ring with a setting of powerful, old, black fir trees, reflected even blacker in the clear water… Walchensee is gorgeous when the weather is fine but incredible when the elements rage… It is called the 'suicide lake'. A small shed with nailed up windows is located in a hidden valley; that's where the victims are recovered from the lake. The black reflections on the water only make the eeriness even more spine-chilling."[44]

In 1921, Corinth painted *Walchensee: View of the Wetterstein* from the balcony of his house—the balcony railing and flowers at the lower edge of the painting are a clear indication of the artist's position.

The vehement pull towards the depths of the bluish mountains and the striking peak shown in the painting is impressive proof that Corinth must have frequently cast his gaze towards the Wetterstein. Although the tree in front of the house takes up quite a bit of space, it is clear that this was not what really interested him: it appears much more like the out-of-focus foreground one perceives when one concentrates on the distance. The smoothness of the lake with the mountains and sky reflecting on its surface is captured masterfully with a few streaks of color.

In this painting, a sense of depth and expanse are created using the simplest means, but with the utmost confidence, and here, principally, because with the effectiveness of the colors, Corinth takes the visual experience of the viewer for granted. The green of the summer meadow, the blue of the hills and mountains, and the violet and green of the forest slopes, are so precisely captured that the atmosphere of this day is in no way limited by the missing depiction of details. The brushstrokes are passionately rhythmical: short, often parallel, occasionally like a patter of strokes, and give an idea of the speed at which he worked.

In *The Herzogstand on Walchensee in the Snow*, 1922 (fig. p. 120), the patches of snow are dirty, and only a few leaves—whose yellow and reddish brown flicker in the lightly colored tones of the picture—are still hanging on the trees. A snowy white open strip leads from the slope to the lake with a wider one with sparse young trees in front of it. The surface of the lake is completely dreary and lusterless; the sky above the mountains is cloudy, but not oppressive. In spite of the snow, warm colors dominate the picture. In addition to the many brown tones, the pale green of the opposite slope is spotted with blue and violet and only in the distant mountains do we see a dazzling blue. All of this is painted openly and freely without paying attention to the details.

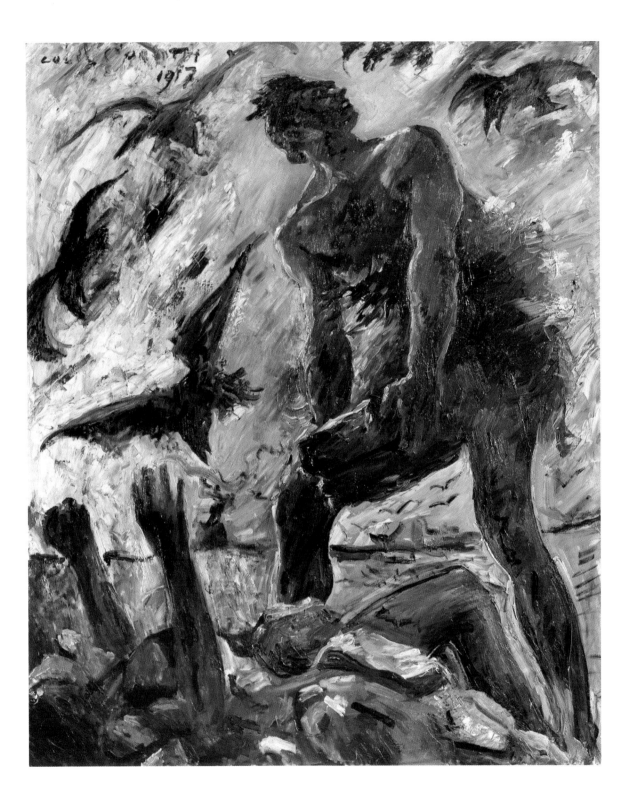

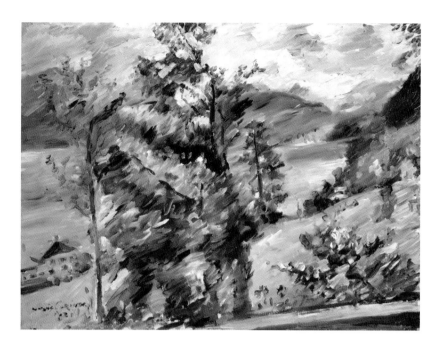

Emotions are evoked, and all of these things depicted, solely through the absolute confidence in the choice of the tones and nuances of the colors.

Seen from a distance, the picture develops into a felicitous description of the atmosphere of warm weather (it is possible that the *föhn* wind was blowing on the northern edge of the Alps). The strong contrasts, the darkly glowing brown and rich black of the trees, as well as of the individual trunks in the foreground, and the fact that the colors and objects appear so close that one can touch them, come across vividly.

In *Walchensee, New Snow* (1922) the view glides down the slope—only interrupted by a few trees—to the lake whose bright surface stretches across the entire width of the

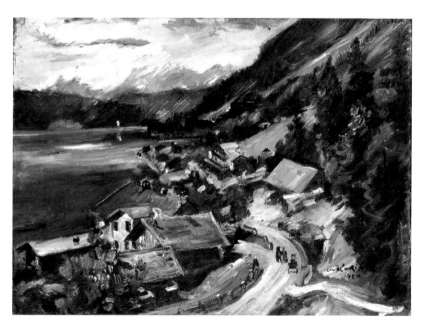

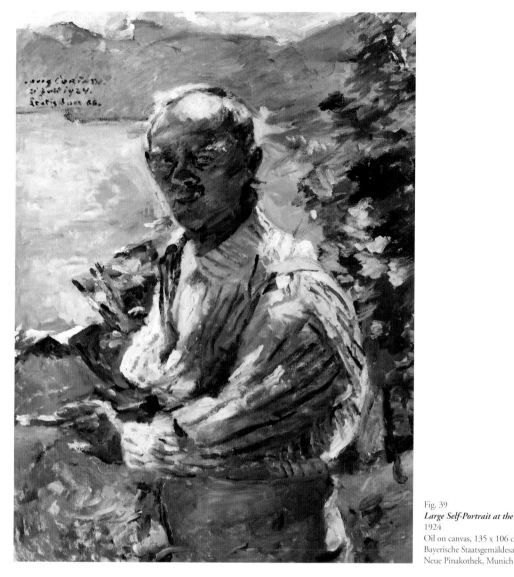

Fig. 39
Large Self-Portrait at the Walchensee,
1924
Oil on canvas, 135 x 106 cm
Bayerische Staatsgemäldesammlungen,
Neue Pinakothek, Munich

painting behind the verdant green of the foreground. It is balanced on the other shore of the lake by the powerful, almost black, dark red of the hills with the glaring white of the fresh snow on the peaks rising up behind them. There are still snow clouds above the mountains on the left edge of the picture but, on the right, the sky is starting to clear up. The mountains appear bright and drawn close, the atmosphere glistens—but everything still seems solemn. The picture obtains its sense of depth to a large extent through color, a color perspective that relies less on atmospheric effects than on the cold and warm values of the colors.

It must have been one of those mornings that comes as a complete surprise in late summer or early autumn when the first snow lies, dazzlingly white, on the mountains and creates a strong contrast with the luxuriant vegetation of the season. Corinth hurled this picture, which only reveals itself entirely to the viewer from a distance, onto the canvas using a palette knife with unbelievable openness and spontaneity, to capture the strong contrasts and character of the colors ranging from dazzling and unrestrained to muted, subdued and heavy—for example, from the controlled dark

Fig. 40
Moonlit Night, 1920
Oil on canvas, 18.5 x 26.5 cm
Museum Pfalzgalerie Kaiserslautern

Fig. 41
Walchensee, New Snow, 1922
Oil on cardboard on wood, 54 x 66 cm
Private collection

red and violet of the hills to the cheerful (rose, dusky pink and light green) and the serious (black-green and the darkest red and violet tones). The extremely clear, razor-sharp impression made by the objects standing there, and the glow of the heavy colors that play a major role in the overall effect with their precious materiality create the profound, pure splendor of this painting. The use of complementary colors—at the extremes of their values—invests the picture with its deep, austere beauty and, at the same time, its chromatic tension.

A similar formal resolution occurs in the floral still lifes that, at times, celebrate their colors in an ecstatic manner. The floral arrangements frequently only appear to be the point of departure for a free color composition. The illustration of individual flowers takes second place to this and the space is also often dissolved so that everything becomes subordinate to the pure effect of the colors (cf. fig. p. 91).

To Corinth's amazement, the still lifes and Walchensee pictures sold extremely well in the years when Berlin was trying to forget the lost war as quickly as possible and looking for more stable values in economically unstable times.

Corinth's painting arrived at purer, more intense colors and a brushstroke committed to the painter's inner world that expressed feeling by way of style. The increasingly independent spots of color and brush strokes could now be fitted into a more abstract structure of overriding importance. This late style cannot simply be explained as being stylistically a further evolution but, much more, the result of Corinth's more profound questioning of the foundations of his existence and the beauty of things—not, however, in an intellectual sense from outside of the object but in the heightening of the insight over the path of direct perception. "That which appears to be dissolution in his late work is ultimately only the progressive detachment of Corinth's pure sense of color from the coarser carnality and worldly sensuality to which many of his older paintings often did not shy away from bearing brutal witness. Corinth increasingly saw the world through a veil of color—in this respect, he is an absolute Impressionist. Unlike Cézanne's color, his was never pure

48

color without any materiality that only meant to beguile the eye. Quite the contrary, the impression of dampness that most of Corinth's late pictures show takes physical sensual associations for granted… Here, it is not true—or at least imprecise—to speak of intellectualism because, even in Corinth's late works, the impact is still the result of the material… The characteristic spiritualization in Corinth's late art is that the coarse, sensual world almost completely loses itself behind a veil of color. What remains, is a new vision of the world grounded completely in art and developed completely out of the person."[45] On 31 March 1925, Corinth wrote in his diary, "I have found something new: true art means seeking to capture the unreal. This is the highest goal!"[46]

These pictures manifest the same lust for life that dominated all his work—but now, on another plane. We are no longer confronted with the simplistic sensuality of pleasure; we are now dealing with the splendor of existence, the richness of life itself. However, this does not have itself to thank and is always endangered by transience. And so, these pictures by Corinth seem to be painting against time, against passing—and also—against his own mortality.

In a final, incredible act of strength, Corinth hurls picture after picture out of himself in an effort to snatch finiteness from mortal reality through the metamorphosis of his spirit and artistic genius.

Fig. 42
Walchensee Landscape, 1919
Oil on wood, 45 x 56 cm
Staatliche Kunsthalle Karlsruhe

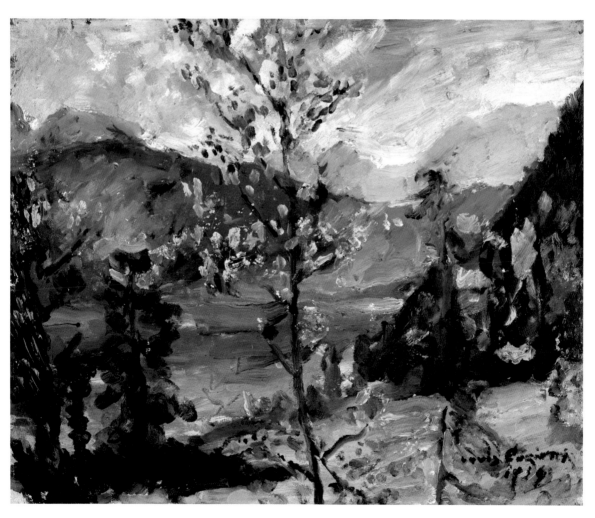

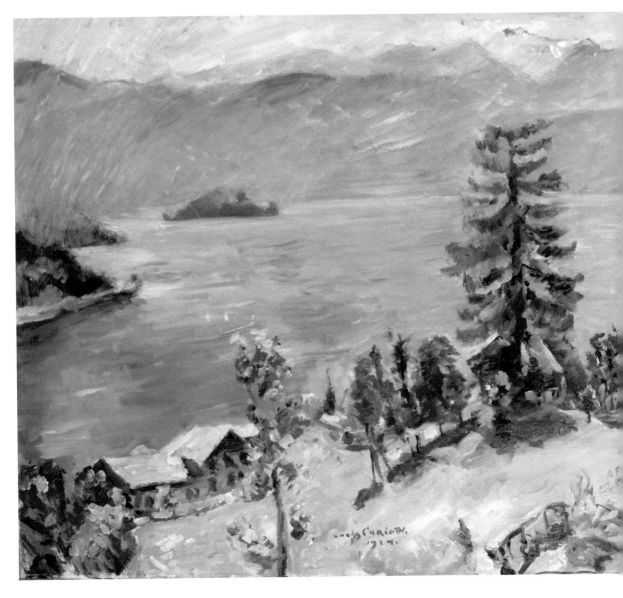

Towards the end of his life, he dealt increasingly with the passion and death of Christ. His *Ecce Homo* from 1925 sums up his experience of life and his artistic activity. Flanked by Pilate and a soldier—one the embodiment of cowardly relativism and the other brutality and violence—the abused Savior is presented to the viewer as a picture of suffering mankind itself. His towering, slender figure and the magnificently glowing red of His cloak invest Him with a special kind of dignity. Corinth ultimately sees himself in this figure as drawing the *Self-Portrait as the Man of Sorrows* from the same year shows.

However, the most amazing thing about the picture is that the figures, whose faces are only summarily indicated, appear to be woven into a carpet of bound pigments with only Christ standing out against this background due to His more pronounced coloration.

The presence of death is apparent in Corinth's *Last Self-Portrait* painted in 1925. Searchingly, the painter evaluates the artistic power remaining in his feeble body and by turning his eyes to collect everything (the entire intensity of the picture) in his

gaze. This not only radiates outwards; it is also aimed inwards. One final time, the artist is split between the visual phenomenon that the mirror behind him shows and the higher reality of art that he has created on the canvases around him.

This attempt to conquer the material through painting, fundamentally corresponds with the view of life and feeling of the Baroque period: in striving to discover the reality behind sensual pleasures and the depiction of what can be seen, in the permanent awareness of mortality. Along logical lines, Wilhelm Hausenstein wrote, on the occasion of the memorial exhibition in the National Gallery in Berlin six months after Corinth's death, "Corinth's real origins are not in Munich and not in Paris; nor in the Berlin of 1900; they can be found in the Baroque … In the depths of his nature, he participated in the fundamental ambiguity that gives the fascinating and terrifying effects of the problematic to Baroque productivity. … Along with the Baroque genius, he called up our most intimate doubts about the reality of its appearance—by paint-

ing, painting; only painting … We did not want to believe all of those realizations that Lovis Corinth produced with much too much naturalism, much too much radicalism; his consolidations did not entirely convince us. But his solutions did convince us … When his painting just happened instinctively, it was the most precious; and then it almost no longer existed."[46]

Fig. 44
Still Life with Lilacs, 1922
Oil on canvas, 100 x 80 cm
Private collection

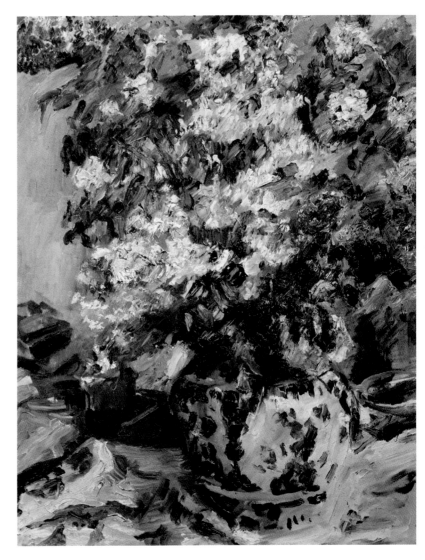

Fig. 45
Ecce Homo, 1925
Oil on canvas, 190 x 150 cm
Kunstmuseum Basel

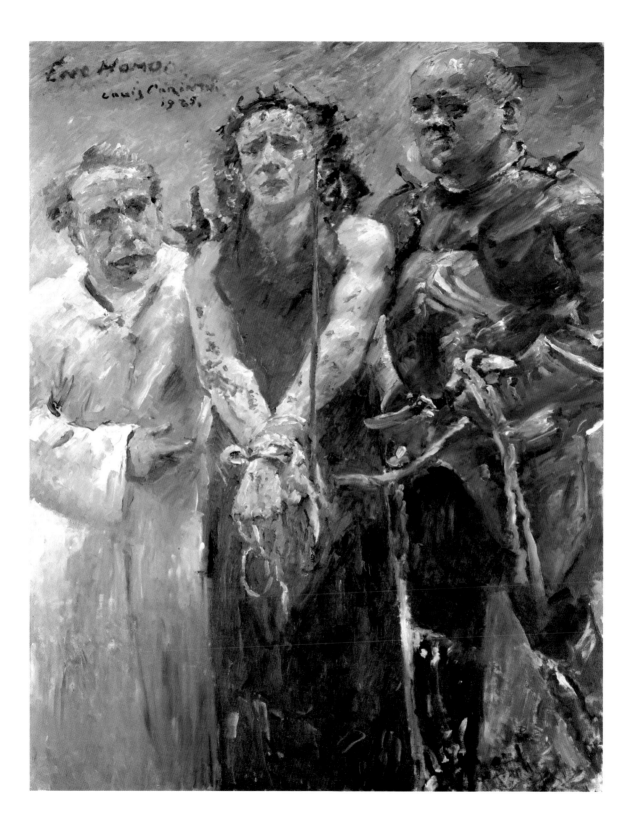

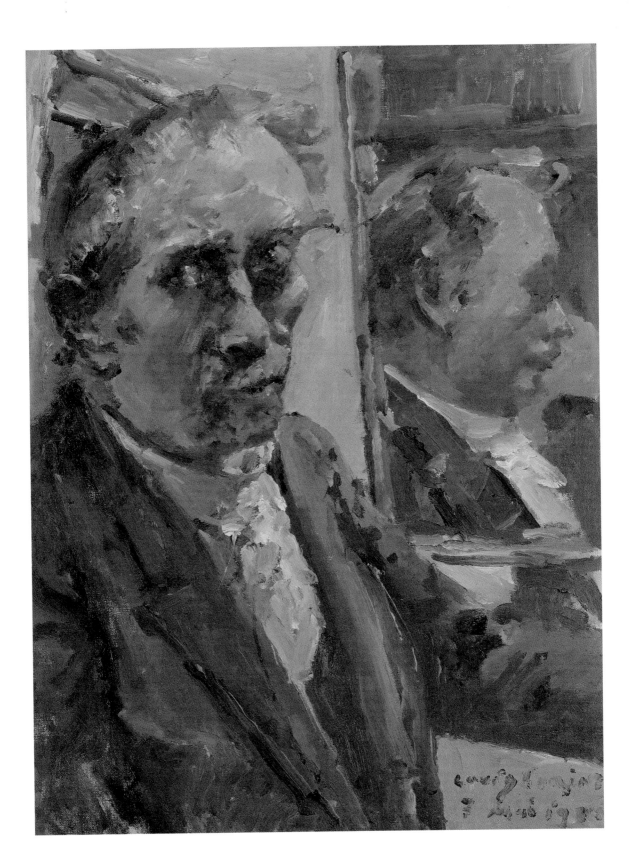

1 "An artist who wants to achieve something must struggle with his art as Jacob with the angel." Lovis Corinth, "Aufruf an die Jugend," *Gesammelte Schriften* (Berlin: Gurlitt, 1920), p. 87.

2 Lovis Corinth, *Selbstbiographie* (Leipzig: Hirzel, 1926), p. 109.

3 Thomas Corinth (ed.), *Lovis Corinth. Eine Dokumentation. Zusammengestellt und erläutert von Thomas Corinth* (Tübingen: Wassmuth, 1979), p. 157, fig. 86.

4 Lovis Corinth 1920 (see note 1), p. 30.

5 Wilhelm Trübner, "Personalien und Prinzipien", cited from *Wilhelm Leibl und sein Kreis*, exh. cat. Städtische Galerie im Lenbachhaus (Munich: Prestel, 1974), p. 50.

6 Lovis Corinth, "Wilhelm Trübner," *Gesammelte Schriften* (Berlin: Gurlitt, 1920), pp. 35–36.

7 Lovis Corinth, cited from Hans Platte, *Deutsche Impressionisten* (Gütersloh, Munich, Vienna: Bertelsmann, 1971), p. 123.

8 Lovis Corinth 1920 (see note 1), p. 36.

9 Lovis Corinth, cited from *Lovis Corinth 1858–1925: Gemälde und Druckgraphik*, exh. cat. Städtische Galerie im Lenbachhaus (Munich: Prestel, 1975), p. 87.

10 Julius Meier-Graefe, *Entwicklungsgeschichte der modernen Kunst*, vol. II (Munich: Piper, 1987, orig. 1927), p. 387.

11 Lovis Corinth, "Wilhelm Trübner," Corinth 1920 (see note 1), pp. 33–34.

12 Max Halbe, *Jahrhundertwende* (Danzig: Kafemann, 1935), p. 272.

13 Carl and Felicie Bernstein, *Erinnerungen ihrer Freunde* (Dresden: 1914), pp. 47–48.

14 Lovis Corinth, "Gedanken über den Ausdruck 'Das Moderne in der bildenden Kunst' und was sich daran knüpft," *Lovis Corinth. Gesammelte Schriften*, ed. by Kerstin Englert (Berlin: Gebrüder Mann, 1995), p. 156.

15 Ibid., p. 168.

16 Cited from Mechthild Frick, *Lovis Corinth* (Berlin: Henschel Verlag, 1976), p. 16.
 "On 5 September 1907, Corinth wrote from the Hotel Royal in Kassel to Charlotte in Berlin that he intended to copy Frans Hals; the copy-book of the Staatliche Kunstsammlungen, Kassel records that Corinth painted the *Young Man with Slouch Hat* from 6 to 7 September." Corinth (see note 3), p. 344.

17 Lovis Corinth, *Das Leben Walter Leistikows. Ein Stück Berliner Kulturgeschichte* (Berlin: Paul Cassirer, 1910), pp. 48–49.

18 Oscar Wilde, *Salome* (Paris: Libraire de l'Art Independent, 1893).

19 Gerhard Gerkens, "Die literarischen Themen im Werk von Lovis Corinth," *Lovis Corinth*, exh. cat Museum Folkwang Essen, Kunsthalle der Hypo-Kulturstiftung Munich (Cologne: DuMont, 1985), pp. 30–31.

20 Ibid., pp. 36–37.

21 Lovis Corinth, *Selbstbiographie*, edited and with an epilogue by Renate Hartleb (Leipzig: Hirzel, 1993), p. 143.

22 Lovis Corinth in a letter to Dr. Carl Graeser, Naples, 19 August 1900; Corinth 1979 (see note 3), p. 61.

23 Corinth 1979 (see note 3), p. 343.

24 In addition to Manet, Hugo von Tschudi purchased works by Pissarro (1897), Monet (1899) and Renoir (1906) for the National Gallery in Berlin; the Städelinstitut in Frankfurt acquired a Sisley in 1899, a van Gogh in 1908, 1910 a Renoir and, two years later, a Degas and a Manet; Bremen began with a Degas in 1903, followed by a Monet in 1906, a Manet in 1908, followed by a Pissarro in 1909 and a van Gogh in 1911.

25 Lovis Corinth, *Das Erlernen der Malerei. Ein Handbuch* Berlin: n.d. (1908), p. 84–85.

26 Gerkens 1986 (see note 19), p. 31.

27 Werner Hofmann, *Das irdische Paradies. Motive und Ideen des 19. Jahrhundert*, (Munich: Prestel, 1974), p. 31.

28 Ibid., p. 19.

29 Eduard Beaucamp, "Der Super-Makart und die Metaphysik der Malerei," *Frankfurter Allgemeine Zeitung*, 16 January 1976.

30 Karl Scheffler, "Lovis Corinth" on the occasion of the 32nd Berlin Secession Exhibition, Berlin 1918. Cited from the exh. cat. *Lovis Corinth* (Munich–New York: Prestel, 1996), p. 390.

31 Corinth 1908 (see note 25), p. 133.

Fig. 46
Last Self-Portrait, 1925
Oil on canvas, 80.5 x 60.5 cm
Kunsthaus Zurich

32 Gert von der Osten, *Lovis Corinth* (Munich: F. Bruckmann, 1955), p. 108.

33 Meier-Graefe 1987 (see note 10), p. 361–362.

34 Charlotte Berend-Corinth Vienna/Hanover 1992 (see note 18), cat. no. 13.

35 Joachim Heusinger von Waldegg, "Tradition und Aktualität. Über Corinths Selbstbildnisse und einige andere Motive," *Lovis Corinth*, exh. cat Museum Folkwang Essen, Kunsthalle der Hypo-Kulturstiftung Munich (Cologne: DuMont, 1986), p. 60.

36 Julius Meier-Graefe in the catalogue of the 32nd Berlin Secession Exhibition, 1918, cited from Georg Bussmann, *Lovis Corinth. Carmencita. Malerei an der Kante* (Frankfurt am Main: 1985), p. 25.

37 Heusinger von Waldegg 1986 (see note 35), p. 34.

38 Corinth 1993 (se note 21), p. 149.

39 Ibid., p. 149.

40 His son Thomas reports that: "After Lovis Corinth's death, one read about a 'paralysis of the left side' in his autobiography that was published in 1926. After the attack in 1911, this had receded and improved satisfactorily. However, the artist still found it distressing enough. In any case, he was able to once again move his left side freely and energetically. Corinth never had a stroke to the right side. On the same page in the autobiography, we read 'a terrible shaking of the right hand increased by stress with the etching needle and caused by excessive alcohol consumption.' This disorder only made itself felt occasionally and the master managed to control it well when painting, drawing, etching and writing, and the symptom was rarely noticed in everyday life." Corinth (see note 3), p. 321.

41 Lovis Corinth, 1923, on the occasion of his exhibition in the Berlin National Gallery; cited from Platte 1971 (see note 7), p. 139.

42 Hermann Broch, *Hofmannsthal und seine Zeit* (Frankfurt am Main: Suhrkamp, 1974), p. 17.

43 For example, Corinth waited until the bright laundry of the "Fischer am See" Hotel was hung on the clothesline in front of the house before starting to paint. On another occasion, his son caught him sitting on the balcony at five o'clock in the morning, dressed only in his night clothes, to capture the morning mist in a picture.

44 "Am Walchensee," *Lovis Corinth. Die Bilder vom Walchensee. Vision und Realität*, exh. cat. Museum Ostdeutsche Galerie, Regensburg et. al. (Regensburg: 1986), pp. 23–24.

45 Hermann Beenken, *Das neunzehnte Jahrhundert in der deutschen Kunst* (Munich: F. Bruckmann, 1944), p. 219.

46 Corinth 1993 (see note 21), p. 216.

47 Wilhelm Hausenstein, "Corinth der Maler. Anmerkungen zur Ausstellung in der Berliner Nationalgalerie," *Frankfurter Zeitung*, 20 February 1926, cited here from Horst Uhr, *Lovis Corinth* (Berkeley: Berkeley UP, 1990), p. 295.

The Paintings in the Belvedere

Slaughtered Calves, 1896

Oil on canvas

68 x 88 cm

Belvedere, Vienna, inv. no. 3793

In spring 1892, Lovis Corinth traveled to Kraiburg on the Inn River where he created his first of a total of fourteen slaughterhouse scenes—a motif that Corinth was to deal with over a span of many years: in the 1890s, in 1905 and 1906, as well as in 1912 and 1914 and, one final time, in 1921. This periodic repetition of a motif not only applies to his paintings of slaughterhouses, but it is nevertheless striking that Corinth dealt with this unusual subject so often. In doing so, he shifted the perspective from a view into the room, occasionally with the people working there, to a depiction of the slaughtered animal.

The picture in the Belvedere was created in 1896 and the painting *Butcher's Shop* in *Schäftlarn on the Isar* in the following year. In light of the fact that Corinth spent some time in Schäftlarn, a village in the vicinity of Munich, in both 1896 and 1897, we can assume that the two pictures show the same premises. However, two different rooms are depicted: the 1897 painting shows the shop where the individual pieces of meat were sold, whereas the one painted the year before depicts the actual slaughterhouse, or the cold storage area, with the slaughtered animals hanging from a brace, still nearly intact. Corinth was quite interested in how the carcasses were hung and also devoted attention to his depiction of the background: we see some sausages and cuts of meat hanging on a row of hooks at the left edge of the picture with a large vat on the ground beneath them. The wall opens in a wide arch behind the centrally positioned carcass and a large niche in the wall can be seen behind a windlass on the right edge of the picture. There is another brace lying on a bench beneath it. The wall is painted approximately half way up in a dark brownish red and in a lighter color above, which has, however, become discolored in the greenish light falling into the room. With his precise observation of the lighting situation, Corinth repeats the color combination of the wall in the main motif.

Comparisons are frequently made to Rembrandt's painting *The Slaughtered Ox* from 1655, which the young artist had probably seen in the Louvre while he was studying in Paris (1884–1887). However, the fact that Corinth painted so many slaughterhouse pictures over such a long period of time make it seem doubtful that Corinth was really trying to compete with his great predecessor. The critique that appeared in the *Berliner Börsenkurier* in January 1893 is more appropriate:

"Corinth is represented with three works, of which one is, unfortunately, hung in an unfavorable place that cannot do it justice: we are referring to the masterly drawn and painted study of a slaughterhouse.[1] It shows a historic motif, that was favored by the Old Dutch Masters and which is now shown in a new light by modern art, thanks to a strong, artistically sure hand…"[2]

Three slaughterhouse pictures were painted in 1892 alone; Corinth exhibited them in Munich where they met with great disapproval:

"After the staircase, we are greeted, first of all, by a piece of butcher's work, hanging from a brace, a gutted animal by L. Corinth, on the right. Come in ladies and gentlemen; don't let it spoil your mood…."[3]

In these first paintings, Corinth was already differentiating between a wide view of a room and the people working in it, on the one hand, and the focused depiction of the slaughtered animal hanging there, on the other. However—in all of the paintings with this motif—the artist's interest is focused on the effect made by the light and the absolute mercilessness of the depiction. In a style that cursorily captures the form, the painter creates an impression of the enormous masses of flesh and the bloody work of the

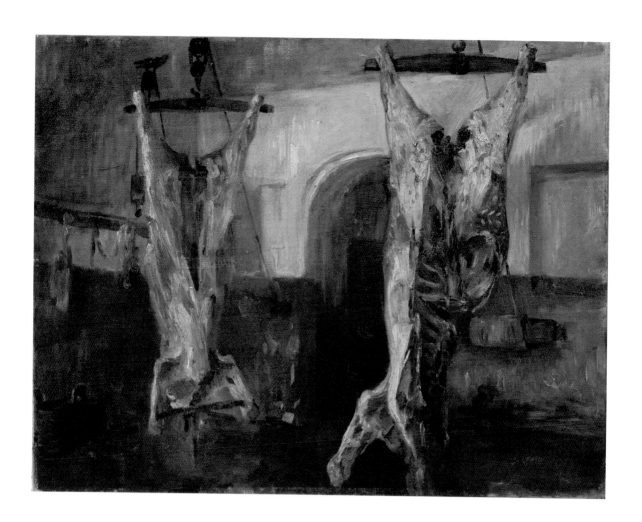

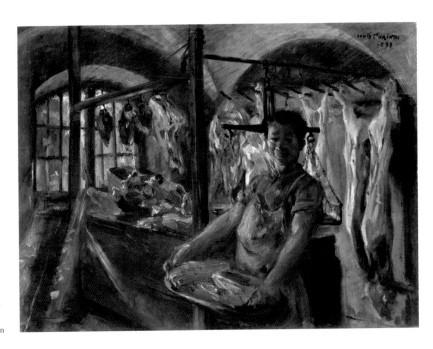

Butcher's Shop in Schäftlarn on the Isar, 1897
Oil on canvas, 69 x 87 cm
Kunsthalle Bremen—Der Kunstverein in Bremen

butchers, whereby the anatomy of the slain animal; the distribution of fat, skin and muscles is made more tangible by the light. The sometimes blotchy, seemingly streaked, application of paint makes a precise differentiation between the various consistencies and surfaces without wearying the viewer with fussy details in any of the paintings. As his style shows, it appears that Corinth found the atmosphere of the slaughterhouse much more stimulating and energizing.

In this respect, it seems likely that his interest in slaughtered animals can be traced back to the artist's childhood as the son of a master tanner in the rural environment of a small town. His father's profession meant that he became accustomed to the slaughter of animals at an early age, and the farm that was attached to the business also gave the child numerous opportunities to see slaughtered animals in his own home:

"The butcher came to our house at certain times: cows and fat pigs were knocked off.... It was different when big animals were killed: I couldn't watch the first part—I would hide. But later, when I could no longer recognize the animal I had known before, I feasted my eyes on it."[4]

The reader should take notice of the choice of words, which suggests that the child considered the dead animal something beautiful and magnificent and not, as one could imagine, something that he was afraid of or disgusted by. It could be this childlike fascination that Corinth once again sought as an adult. This was complemented by purely artistic interests: the depiction of flesh that repeatedly engaged his interest in all other forms—especially the female nude. The depiction of an animal that had been alive shortly before and was now dead also required other artistic qualities in a painter than a piece of game as part of a still life (if only because a bull is much larger than a hare). Nevertheless, Corinth still often complained about the heat, stench and hard work of painting a slaughterhouse picture in his letters to his wife before announcing, full of pride, that he had just completed such a work:

"...The picture is finished now and, in this way, another creation comes into the world. ... We could come here for a day the week after next; then you can see the picture in the real pear-wood frame that I ordered from a carpenter here today. The air and conditions in the slaughterhouse were nowhere near as revolting as in Eberswalde; ..."[5]

1 Berend-Corinth, no. 87, Kunsthalle Bremen; according to the catalogue raisonnée this study was also painted in Kraiburg am Inn.

2 Thomas Corinth (ed.), *Lovis Corinth. Eine Dokumentation. Zusammengestellt und erläutert von Thomas Corinth* (Tübingen: Wassmuth, 1979), p. 41.

3 Newspaper excerpt, *Generalanzeiger*, Munich, New Year 1892/1893, cited from *Corinth* (see note 2), p. 40.

4 Lovis Corinth, *Gesammelte Schriften* (Berlin: Gulitt, 1920) p. 11.

5 Letter from Lovis Corinth to Charlotte Berend-Corinth dated 19 August 1905, cited in *Corinth* (see note 2), p. 93. The letter refers to the painting *The Slaughtered Ox* (Berend-Corinth, no. 318).

Barent Pietersz. Fabritius
The Slaughtered Pig, 1656
Oil on canvas, 80.9 x 66.9 cm
Staatliche Museen zu Berlin, Gemäldegalerie

Oil on canvas

120.5 x 101.3 cm

Belvedere, Vienna, inv. no. 3915

The portrayed woman is the mother of Oskar Moll, a friend and former pupil of Corinth's and Walter Leistikow's. He collected paintings by Corinth and, for this reason, commissioned the artist to paint his portrait as well one of his wife Marg (who had also studied with Corinth), his brother and his mother Marie. It shows the old lady seated in a simple armchair. A screen placed behind her shuts off a section of the room (recognizable by the way the wall juts out slightly to the right of the screen). In front of her is a small black table with a decorative bronze figure on it. Frau Moll is shown wearing a gray dress with a pleated skirt and frills around the neck and sleeves. She has a fine black coat made of thin fabric, with big black ruffles, draped over her shoulders. Her bonnet is also black and seems to have long ribbons, as one is clearly visible hanging down on her left side. She is holding a white handkerchief in her right hand.

Portraiture runs through Corinth's entire œuvre and—as is the case with his work as a whole—underwent an amazing development. While in Munich, Corinth was still influenced by the Academy and the artistic environment in general, thus favoring dark tones in his portraits, which he staged as milieu scenes with all kinds of attributes. However, even before moving to Berlin, he began experimenting with freer and, at the same time, simpler portraits: in addition to narrative portraits, such as the *Portrait of Mother Rosenhagen* (1899), he painted close-up "head studies," like *Frau Halbe with a Straw Hat* (1898), or composed the portrait in a landscape, as was the case with the picture of his friend Leistikow (1900).

Portrait of Mother Rosenhagen, 1899
Oil on canvas, 63 x 78 cm
Staatliche Museen zu Berlin, Nationalgalerie

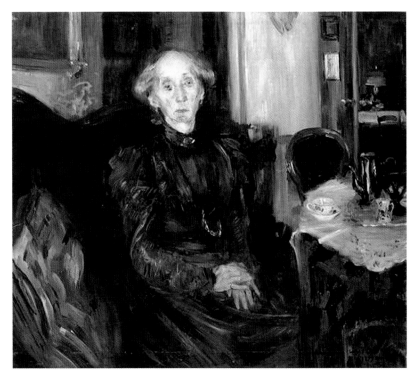

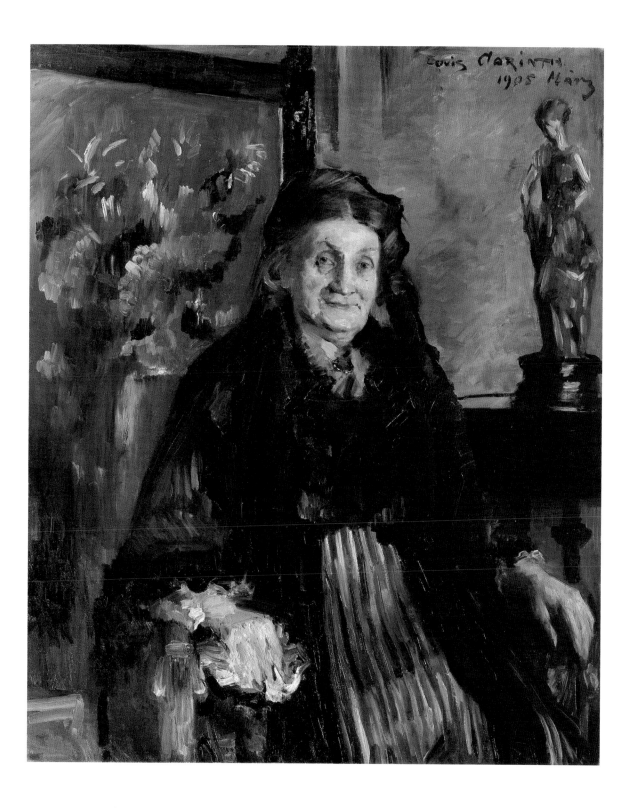

Portrait of Marie Moll, 1905
Pencil drawing, measurements unknown
Illustration from Georg Biermann,
Der Zeichner Lovis Corinth, Dresden 1924

Compared with the *Portrait of Mother Rosenhagen*, in which the spatial situation is depicted down to the smallest detail, in his portrait of Frau Moll, Corinth restricts himself to a few terse indications of the bourgeois environment and focuses his attention on the depiction of the person. Frau Moll is painted closer up, her bearing seems receptive, her smile slightly mocking. When we compare this work with the *Portrait of Frau Schreiber*, Corinth's special (and especially sought after) talent for characterizing the people he portrayed becomes apparent. Corinth did not restrict himself to precise observation. He prepared—at least in the case of Frau Moll—a precise, preliminary portrait study, which he repeatedly used as a reference. It also preserved Corinth's important first impression of his vis-à-vis. In this way, while working on the portrait, Corinth could go beyond a mere exact reproduction of the external features of his model and was able to use his technical prowess to capture the atmosphere, physical presence and personality. The use of brown tones and yellowish light to depict the warm lighting situation stresses Frau Moll's most outstanding characteristic: her human warmth. The reflection of light on the tabletop, the figure and wall create an impression of cozy domesticity with her in the center. Corinth relieves the somewhat gloomy appearance of the black clothing, typical of an elderly woman, with the screen behind her that he uses as a pure color contrast.

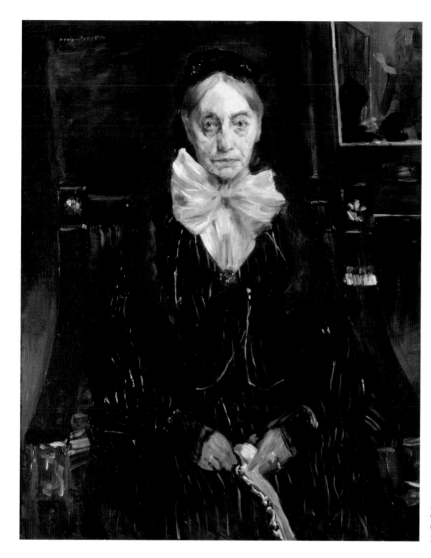

Portrait of Frau Schreiber, 1902
Oil on canvas, 107 x 88 cm
Galerie Neue Meister,
Staatliche Kunstsammlungen Dresden

Finally, as a virtuoso painter, he uses his brilliant technique to place long white pleats, which appear to simply flow from his hand, over the mass of black in her skirt. In this way, a picture was created that not only charms us by virtue of the person portrayed but also amazes the viewer with its masterful technique.

The Singer Frieda Halbe, 1905

Oil on canvas

120 x 90 cm

Belvedere, Vienna, inv. no. 3837

The singer Frieda Halbe was a cousin of Corinth's long-time friend Max Halbe, to whom he had been introduced in Berlin by Walter Leistikow. However, they only became close friends in Munich, when they both happened to live on the same street in the 1890s. After Corinth moved to Berlin, the two did not see each other as often, but remained in contact, and various portraits showing Max Halbe's whole family, as well as individual members, were created. Max Halbe obviously arranged the contact to Frieda Halbe.

The picture shows a commanding woman in an unusually large-scale knee-length portrait. She is depicted standing, turned in profile, with her two hands on her clearly ample hips. The light colored dress serves to hide her figure more than to draw attention to it, and the fur-trimmed gossamer cape loosely draped over her shoulders gives a suggestion of her bare arms. A large, orange-red, blossom is resplendent in the middle of her bosom and covers the lower section of a fine string of pearls. Her luxuriant blonde hair has been pinned up, but then falls from the back of her head in a wavy ponytail. Corinth painted all of these details of her apparel with exceptional dexterity to capture the materiality and reflection of light in a sophisticated manner. It gives the impression that Corinth had created the portrait in a single sitting.

The decoration of the background is particularly striking. There are clear signs of the area behind her head having been painted over. It is also unusual to see how various colors in the background are mixed directly on the canvas. Although it is something of a dazzling display in blue and brown tones, this manner of painting almost gives the impression of being preparatory work—almost as if it was intended to introduce individual details by way of the color. And, although the lower edge of the picture also appears unfinished, Corinth clearly considered the painting complete, as he signed it on the upper right. This is not surprising when one considers the perfection of the depiction of the fine material of the cape and of the face.

The picture may have been one of those commissions that Corinth regularly received and on which he was quite dependent for his livelihood. The financial returns from his painting school assured him a certain basic income, and this was augmented by sales made at exhibitions, but commissioned works were also very important—not least of all for Corinth's reputation. He liked to show his portraits at exhibitions and often asked their owners to lend them for this purpose; however, the portrait of Frieda Halbe was never exhibited during Corinth's lifetime.

The absolute concentration on the person makes this picture so special, when compared with the other portraits of his early Berlin years. There are no superfluous elements to conjure up an atmosphere of domesticity, no attributes—such as sheet music—to indicate her profession, something Corinth did so painstakingly in his 1902 portrait of the poet Peter Hille. Although this was painted entirely in Corinth's studio on Klopstockstraße, he surrounded his model with all the trappings of a coffee house, where the bohemian actually spent a great deal of time, so that the unusual depiction of the poet in a coat is also completely convincing.

A portrait of another lady, painted in 1911, exhibits greater similarity to the concentrated approach found in the portrait of Frieda Halbe. It shows Mrs. Luther, whose husband, the sugar exporter Hermann Luther, commissioned Corinth with her portrait. In this picture, Corinth also did away with most of the additional elements—with the exception of her lap dog. The working of the background as an area developed entirely

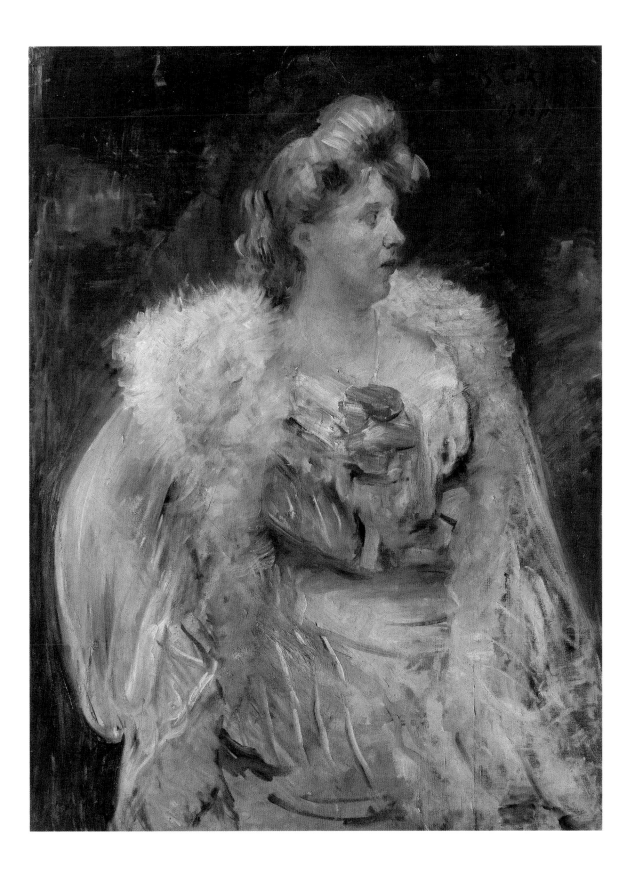

out of the color is also similar. Unlike his portrait of Frau Luther, Corinth painted the singer, who was so used to having an audience, less decorously and with less rigid detail, thereby investing the portrait with the bravura typical of Frieda Halbe's artistic profession. What appears to be a result of impetuous preparation, in fact consciously reveals aspects of the creative process: one recognizes the *pentimenti* behind the back of the singer's head, he forms a flower out of fat daub of paint on the artist's bosom and—as if from nowhere, but actually well-prepared—he swishes the paint that simulates the

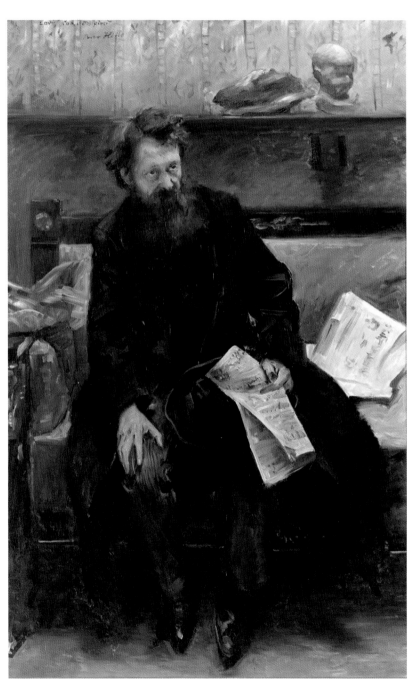

Portrait of the Poet Peter Hille, 1902
Oil on canvas, 190 x 120 cm
Kunsthalle Bremen—Der Kunstverein in Bremen

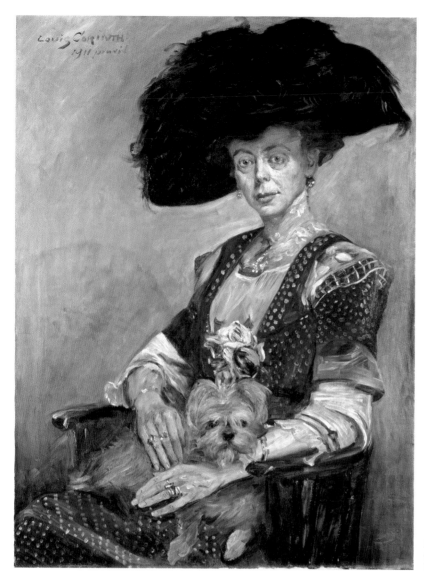

transparent material of her cape over the arms of the posing diva. Corinth used this approach to paint a portrait that not only resembled his model, but also made her character visible.

Reclining Female Nude, **1907**

Oil on canvas

96 x 120 cm

Belvedere, Vienna, inv. no. 3809

Lovis Corinth painted this naked female body lying on a table that is covered with a white cloth against the backdrop of a light colored wall with great sobriety. Nothing is shown to gloss over the model's nudity in any way. On the contrary, Corinth drapes the nude with its limbs twisted at complicated angles as if it was on an artistic dissecting table, reminiscent of figures from Italian Baroque and Renaissance frescos. Lovis Corinth used this picture as an illustration in his manual *Das Erlernen der Malerei* (Studying Painting), which was published by Cassirer in Berlin in 1908. At the same time, this reproduction of his painting showed the result of what could be achieved if all of his tips and advice were followed. But, of course, this reclining female nude is more than just an example. In this work, Corinth appears to have amalgamated all of his knowledge of the history of art and his technical prowess to create something new: He uses the nude almost as an allegory of painting itself and ultimately moved the paragone—the struggle between the arts of the fifteenth and sixteenth centuries—into modern art. This also explains a paragraph in his handbook on painting:

"*The shortening of the entire body mainly occurs with reclining figures when the top of the head or the soles of the feet are positioned towards the eye of the viewer. … Shortening is a special property in painting. No other branch of the fine arts exhibits this.*" [1]

Corinth's Reclining Female Nude foregoes the use of all narrative elements, which were still often used in the early twentieth century as a means of legitimizing the display of the naked body, since it quite simply shows the "*specific characteristic of painting: the revocation of the surface and the creation of depth.*"[2] In spite of the representational depiction, this kind of painting receives its legitimacy not from the importance of what is shown but from the art of portrayal per se. In this way, Corinth already took his final steps on the path towards abstract art in 1907.

1 Lovis Corinth, *Das Erlernen der Malerei. Ein Handbuch* (Berlin: Cassirer, 1908), p. 44.
2 Ibid., p. 44.

Reclining Female Nude, 1913
Lithograph, 32.7 x 41.4 cm
Albertina, Vienna

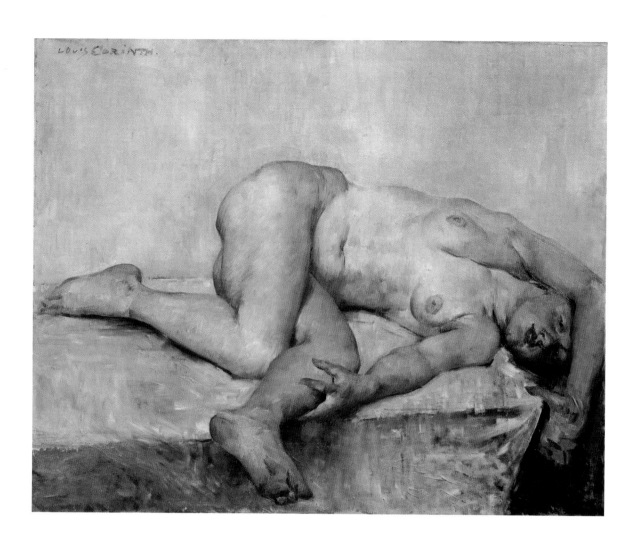

The Weapons of Mars, **1910**

Oil on canvas

141.5 x 181 cm

Belvedere, Vienna, inv. no. 3792

By the time Corinth painted *The Weapons of Mars* in 1910, he had been living in Berlin for almost a decade, achieved an important position in artistic circles and established himself as one of the highest-paid painters in Berlin society. He was regarded as a representative of modern art and as one of the guarantors for Berlin's leading position among the centers of art in Germany. Seen from today's point of view, this makes it appear even more surprising that, throughout his life, Corinth dealt with mythological subjects that are considered the epitome of Academic painting and idealism. However, the literary figural painting is consistent with Corinth's understanding of art, which he included, en passant, in his 1908 textbook *Das Erlernen der Malerei*. There, he wrote on composition and choice of subject, concluding:

"*Everybody is free to choose other compositional subjects, e.g. motifs from contemporary life, but experience and practice recommend those mentioned ['from the Bible and from ancient history'] and similar topics because precisely these depict human nature and many things one needs to learn.*"[1]

In this way, Corinth—who was born in 1858—positions himself as a representative of a humanistic educational ideal that, in its principles, was not far removed from the historical idealism of the art academies. During his education in Königsberg and Munich, Corinth expressed a certain aversion towards the traditionalists without, contextually, separating himself from the ideals of the Academy. However, it was precisely his depictions (of Diogenes, for example) that received harsh criticism—especially, in Munich. This was mainly due to the unusual, trivializing and crude manner in which Corinth dealt with these traditional subjects.

In *The Weapons of Mars* the viewer is also initially confronted with a confusing scene: alongside the centrally-positioned female nude, an young man, who is also naked, is holding a shield so that she can see her reflection in it. The man also looks down on the reflecting surface of the shield, which remains invisible to the viewer. The back of it is turned towards the observer who sees a young boy, perhaps six-years-old, holding a sword that is almost as big as he is in his two hands. This child is offset by two others, who are also involved with pieces of armor. On the right side of the picture, the second boy has succeeded in heaving a heavy a plumed helmet onto his shoulder —with some difficulty—and the third child is seen sitting behind him on the ground reaching for a silver shoulder piece. Other pieces of armor are scattered around in the foreground, while a broad river valley with hills rising above it is depicted in the background.

The title of the painting makes it seem likely that we are dealing with the figures of Mars and Venus and their three children Pallor, Pavor and Concordia, although Mars appears to be much too young and is possibly simply just someone hoping for Venus' favors.[2] Curiously enough, the adults are only concerned with themselves—especially with Venus and her charms—while the children play, unsupervised, with the weapons. The boy on the left, who appears to be Pallor (Terror), has grasped the sword and seems—in spite of his childish weakness—determined and challenging. Pavor (Fear) is also about to arm himself by putting on the heavy helmet. Concordia (Harmony), on the other hand, is not participating in her brothers' activities and has no interest in the adults so that she is literally relegated to the background.

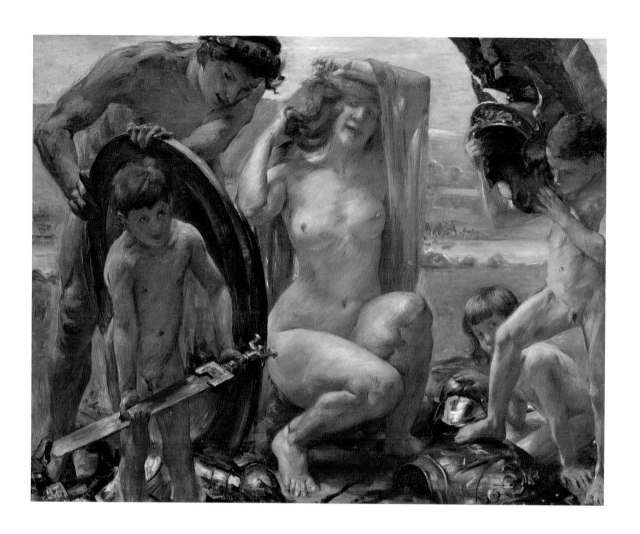

The central figure of Venus, whose face in no way corresponds with the image of a goddess of love, is especially noteworthy. However, her pose resembles that of an ancient statue of Venus in the Louvre that Corinth might have known from the period he spent studying in Paris. Her complacent attitude does not shed a positive light on her—it is, however, in keeping with her bad reputation in Greek mythology where, as the adulteress Aphrodite, she was considered absolutely irresponsible and the personification of sensual lust. Her son Pavor is a mirror image of her youthful lover and, in this way, creates a magnificent sense of balance in the composition of the scene. The boy is much smaller than the young man, but Corinth compensates for this with the plumed helmet so that the central figure of Venus becomes embedded in a beautiful arch. Corinth achieves a similar effect with the boy, who resembles his son Thomas: he stands protected in the curve of the shield. The figures are forced into the confines of a narrow stage that stands in contrast to the broad landscape, painted in a flowing manner.

When dealing with Corinth's literary portraits, it has repeatedly been expressed that—especially in Munich—he loved painting provocative, ridiculing or trivialized depictions as a reaction to old-fashioned moral and Academic ideas. The provocative interpretation of noble subjects created a certain, intended, uproar in Munich, as well as in Berlin, particularly among the educated classed with their opposition to the Emperor's fussy traditionalism in artistic matters. However, when Corinth painted *The Weapons of Mars* he was in such a position as a painter that he no longer had to rely on such benevolence. The question of why he, as a modern artist, felt that he had to tackle a subject that had been popular since the Renaissance still remains open.

For me, the answer lies less in the determined search for success and fame than in Corinth's honest preoccupation with human nature, which, as he once stated, he believed could be found in ancient and biblical subjects. Therefore, the gods became personifications of human behavior: vanity and narcissism, on the one hand, as well as pugnacity and hidden aggression, on the other. The only amiable person in this depiction of the gods is Concordia, who has been forced into the background.

Of course, Corinth could have expressed his criticism of the people of his time differently—in a display of flagrant realism or as an allegory in a classical-idealized manner. However, he chose a mixed form that presented his criticism in a milder, considerably more generalized, form. As early as 1904, Meier-Graefe noted "It often appears that the academicians only play with recipes, as if the trivial was making fun of the time in which it lives through exaggerated triviality."[3] Venus is actually exceptionally common, and that can only be intended. One automatically makes a comparison with the dirty soles of the peasants' feet in Caravaggio's *Rosary Madonna*. However, we also find similar forms of trivialization, as well as the inclusion of naturalistic clichés, in the works of the Old Dutch Masters Corinth admired so greatly. The intention behind this appears clear: the burlesque depiction of a mythological or biblical subject forces the viewer to regard the picture not as a distant ideal, but instead to create a connection with his own life. An additional detail—the pieces of armor—indicates that Corinth used these figures from antiquity to represent general, human behavior and form a link with his own contemporaries. Pieces of armor and armed men can often be found in Corinth's work; he even liked to show himself as the armed protector of the weak and defenseless and as the proud fighter for good. However, in 1918 he used the *Pieces of Armor in the Studio* as a symbol for the collapse of the social order that he regarded as the only legitimate form of government—despite all of his criticism of the Emperor.

After Corinth's stroke in 1911 he painted far fewer literary paintings, so that it seems justified to describe *The Weapons of Mars* as one of his last "Munich" creations—because, "after leaving Munich [Corinth left] the art of the nineteenth century behind him and [became] a genuine twentieth-century painter in Berlin."[4]

1 Lovis Corinth, *Das Erlernen der Malerei. Ein Handbuch* (Berlin: Cassirer, 1908), pp. 79–80.

2 The children of Mars and Venus are better known under their Greek names: Deimos, Phobos and Harmonia.

3 Julius Meier-Graefe, *Entwicklungsgeschichte der modernen Kunst in drei Bänden*, vol. 2 revised edition by Hans Belting (Munich: Piper, 1987), p. 387, cited in Peter-Klaus Schuster, "Malerei als Passion," *Lovis Corinth*, exhibition catalogue Munich, Haus der Kunste; Berlin, Nationalgalerie; Saint Louis, The Saint Louis Art Museum; London, The Tate Gallery, ed. by Peter-Klaus Schuster, Christoph Vitali, Barara Butts (Munich and New York: Prestel, 1996), p. 43.

4 Schuster, (see note 3), p. 48.

Pieces of Armor in the Studio, 1918
Oil on canvas, 97 x 82 cm
Staatliche Museen zu Berlin, Nationalgalerie

Woman Reading near a Goldfish Tank (The Artist's Wife), 1911

Oil on canvas

74 x 90.5 cm

Belvedere, Vienna, inv. no. 1829

Lovis Corinth suffered a stroke in December 1911 that—as he himself stated—brought him "close to death." The artist's excessive lifestyle was obviously one of the causes of this illness, yet it still hit him completely unexpectedly. In January he had been elected as the new president of the Berlin Secession. During the course of the year he also completed more than sixty oil paintings, and took part in several exhibitions. This picture of his wife, Charlotte, was also painted in their Berlin apartment on Klopstockstraße in 1911.

After marrying Corinth in 1903, Charlotte immediately started out to set up a home; that meant decorating the suitable apartment (which they moved into in 1904) and hiring domestic staff, so that Corinth could also meet his social obligations in his own house.[1] In addition, the apartment was decorated with plants, pictures and other *objets d'art* in a prestigious, bourgeois style.

The picture appears to have been painted in one of the bay windows of their apartment, since only these had two adjacent windows opening directly onto Klopstockstraße.[2] Here, Charlotte had arranged a reading corner surrounded by plants, flower vases, and a goldfish tank complete with a murmuring fountain, almost as if in a winter garden. The decoration scheme was completed by a statuette in the background and a picture on the wall. Charlotte is shown seated on a patterned, light-colored chaise lounge, with the light coming through the partially opened curtains falling onto her book.

Although the picture appears to have been painted quickly, when one makes a closer examination, one sees how carefully Corinth placed the white highlights on the leaves, how he captured the multi-colored shimmer of the goldfish, and how he alternated between wide and fine brushes in order to do justice to all the surfaces and materials. In an Impressionist fashion, he succeeded in capturing the atmosphere and light of the moment that had inspired him to paint. In her memoirs, Charlotte has her husband describe the birth of the picture: "The way you and all the other things appear is absolutely charming. I would like to go into this picture in detail, discuss it at length." Charlotte added, "He spent four days working on the painting. He took his time because, as he said, he found the details so fascinating."[3]

Household scenes can be found in Corinth's œuvre from the time of his marriage until the end of his life. Charlotte, who stands at the heart of these pictures, also modeled for a wide range of painting genres after she became the first student at his painting school (then at Klopstockstraße 52). Although she is recognizable in all of the pictures, Corinth managed to differentiate between the private paintings of his wife and those in which Charlotte was simply a model. His portrait of his standing, heavily pregnant wife with her candid gaze and the depiction of a weary pause, trusting in his kind-heartedness, is especially touching. In the painting *Morning Sun* (1910) he also captured a magical moment with rapid brushstrokes as if wanting to preserve the memory of this moment in which his wife has just awoken forever.

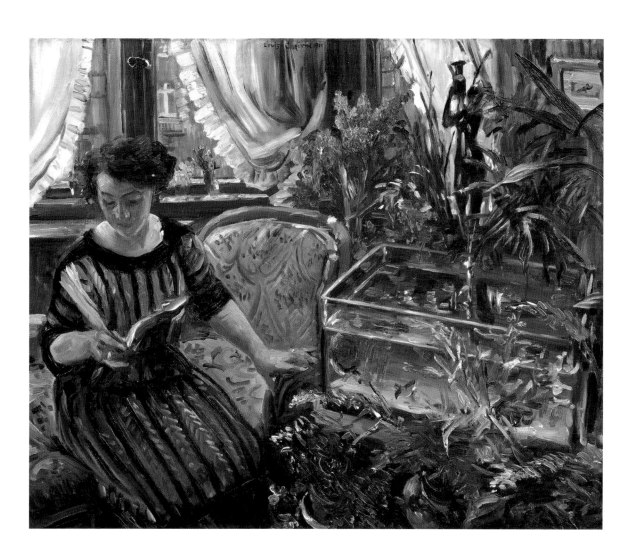

The Corinths' balcony and music room,
Klopstockstraße 48, Berlin 1925

The Corinths' living room,
Klopstockstraße 48, Berlin 1925

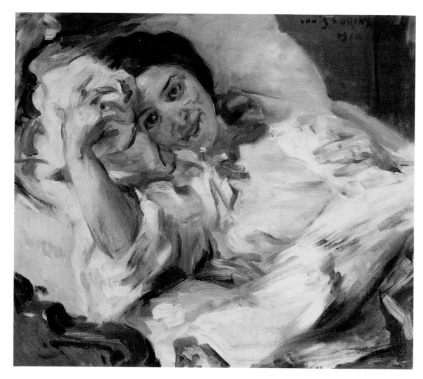

Morning Sun, 1910
Oil on canvas, 68.5 x 80.5 cm
Hessisches Landesmuseum Darmstadt

1 Cf. Thomas Corinth (ed.), *Lovis Corinth. Eine Dokumentation. Zusammengestellt und erläutert von Thomas Corinth* (Tübingen: Wassmuth, 1979), p. 90. Under the entry "5 February 1905", mention is made of a large dinner party which leads to the assumption that the Corinths—at least occasionally—had house staff. A nurse is mentioned from time to time, they had a farmhand in Urfeld, etc.

2 Cf. information on the creation in Berend-Corinth, *Lovis Corinth. Die Gemälde. Werkverzeichnis*, revised by Béatrice Hernard, (Munich: F. Bruckmann, 2nd revised ed.1992), cat. no. 501, p. 130. It is also certain that the picture must have been painted on the second floor of Klopstockstraße 48 as the Corinths did not move into the apartment on the first floor until 1915.

3 Cited from Stephan Koja, *Von der Romantik zum Impressionismus. Meisterwerke der deutschen Malerei des 19. Jahrhunderts aus dem Bestand der Österreichischen Galerie Belvedere*, (Vienna: Belvedere, 1992), p. 102.

Tyrolean Landscape with Bridge, 1913

Oil on canvas

95.5 x 120.5 cm

Belvedere, Vienna, inv. no. 2885

The Corinth family spent the summer of 1913 in St. Ulrich in the Gröden Valley of, what is today, South Tyrol. There he completed two landscapes and several portraits.[1] The family had visited the village previously, during their summer holiday in 1911, when Corinth appears to have painted only one picture, which had no specific connection to the location.[2] The *Tyrolean Landscape with Bridge* is a completely different matter—here we can clearly see the characteristic, precipitous rock-face behind the Raschötz Ridge, which is so typical of St. Ulrich, yet remains the only indication of the Dolomite landscape. It is clear that the artist was not interested in painting a mountain panorama, but merely a detail seen on a stroll, a small, massively constructed wooden bridge over a stream. This bridge made it possible for hikers to effortlessly make their way to a bench standing in the shade of a woods without having to leap across the brook. This bridge and the bench are the elements that initially draw the viewer into the picture: the sunny foreground is part of the loamy hiking trail. On the left, a paddock fence comes down to the brook where the massive construction leads across this into the woods. It was probably this structure that was built to resist the forces of nature of spring but seemed so strikingly oversized in summer that stimulated Corinth to paint the bridge.

In this painting, Corinth repeated the unusually limited number of colors on the palette without any finely nuanced transitions, thus making it appear likely that the artist actually painted his picture *en plein air* in front of the bridge.[3] This would not only explain the choice of colors but also Corinth's obvious haste to finish the picture: Corinth first painted the woods itself in various patches of green positioned next to each other with a few individual trees in the center of the picture merely hinted at with fleeting brushstrokes in other hues of green. The markedly long, yellow streaks in the upper section of the picture probably represent larch trees that change color early in the season and which Corinth painted smoothly so that they shine out of the green ground. In order to draw the viewer into the center of the picture, Corinth used the bench as a prominent point in the axis of vision and repeated its red in the flowers in the foreground and red spots in the dense thicket.

However, Corinth also paid particular attention to the light and weather in his depiction: the sky is depicted in a state of chaos as if the clouds had been put to flight by the wild *föhn* wind. This is a phenomenon he knew from his time in Munich but, as a North German, it still continued to fascinate him.

Corinth reverts back to an Impressionist heritage in his depiction of this weather situation and this also explains his endeavors to make the limestone rockface shine in the sunlight. But, the Tyrolean landscape goes beyond Impressionist painting because Corinth's individual approach and the application of paint as stylistic means are already strongly developed.

Corinth painted a picture of a young woman (Charlotte Berend-Corinth) sitting on rocks in a brook (*Girl in the Brook*, 1913), which is roughly the same size and similar in its style and range of colors. The figure of the girl and the stones are modeled in light, thereby conveying a feeling of the Impressionist roots on which Corinth's art was founded. As in the landscape with the bridge, Corinth concentrates on the figure in the foreground and executes the background with fleeting brushstrokes. He indicates details of the undergrowth using agitated strokes on a dark background similar to that of the

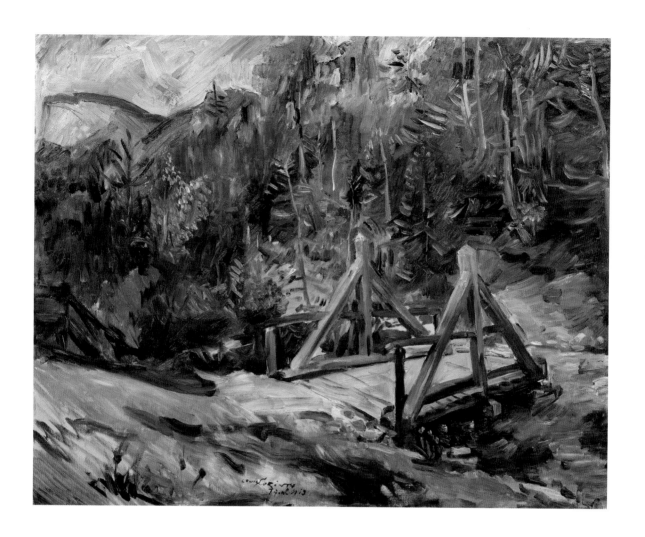

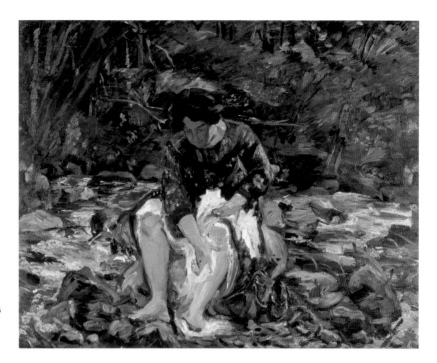

Girl in the Brook (Charlotte Corinth), 1913
Oil on canvas, 94 x 118 cm
Private collection

wood in the Tyrolean landscape. From the catalogue of his works, we know that this painting technique resulted from the conditions that forced Corinth to finish the picture hastily. As Charlotte Berend-Corinth writes, "The situation with this picture was difficult. Corinth was also almost sitting in the water with his easel. The current flowing around me was so strong and the water so deep that … Corinth [jumped up] and exclaimed, 'No, the situation is really too dangerous, you can't possibly sit there! Or, maybe just until I'm finished, I'll paint as quickly as I can!'"[4]

1 They are: *Tyrolean Woman with a Cat* (Berend-Corinth, no. 584), *Wilhelmine in Traditional Costume* (Berend-Corinth, no. 585), *Self-Portrait in Tyrolean Hat* (Berend-Corinth, no. 586), as well as *St. Ulrich in Gröden Valley* (Berend-Corinth, no. 583) and this *Tyrolean Landscape with Bridge*. In addition, *Girl in a Stream in the Woods* (Berend-Corinth, no. 579) and *Naked Child in a Washtub* (Berend-Corinth, no. 578) were also created here.

2 This is the painting *Young Woman in the Countryside*, a portrait of Charlotte (Berend-Corinth, no. 500).

3 The picture originally had a so-called folding frame that made it possible for the painter to fold it in the middle to make it easier to transport.

4 Charlotte Berend-Corinth, *Lovis Corinth. Die Gemäld*e. *Werkverzeichnis,* revised by Béatrice Hernard (Munich: F. Bruckmann, 2nd revised ed. 1992), p. 142.

The Corinth family's summer holiday
in St. Ulrich, 1913

The Herzogstand on Walchensee in the Snow, 1922

Oil on canvas

78 x 98 cm

Belvedere Vienna, inv. no. 2377

Charlotte Corinth had the idea of looking for a country house in Bavaria as a place for the sixty-year-old Corinth to relax and recover from the quarrels in the Berlin Secession and the stress of city life, a place where he would be able to devote himself entirely to his work. She found a plot of land in Urfeld on Walchensee in Upper Bavaria and commissioned the building of a house there in the summer of 1919. From that time on, the Corinth family returned to Urfeld several times a year. As a result, Walchensee became a central motif in the artist's late work: Lovis Corinth depicted the lake and surrounding landscape at various times of the day and year in more than 60 paintings and numerous watercolors and graphic works. He did not shy away from working in inclement weather or at night or in the early morning when the atmosphere inspired him to paint.[1]

In this work, Corinth did not paint a large Walchensee landscape (as was the case with the *Walchensee: View of the Wetterstein*,[2] which was obviously painted from the balcony), but instead chose a narrow section concentrating on the nearby slopes of the Herzogstand. Slightly to the left of the center, three slender trees rise up from the lower to the upper edge of the painting. There is still dry foliage hanging on their thin twigs. The motif of the slender trees is repeated on the far right of the painting. The winter landscape is laid out between these trees that stand more at an angle than upright. The snowy slope with the dark forest, still showing some traces of autumnal color, to the left takes up the entire central section of the picture. A small section of the lake can be seen on the far left of the picture with the blue of distant mountains beneath a violet sun, whose light seeps through the milky, clouded air, above it. A path, protected by a simple wooden handrail, leads from the foreground into the depth of the picture, making it easy for the viewer to grasp the painting. However, Corinth's main aim was not to render a detailed representation of the landscape, but to display the concurrence of what were actually not simultaneous color phenomena: namely, the glowing remnants of the autumn leaves, which characterize the forest, and the dirty snow, which seems to mix with the wet earth. The overcast sky shows that more snow is on the way although it is obvious that it could not have been a cold winter day when Corinth painted the picture. The colors appear damp and, in spite of the veil of mist, the sun sends warm light to the slope creating the feeling of a thaw.

An interesting aspect that can be frequently observed in Corinth's late work is the formal proximity of this depiction to purely abstract art. All of the elements in the landscape can be easily identified—but they are clearly treated as components of the picture: the many different tones that Corinth used to depict the forest and the sharp contours on the slopes make it possible for the viewer to perceive the individual sections of the painting as separate entities. In this painting, it is neither the space, nor the air—and hardly the light—that plays the main role—the colors speak for themselves. The fact that they are able to do this, that one can hear them, as it were, results from the irritating structure of the picture with its tilted primary lines—the predominant trees that seem to strike a chord to set the key in the foreground and the slanting slopes.

Corinth chose a similar view one year later for his picture *Walchensee in Winter*. In this painting, the view opens onto the lake and the village on the slope from a little further down the incline so that the tight composition of the Viennese painting is developed into a wide-open depiction of the landscape. But, this picture is also animated by the arrangement of the colors, the slanting trees growing into the picture, and the autonomy of the individual elements. Akin to Monet's late pictures from Giverny, Corinth's Walchensee landscapes point the way towards abstract painting.

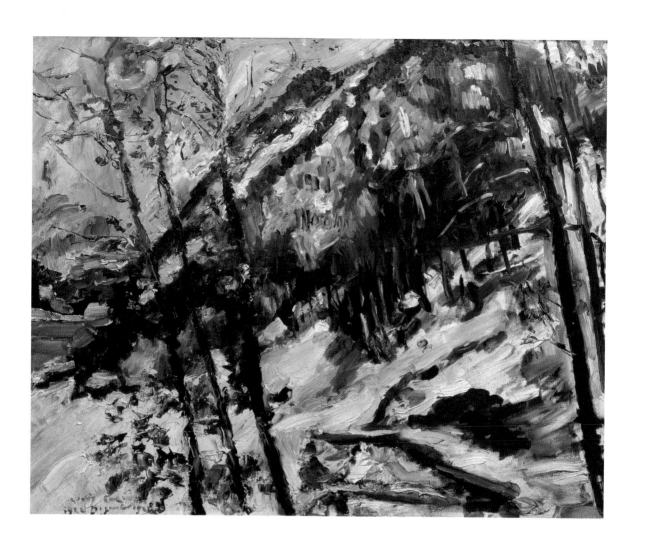

The Corinth family in Urfeld on Walchensee, 1921

Corinth painting in Urfeld on Walchensee, 1921

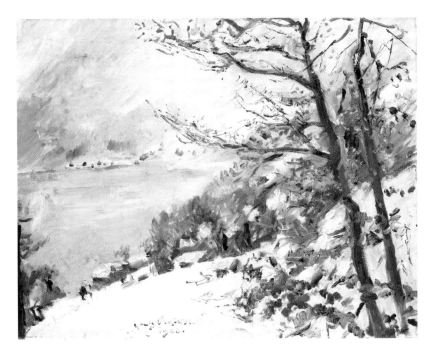

The Walchensee in Winter, 1923
Oil on canvas, 70 x 90 cm
Städel Museum, Frankfurt am Main

1 As in the painting *Walchensee St. John's Eve* (Berend-Corinth, no. 804), *Lovis Corinth, die Bilder vom Walchensee. Vision und Realität*, exh. cat. Regensburg, Ostdeutsche Galerie; Bremen, Kunsthalle (Regensberg: Ostdeutsche Galerie,1986), no. 15, or *Walchensee, Morning Mist* which he painted at 5 a.m. (Berend-Corinth, no. 959), *Lovis Corinth*, exh. cat. Vienna, Kunstforum of the Bank Austria/Hannover, Niedersächsisches Landesmuseum (Munich: Prestel, 1992), p. 11, figure 3.

2 *Walchensee: View of the Wetterstein*, 1921 (Berend-Corinth, *Corinth*, 1992, plate XIII), exh. cat. Regensburg, 1986 (cf. note 1), no. 25.

Still Life with Chrysanthemums and Amaryllis, 1922

Oil on canvas

121 x 96 cm

Belvedere, Vienna, inv. no. 2446

Corinth was a master of all styles, but he did not turn his attention to the still life until relatively late in life. His interest in floral arrangements only began to grow in 1911—before his stroke—and ultimately became a favorite subject of his late work. After his stroke, Charlotte, who had always been fond of flowers and plants, decorated the rooms of the homes—no matter whether they were in Berlin or in their country house in Urfeld on Walchensee—with fresh flowers to provide Corinth with inspiration to paint.

However, its large size makes the *Still Life with Chrysanthemums and Amaryllis* an exception among the numerous small paintings of this genre.

This floral still life is based on an arrangement of various vases with colorful bouquets of big flowers. Together with a few apples in the right foreground and some empty glasses, these vases are placed on a table in such a manner that it is difficult to distinguish the individual bouquets from each other. A large-leafed indoor plant creates a vertical boundary on the left edge of the picture with a maze of blossoms and light merging to cover the rest of the surface. The exclusion of spatiality goes so far that not even the edge of the table is shown.

Corinth was obviously standing in front of the table while he was painting, because most of the flowers are seen from above. This is particularly the case with the bouquet in the glass jug that forms the center of the composition—however, the large chrysanthemum blossoms seem to tower over it from above and are shown almost directly from the front. Here, a marked "cleft" can be discerned, which makes its way through the entire painting: while the lower section of the painting is composed meticulously and logically, it is impossible to recognize where the oversized blossoms in the upper half of the picture come from. These flowers display a definite tendency to gravitate towards the left, making the upper section of the painting appear more dynamic than the lower. It almost seems as if a strong gust of air was suddenly flowing through the arrangement. It ruffles the petals and, in this way, blows open the firm form of the flowers in the lower section. There, Corinth applied a thick layer of paint and pressed it onto the canvas with a palette knife so that the individual colors mix. It is fascinating that Corinth prepared the center behind the flowers in a dazzling yellow. This makes it appear as if a light is emanating from the blooms, red and green appear much richer in front of yellow, and the blue tones with their white highlights glitter like flashes of light.

In his floral still lifes, Corinth continues with experiments that had been made by generations of painters since Eugène Delacroix, since the proper juxtaposition of individual colors makes each and every one of them more vibrant. Of course, floral still lifes were particularly well suited for this kind of color experimentation, but hardly any other twentieth-century artist had such an intense interest in flowers as Corinth. The early Expressionists were mainly interested in figural painting in their attempts to break with tradition—especially in the area of coloration. Corinth, on the other hand, repeatedly—and consciously—referred to the Old Masters (and mainly the Dutch painters among them) to create new developments out of tradition. Compared with Delacroix—whose *Floral Still Life* (1834?) was probably unknown to Corinth—the German artist's painting of flowers appears excessive and chaotic, however the passionate work with color, as well as the overflowing abundance of the blossoms, creates a connection between the two works. The principal difference is the clear organization of the space in Delacroix's work, which contrasts with the disappearance of any feeling of spatiality in Corinth's painting that culminates in a complete divergence of the composition. This "rupture" is discomforting and gives rise to as many questions as does the double signature—at the lower left

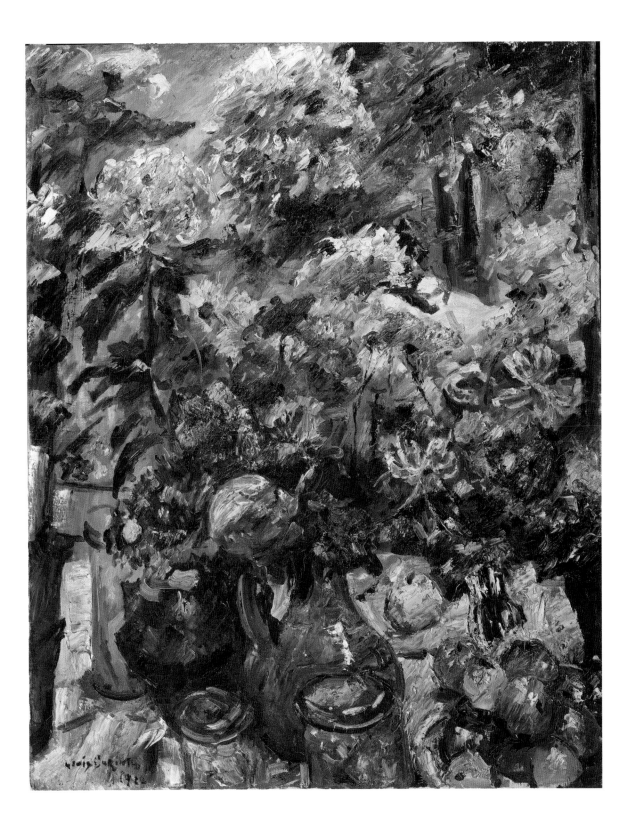

and in the upper centre of the picture—as if the separation into two halves was actually more a case of the unification of two independent pictures. In his 1955 Corinth monograph, von der Osten characterized Corinth's late style as the result of a change following the artist's stroke and connected this with an entry in Corinth's diary from 31 March 1925 (only a few months before his death) where the artist wrote "*I have discovered something new: true art means seeking to capture the unreal.*" Von der Osten correctly interprets this as showing that Corinth was in no way attempting to summarize his criticism of realism, but "*No, reality became clear to him in a new way, and he is about to do away with that artist's ego—so much of which can make its way onto the canvas—as best he can. A different ego, deep inside, simultaneously productive and meditative, increasingly develops into the genuine source of his art.*"[1]

Corinth certainly regarded floral still lifes as symbols of nature squandering itself and, in this way, eternally recreating itself. But, there seems to be an additional level of meaning in the Vienna still life that only the sensitive painter can perceive. Corinth painted the "unreal", the perceivable behind the visible world, in the upper half of his *Still Life with Chrysanthemums and Amaryllis*.

Lilac and Tulips, 1922
Oil on canvas, 120 x 90 cm
Städtische Kunstsammlungen, Chemnitz

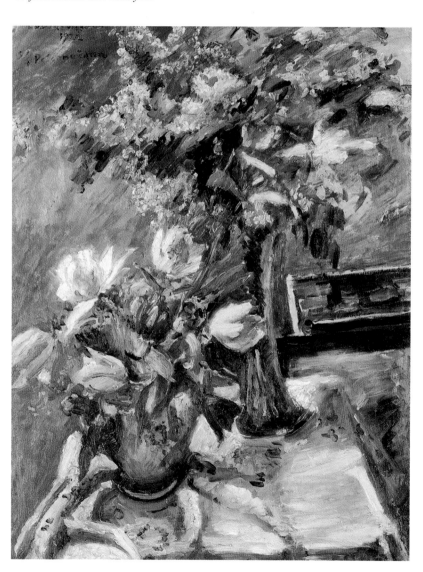

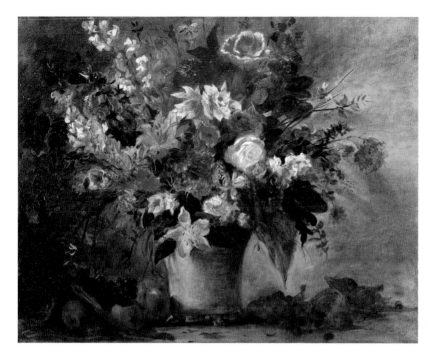

Eugène Delacroix
Floral Still Life, 1834 (?)
Oil on canvas, 74 x 92.8 cm
Belvedere, Vienna

1 Gert von der Osten, *Lovis Corinth*, Jahresausgabe Kunstverein Hannover (Munich: F. Bruckmann, 1955), p. 113.

Herbert Eulenberg, 1924

Oil on canvas

60 x 50 cm

Belvedere Vienna, inv. no. 2884

Herbert Eulenberg

Back cover of: Herbert Eulenberg,
*Lovis Corinth, ein Maler unserer
Zeit,* 1918

Herbert Eulenberg, now almost forgotten, was one of the most important German playwrights and writers of his time. Born in Mülheim am Rhein (now Cologne-Mülheim) in 1876, he earned a law degree before deciding to work as a dramaturge at the Düsseldorf Theater, in 1903, and as a free-lance writer, after 1909. In 1904, Herbert Eulenberg and his wife Hedda purchased the "Haus Freiheit" (Freedom House) in Kaiserswerth near Düsseldorf, which became a meeting place and symbol of the German artistic scene in the Weimar Republic and, particularly, later. The couple's circle of friends included all of Germany's prominent artists of the period, as well as authors and politicians. Herbert Eulenberg was a co-founder of the *Junges Rheinland* (Young Rhineland) artists' association and one of the organizers of the "First International Art Exhibition in Düsseldorf" in 1922. As a result of his experiences in the First World War, his pacifist attitude changed into the open antimilitarism that would have almost led his undoing under the Nazi regime if he had not been so well integrated in Düsseldorf society and German artistic circles.

As Eulenberg recalls, he met Corinth purely by chance after the First World War in the artists' pub under the Deutsches Theater.[1] After 1902, Corinth had repeatedly created stage sets and decorations for Max Reinhardt and also had a friendly relationship with the director by way of Alice Berend. Eulenberg, on the other hand, had a professional interest in the theatre (and the pub that had been established beneath it).

In 1917, Eulenberg published his book *Corinth, ein Maler unserer Zeit* (Corinth, a Painter of our Time). From a brief remark in a letter to his friend Hermann Struck, we know that Corinth and Eulenberg probably met each other frequently afterwards[2] and that this ultimately led to the first portrait in 1918. He gave the completed painting to Eulenberg, who later stated that "unfortunately, we were forced to part with it when we were in particularly dire straits during the inflation period."[3] Eulenberg continues by saying "Although he found out about it—something an artist never likes to hear—he painted me a second time later and it was even better."[4]

The second portrait, completed in 1924, shows Eulenberg at the peak of his personal success, although not completely untroubled. Corinth painted him extremely close up, sitting directly opposite the painter and scrutinizing him. A section of the straight back of a simple chair can be seen behind him on the left. He has a small, unopened book in both hands in front of his chest. Eulenberg appears to be holding the book, mentioned above, *Corinth, ein Maler unserer Zeit* with the back cover towards the viewer; at least the size and color of the book in the painting support this conclusion. The somewhat odd posture can be explained when one assumes that Eulenberg had both elbows propped up on the armrests (not visible) throughout the sitting.

Eulenberg's face takes up half of the painted surface and his body, constructed rock-like out of layers of paint, fills the lower half of the portrait. Corinth only hints at the lapels and tie with rough lines and paints the remaining clothing with a very broad brush so that the reflection of light on the smooth, elegant material can be recognized. It is notable that the right half seems to be much less concrete than the left, which is closer to the viewer (and painter). It appears that Corinth found it completely unnecessary to complete the hands—they are only suggested with a terseness akin to drawing.

This portrait, therefore, lives from the subject's intense gaze, which is almost impossible to avoid. This gaze, the narrow, closed mouth and the raised book develop into a depiction of an inquisition-like interrogation; they force one to take a stance and question one's own conscience. It is certain that, here, Corinth captured one of, if not the most

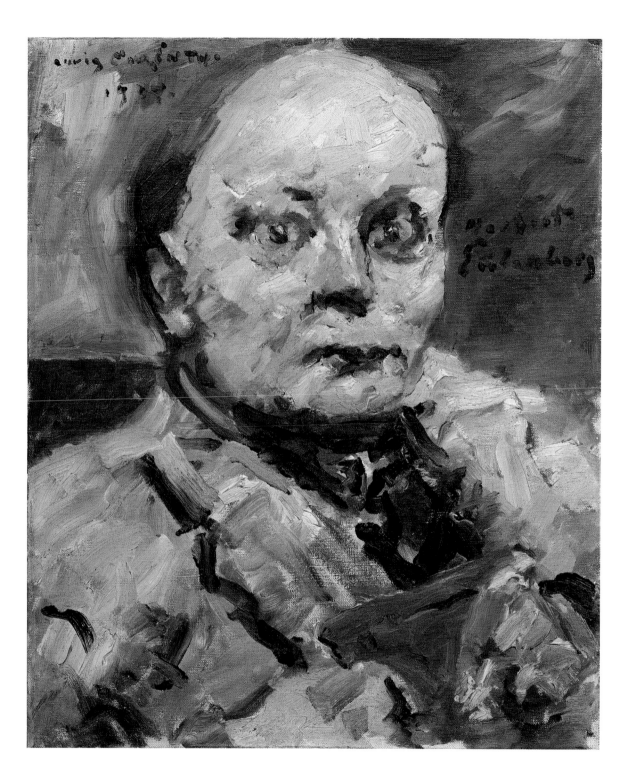

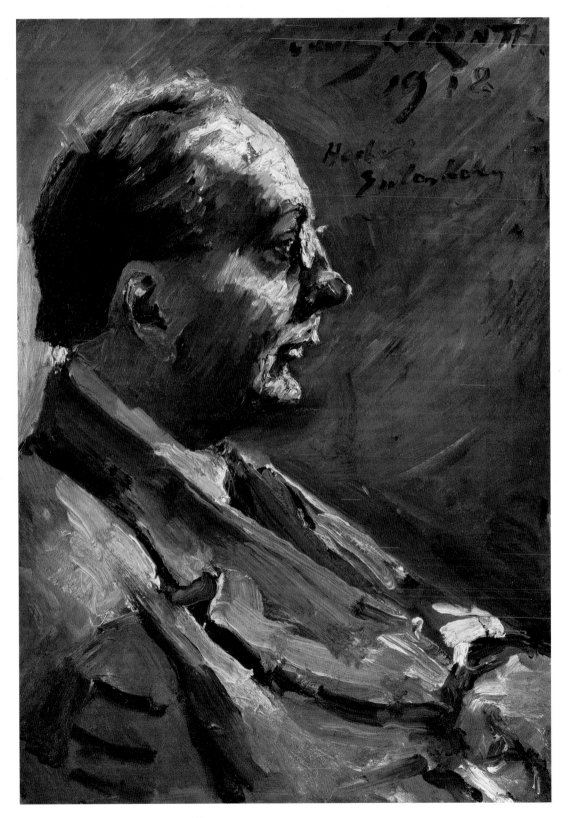

96

important, personal traits of this man who, in the face of all adversity stood up for his unconditional political and humanitarian convictions despite all the consequences. Yet to a certain extent, this is also a self-portrait of Corinth: while he was painting it, the portrait—as his alter ego—confronted him with the matters of his own conscience.

1 Herbert Eulenberg, *So war mein Leben* (Düsseldorf: Die Faehre, 1948), pp. 204–205, cited in Charlotte Berend-Corinth, *Lovis Corinth. Die Gemälde. Werkverzeichnis*, revised by Béatrice Hernard, (Munich: F. Bruckmann, 2nd ed. 1992), pp. 223–224.
2 Letter from Corinth to Herbert Eulenberg dated 25 September 1917 (cf. fig.).
3 Ibid, p. 223.
4 Ibid, p. 223.

Portrait of Herbert Eulenberg, 1918
Oil on canvas, 71 x 50 cm
museum kunst palast, Gemäldegalerie,
Düsseldorf

97

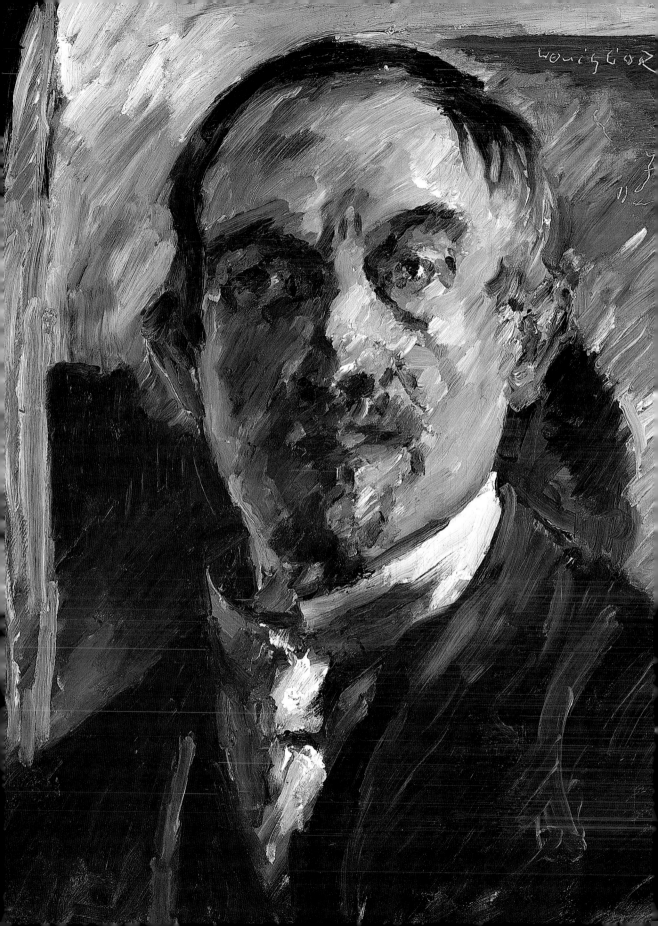

Corinth's Creative Process

The After-Effects of the Stroke
The Painting Technique

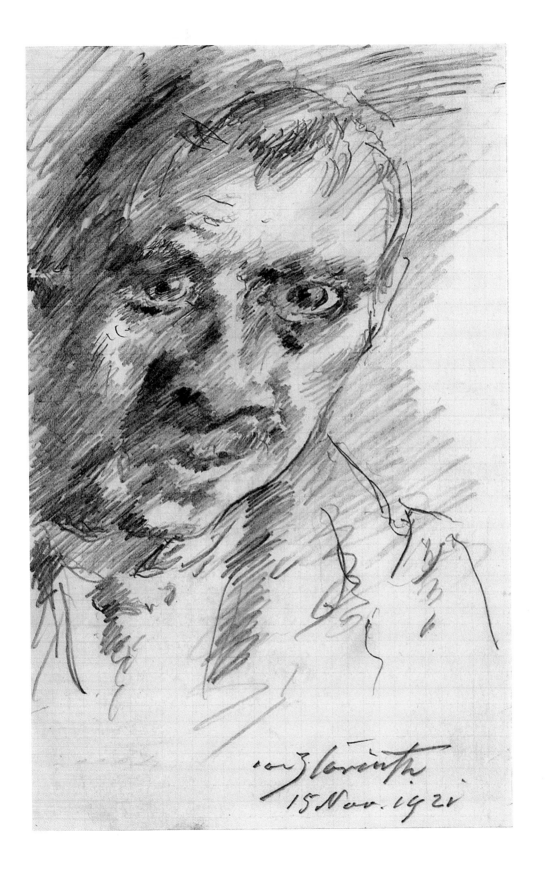

von Corinth
15 Nov. 1921

Hansjörg Bäzner

Lovis Corinth's Stroke and the After-Effects

"What a lamentable species, that is so disturbed in its relationship to art as to begin by taking biological factors into consideration and demands that an artist first produce a clean bill of health!" Thus Gert von der Osten when writing about the artist's serious illness of 1911 in his 1955 Corinth biography.[1] It therefore appears important for us to establish that this study is not calling for a clean bill of health. We do not intend to deal with the attribute of "being ill" in our approach to Lovis Corinth's art following his stroke in 1911 and do not have the intention of making an evaluation of the art when dealing with Corinth's illness. However, as a doctor of medicine (and artistic layman), Lovis Corinth's medical history represents a particularly attractive constellation. On the one hand, many art historians and experts regard the year of his stroke, 1911, as a turning point in his artistic development without, however, seeing it as related to the affliction and then divide their biographies and catalogues into the period before and after the illness. On the other hand, precisely those biographical sources at our disposal, and studying his work before and after the stroke, would seem to suggest to the medically informed viewer that the damage to the right side of his brain that occurred at the time had an obvious influence on his work.

Fig. p. 98
Self-Portrait, 1920 (detail)
Oil on wood, 59 x 50 cm
Kunstforum Ostdeutsche Galerie Regensburg

Unfortunately, these attempts were made considerably more difficult by the reprehensible National Socialist campaign against "degenerate art." At the time of the Nazi regime, almost 300 of the master's works were confiscated as being "degenerate" and, absurdly, this evaluation was made in connection with the stroke. The organizers of an exhibition of photographs of individual Corinth paintings labeled them as "Painted after the first stroke" and "Painted after the second stroke" and compared them with supposedly "healthy" pictures. Personified by the organizer of the "Degenerate Art" exhibition, Adolf Ziegler, the NS artistic community maintained that Corinth, paralyzed on one side as a result of his stroke, was only capable of producing "sick, obscure squiggles."[2] The Nazi ideologist Alfred Rosenberg described Corinth's post-1911 works as "a slimy, pallid racial blend of neo-Syrian Berlin." Rosenberg continued by saying, "Under other temporal and personal circumstances, the sick Corinth would have definitely rather laid down his brush than paint these formless pictures of his old age that shock us with their decline in talent and power. … Corinth, the man whose paralysis only permitted him to carry out certain movements with the brush and who, commensurate with his illness, probably also suffered from a serious visual impairment, was allowed to paint picture after picture reflecting the complete deterioration of his former creative powers and making it more likely that those viewing them weep rather than feel any admiration."[3] In this case, Rosenberg, blinded by his ideology, makes several historical and medical mistakes simultaneously. Of course, the stroke on the right side of Corinth's brain was not capable of leading to a paralysis of the right hand or having a negative influence on his brushwork. To put it more clearly: the stroke would definitely not have caused the paralysis of his right hand nor had any influence on Corinth's ability to move the right side of his body. There is merely evidence of a, medically plausible, weakness of the left hand that, for example, would not have hindered him in working with a brush or etching needle. It is more difficult to directly disprove the assertion that his sight was impaired "commensurate with his illness." However, it can be stated that the wealth of artworks created after the stroke

Fig. 1
Self-Portrait, 1921
Pencil on squared paper,
22.1 x 14 cm
Albertina, Vienna

rule out the "supposed" existence of any visual impairment. The problem that existed must be evaluated differently: based on the sources available to us, and a discriminating analysis of his works, Corinth most probably did not have an actual visual impairment, but rather a problem with the visual perception of his environment referred to as hemispatial neglect in medical terminology.

The first attempts at such an interpretation were undertaken in 1974 by Richard Jung, the former Freiburg full professor for neurology.[4] This aroused the extreme indignation of the artist's son Thomas—understandably, when one considers the bad experiences with the NS artistic henchmen—when Jung confronted him with the notion that the stroke had led to omissions in Corinth's works: "A doctor has stated that certain omissions in Corinth's drawings were a result of his stoke … The doctor's theory can be contested because Corinth followed the principle that 'drawing means leaving out.'"[5] Corinth's family was always very reserved when making statements on his illness. The extensive biographical material that Lovis Corinth's son Thomas brought together and published in 1979, as well as the biographical notes made by the artist's wife Charlotte[6] and his daughter Wilhelmine's autobiographical novel,[7] provide no conclusive evidence on whether Corinth suffered from additional strokes, as is assumed in diverse sources. There only remains the chance to observe and investigate the many works Lovis Corinth produced after his stroke from a medico-neurological viewpoint. This leads to a view of things differing from the standard art-historical approach of regarding the stroke not as a coincidental biographical entry along the path to a change in the artist's style but interpreting this change as a result of the stroke. And, this casts a completely different light on the statement, already mentioned above, that Lovis Corinth wrote shortly before his death: "Drawing means leaving out!"[8] For more than fourteen years, Corinth was forced to deal with hemispatial neglect, which affected him to varying degrees, and for which he was gradually to compensate and then ultimately declare an artistic principle.

What is Hemispatial Neglect?

Neuropsychology defines hemispatial neglect as a disturbance of perception, usually on the left side—as was the case with Corinth—occurring in the wake of damage to the right side of the brain. As a rule, it results in damage to areas in the right temporal lobe or occipital lobe of the brain leading to limitations in the perception of left-hand space and manifests itself differently from patient to patient. Occasionally, neglect remains the only indication of a stroke. Major strokes frequently damage the areas controlling movement which, when concurrent with an attention disorder, can result in varying degrees of weakness in the left arm and leg. In addition, neighboring areas in the occipital lobe, which represent the actual process of seeing, can become incorporated in the widespread damage, making it difficult for experts to differentiate between a disorder in perception and sight. However, the definition of neglect does not necessarily include paralysis or visual disorders. The fact that a neglect patient is not aware of this disorder at the beginning of the illness is especially conspicuous to both the examiner and the patient's family. This means that, as a rule, these patients act as if their left side does not exist: family members who approach the sufferer from the left remain unnoticed, contact with the left side of the body is not registered and commands coming from the patient's left side not carried out. A tray with various dishes is only half emptied (right side), personal hygiene is limited to the right side of the body—for example, only the right side of the face is shaved. The reactions of all of the senses—hearing, sight, touch and smell—can be distorted as a result of hemispatial neglect. On the other hand, this leads to a neglect of the motor functions of the side of the body opposite the damaged half of the brain. It is important to note that the eye movements are also affected and that the patient does not direct his eyes actively into the field of vision affected by neglect. There are extremely impressive investiga-

Fig. 2
Simple self-portrait sketch of a neglect patient two days after a stroke to the left half of the brain. The left corner of the mouth is left open. The eyes are missing. The patient thought the depiction was complete.

102

tions in the scientific literature demonstrating that neglect patients often have difficulties visualizing their spatial environment in their mind's eye. This type is called representational neglect. In a famous scientific experiment, patients with this disorder were asked to imagine the Milan Cathedral Square and name the buildings that could be seen when looking at the cathedral portal. Patients with representational neglect could only name the buildings in their right field of vision and, in their imagination, depicted none on the left. Following an illusory 180-degree turn—now, with a view away from the cathedral—once again, only buildings on the right side of the viewer were named and those described previously were no longer mentioned.[9] That means that, in the case of representational neglect, the omissions actually existed in images in the patients' mind's eye.

From that aspect, three cognitive processes that lead to a behavioral disorder in respect to the neglect area are relevant: attention, intention, and representation.[10] Additional consequences of neglect, which are significant in artistic depictions, are described in the field of neurology as object-centered or space-centered neglect. Space-centered neglect describes a disorder where the patient only works on the right side of a sheet of paper lying in front of him so that the omissions on the left-hand side become noticeable. Object-centered neglect, on the other hand, means the incomplete representation of an object—for example, missing contours on left side of a face in a portrait sketch, independent of the position of the object on the sheet. Here, it is obvious that dealing with the object in its entirety is absolutely essential for the correct, formal reproduction. Disturbances in the depiction of the proportions of bodies, anatomical interrelations and the depiction of perspectival relationships are naturally rendered extremely difficult through neglect.

How should one imagine the modern examination of patients suffering from such a disorder? In general, the examiner's immediate impression of the patient is important for guiding the diagnosis in the right direction. In the first phase of a recent stroke, it is often observed that neglect patients frequently lie conspicuously close to the edge of their beds and that their heads and eyes—and sometimes the entire axis of their bodies—is turned towards one half of the room. A doctor who visits the patient and enters the room from the side affected by neglect is, initially, not even acknowledged; quite simply, because he is not noticed. Mutual communication only begins when the doctor enters the patient's field of perception. While still in bed, neglect patients are often asked to draw a small sketch—for example, a little self-portrait (fig. 2). Classical tests also include the exercise of copying small, simple sketches (line drawings such as houses with smoking chimneys, flowers, etc.) or a clock and then show the hands at a given time (fig. 3a to 3c).

Patients with left-sided neglect often only draw as far as the right half or sketch the clock face only with the numbers of the hours from one to six and forget those from seven to twelve on the side affected by neglect. Other neglect patients include all of the numbers of the hours on the right-hand side. Another test requires patients to draw a line exactly through the middle of other lines on a sheet of paper. In this case, neglect patients draw it much too far to the right.

Finally, the "cross-out" test, in which the patients are asked to discover and mark all those examples of a certain symbol from a large selection of various letters and symbols printed randomly on a sheet of paper, is often used. In this case, the patients frequently fail to mark the correct symbols on their neglect side. We often observe that neglect patients begin the exercise on their "good" side and gradually make their way towards the neglect side.

However, the investigation of spontaneous drawings is much more interesting than these standardized procedures. Imagine the situation of a neglect patient who is given the task of drawing a sketch on a blank sheet of paper. First of all, the patients have problems depicting an accurate entity in their imagination. Then, their orientation on the sheet of paper is distorted in such a manner that the centre is moved towards the left. Finally, the inner corrective that identifies omissions or "errors" is missing while

Fig. 3a, b, c
Example of a simple examination method of a visual-spatial neglect: two days after a stroke to the right side of the brain, the patient was instructed to copy sketches of a clock and cube. He was not able to show the spatial dimensions of the cube accurately and the left half of the clock was omitted.

making the drawing. In practice, one often observes that patients suffering from left-sided neglect initially only work on the right side of the paper. If the imaginary depiction is incomplete, the sketch will also not be completed. In addition, an accurate depiction of space and the correct perspective are necessary. In this respect, their own visual control mechanisms as applied to the object depicted can even represent an obstacle in cases where the object is drawn from from an inner reservoir of images.

Marshall and Halligan report that their patients often made more accurate sketches with their eyes closed than when open.[11] This means that patients repeatedly attempt to control the product they are drawing and possibly make changes with the aim of remedying a supposed mistake. Here, the corrective of a functioning spatial overall view is missing. The disability with regard to graphic depiction manifests itself on three levels:

1. Manual capabilities are impaired; thus lines on the side affected by neglect are drawn too short

2. The drawing lacks an overall imaginary representation in the patient's own mind's eye and

3. The immediate visual perception of the patient's own artistic production is impaired within the space affected by neglect. A healthy person's real-time correction process is missing.

Finally, the observation that specific disorders lead to impaired perception of sketched sections of the face—for example, the area around the mouth or the eyes—is especially interesting when dealing with the graphic production of inflicted artists. For example, patients with this kind of disorder often omit the mouth and lips, or the eyes.

It is important to mention that, fortunately, the described disorder, as well as many other signs of a stroke, often recedes to a certain extent; frequently, almost completely (fig. 4). The most prominent changes are noticed in the phase of a few days after the stroke. Modern, early rehabilitation methods usually begin after a few days and are carried out during the first six weeks following a stroke. The most pronounced improvements are usually observed in this period. In the case of neglect patients, those who become increasingly aware of their disorder are able to develop compensatory strategies. However, a variable and not easily foreseeable part of the disorder often remains. Patients actually report that the severity of the disability varies from one day to the next during their rehabilitation and later phases following a stroke, this can result in variously noticeable day-to-day difficulties.

Today, a contemporary neurologist would be able to successfully examine Lovis Corinth as a patient using the previously mentioned methods. For example, there are documented case histories of other artists suffering from neglect; these include Otto Dix and Anton Räderscheidt, who were both treated by neurological specialists. Anton Räderscheidt's extremely impressive medical history was recorded by the artist himself. He describes his experiences in the period immediately after his stroke in 1967 as follows, "A stroke took me off the stage, played its game with me in the wings. I was no longer the director. I had to be careful not to miss my cue. The props only react to my ingenuity. … These few discs often move like a torrent. The reproduction of the world around me is a fiendishly difficult affair. Nothing remains in its place, nothing keeps its shape. I was always suspicious of concrete forms. Maybe I will grasp a believable form in this eternal movement; maybe it will reveal itself to me through a careless movement; previously things were only so convincing in my dreams. Formerly, everything seemed to be a hunt, today it is like trying to catch a trout in running water with my bare hands. And the color! It is really throwing its weight around! Painting has become like trying to tame wild beasts of prey."[12]

As far as we know, a neurological investigation was not performed in Lovis Corinth's case. Therefore, studying the descriptions of his contemporaries, autobiographical documents, family reports and—most importantly—by examining his works of art are a particularly interesting way of approaching the period immediately following his

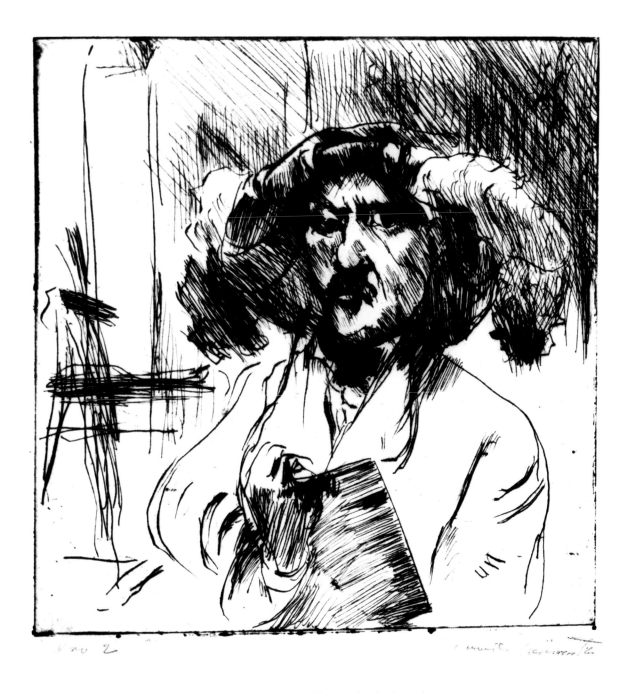

Fig. 4
Self-Portrait in Beret, 1918
Etching, 20.3 x 19.9 cm
Von der Heydt-Museum, Wuppertal

stroke. However, over the lengthy time span from the severe illness to his death, studies of Lovis Corinth's works clearly indicate a visuospatial defect. Interestingly, the evaluation made in works of art history help us here, for example when Gert von der Osten, in describing the large-scale Walchensee panorama from 1924, notes that this painting contains much more "(as Corinth once demanded of landscape painting) than the painter can capture with his eyes, while standing on a single spot and looking straight ahead."[13]

Medical History

As a young man, Lovis Corinth was legendary for his ability to hold his liquor and his impulsive, extroverted nature. His wife described Lovis at the time they met as a "rather strange looking man. A fresh, somewhat red head with an enormous neck and a section of his chest looming out of his half-unbuttoned flannel shirt."[14] Thomas Corinth quotes Karl Schwarz's words, "His face was … tanned and full of stubble" and continues "he was tall and strongly built, but stood stooped … He was shy, meaning he shut himself off from strangers and appeared grumpy and forbidding to them."[15] Among the possible risk factors for a stroke, we have proof of high nicotine consumption as well as the regular intake of large amounts of alcohol. In the autobiography by his contemporary Karl Schwarz, who refers a companion from Corinth's youth, Benno Becker, we see that Corinth enjoyed life "to the fullest." He goes on to say, "He threw himself into everything he did with avarice and developed unsuspected strength, … he loved merry drinking companions and voluptuous women. He drank excessively, could put away an unbelievable amount of alcohol and loved to drink his friends under the table. This excessive lifestyle—especially, the heavy drinking—was also the cause of his illness and his premature aging. … Intellectually, he remained as strong and alert as ever until the very end. And, it was often shocking to stand by and see the spirit that acted out of the decayed shell."[16] There is no evidence of arterial hypertension but, based on the descriptions given by his biographers, this seems quite possible. During the night from 11 to 12 December 1911, Lovis Corinth suffered a stroke to the right side of his brain that, in his own words, "brought him close to death." In the days immediately following his stroke, Corinth experienced dreamlike, visual impressions. In his autobiography, the artist describes them by revealing that "My departed often appear in the night and seem to be beckoning to me while, from above, a power forces me down, ever deeper. I said 'This is it!' to the orderly and when the doctor heard similar suspicions he answered: 'With a heart like yours, you won't die for a long time.'"[17] His wife Charlotte reports, "I must have just fallen asleep when I heard noises and screams coming from his room next to me. I dashed to his bed, he was lying on his left side, moaning. … The doctors arrived quickly and told me that he would survive. … They gave him a morphine injection and his enormous strength subdued."[18] His son Thomas' documentation shows that their friend Dr. Paul Straßmann—actually a gynecologist and male midwife—came immediately "although he himself was in poor physical condition."[19] The then seven-year-old boy recalls that his father "expressed the fear that he would die; his own father had died of the same illness [Corinth's father died on 10 January 1889 as the result of a stroke]. Good Dr. Strassmann replied: "But no, don't worry, you've got 1,000 years ahead of you."[20]

The first written evidence of Lovis Corinth after the illness is a pencil concept for an instruction for payment dated 18 December 1911. Thomas Corinth continues that, immediately after the stroke, his father made pencil drawings showing a skeleton bearing the Greek inscription of "Thanatos."[21] And, in Alfred Kuhn's book, we read that "Corinth asked for pencils and paper while still on his sickbed and sketched a series of terrifying monsters and strange, ghost-like pictures of famous historical figures."[22] According to Alfred Kuhn, the painter was confined to his sickbed for months. Kuhn stresses a noticeable change in character and writes, "When Corinth finally got out of bed, he was a different person. He had become a seer; he could see the otherworldly aspects of a phenomenon. There was hardly ever another painter who loved the world more than this man from Eastern Prussia."[23] It is obvious that, at this time just a few weeks after the stroke, Corinth went through a period of deep depression. According to Charlotte Berend-Corinth, "It could be that the illness had increased his grief but it was not the cause. He had become melancholic because his hand had become heavy and he could no longer lead such a wild life."[24] On 22 December 1911,

Corinth wrote Heinrich Keitel "'Adieu-adieu-adieu' It hurts so much … The bad news that I am in such a miserable state. Pain … terrible. I had to put up with pain that was much too great." A few days later he reports, "I have been confined to my bed for more than a week and am suffering from a lot of pain," and on 22 December 1911 he writes, "from the bed of the greatest pain, I must tell you just how sad I am with the pain that is so terrible…"[25] In this case, his son Thomas' interpretation that this is a form of "neuritis" appears untenable and an attack of gout, such as Corinth had previously suffered from, seems more likely. However, there could possibly be a connection between the pain syndrome and the recent stroke. In addition to the stroke in the area supplied by the central cerebral artery, favored by Jung, the described complaints, with a disorder in the perception of the left-hand environment (neglect), could also indicate a stroke in the vascular territory of the posterior cerebral artery. Here, there is also the possibility of damage to the brain structures of the diencephalon that frequently goes hand in hand with a pain syndrome. On 30 December 1912—more than 6 weeks after the stroke—Corinth excused himself to announced visitors with an "indisposition, due to illness."[26]

On 19 February 1912, Corinth set off for Bordighera on the Italian Riviera with his "faithful nurse" Charlotte Berend-Corinth. While there, Corinth was forced to observe the power struggles in the Berlin Secession that finally led to his resignation from the board. The progress of his recovery in Bordighera was not uncomplicated as Charlotte reports in an impressive document on the, then modern, rehabilitation treatment that is, at the same time, a reflection on her own situation as the closest relation of a stroke patient. "Now, at 9 pm, Lovis is sleeping—he is always very tired here and the doctor, who is very serious and thorough, also told me that his condition gives cause for alarm. He found him to be in great need of recuperation and also told me many other things that I could never find out from the doctors in Berlin. The daily routine has been precisely determined by the doctor: Dear Lovis… drinks decaffeinated coffee. …Then … he has a stroll…he is allowed to take a half-hour walk twice a day. Lovis' lunch is ready for him at 12.30. … 4 o'clock, a light tea. A drive or a short promenade; dinner at 7. … Lovis is very quiet and pensive, infinitely good and thankful for everything, for the smallest bit of encouragement or help… I do not want to leave Lovis alone and the doctor says I am right. At first, I was secretly in despair at having to live in this beautiful natural environment with my arms tied but, after speaking to the doctor, I have changed completely."[27] Charlotte wrote in a different context, "When he found his way back to life after his first serious illness, restricted by the orders of the doctor to always be the server of wine, it was at first incredibly difficult for him to get control of himself, but he managed to do so."[28] (fig. 5)

Lovis Corinth did not write again about an improvement in his health until April 1912, four months after the acute event. However, the artist was not convinced that he would recover completely and, on 1 August 1912, in a letter to his friend Hermann Stuck he wrote that "in the newspaper you can read that I have recovered completely, and I wouldn't dare claim otherwise."[29] His contemporary Karl Schwarz described the Corinth of this period drastically as "a tough man who appears to have almost become a wreck through his suffering."[30]

Of course, mention must be made of the trembling of his right hand—his painting hand. After the stroke, confusion resulted from poorly researched reports that said that Corinth the painter was no longer able to move his right hand—that was clearly not the case. However, it is correct that Corinth, as well as many other fellow sufferers, described a trembling of the right hand that, according to Thomas Corinth, "only occasionally" made itself felt, and must have sometimes been very pronounced but, to the surprise of all the witnesses, stopped when the brush in his hand touched the canvas, or the pencil the paper. This is also shown in a documentary film from 1922. Corinth himself comments that "a terrible shaking of the right hand increased by strain from the [etching] needle and caused by earlier alcoholic excesses [has prevented] a manual calligraphic style in my works.[31] Phenomenologically, this was

clearly a form of trembling when moving or holding objects. This would be typical of a so-called essential tremor—a disorder that is commonly called "old-age shakes" and must be dissociated from the shaking typical of Parkinson's disease.

Corinth's wife Charlotte reported on other after-effects of the stroke paying particular attention to her husband's fears and depression and his exhaustion following the slightest physical exertion. It is noteworthy that, in her memoirs, Charlotte writes several times about her husband's "first stroke" although a definite description of a second stroke is nowhere to be found. As can be deduced from diary entries, Corinth fainted at his sixtieth birthday celebration. Charlotte Berend-Corinth reported that "While a celebratory speech was being made at the head of the table ... I saw you going pale around the nose. To my dismay, this pallor spread across your face and your eyes closed—at the same moment, A. gave me his hand in greeting. 'Quick, quick' I whispered 'take Corinth under the arm and I'll take the other side…' and so we led the staggering birthday boy through the suddenly silent party. When we got upstairs, we put him to bed and he recovered immediately. He was happy to be in bed and fell asleep right away."[32] Corinth gave his own report on this occurrence, recounting that "At the end, I collapsed; I had probably smoked too many cigars." Elsewhere he re-

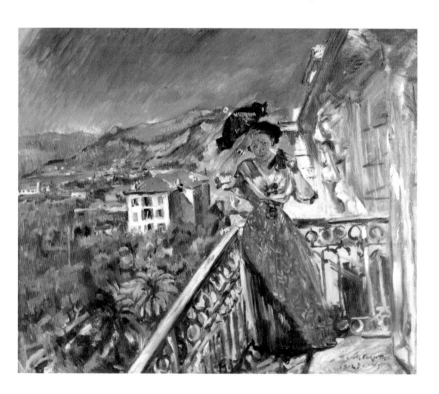

Fig. 5
On the Balcony in Bordighera, 1912
Oil on canvas, 83.5 x 105 cm
Museum Folkwang Essen

ports, "The crush of more than 100 people was probably to blame, along with my years of abstinence and the cigars."[33]

Karl Schwarz documents a very vaguely described illness: " … I believe it was in 1919 or 1920 that Corinth came down with something. He was taken down from his studio into the apartment and put to bed. The doctor prescribed absolute rest." It seems that Corinth was already able to get up and go out one day later.[34] Charlotte reported on her husband's bouts with depression, recalling that "When he was very depressed— and that was every couple of days—I hardly tried to comfort him at all but spoiled him like crazy." Elsewhere she states "After all, we had been living together for almost twenty-five years and the depression kept recurring; especially after his illness in

1912."[35] Regarding his nature after the stroke, she claims, "Over time, I had discovered what would help him. For example, when his nerves were in a mess, or when he was really angry or on edge or about to break out, I always agreed with him … ."[36] Corinth often described his prevailing mood quite drastically: "It's enough to make you weep. I am disgusted by all my paintings. Why should I keep on working, it is all garbage…" On another occasion he claimed, "My intellect is almost extinguished."[37] In later life, he limped a little and his wife described a somewhat stiff leg, his steps became shorter ("dragging his feet, as he has for years. Oh, and—how he tries to keep up with me …" and he had difficulties with the finer movements of his left hand.[38] Shortly before his death, it seems that the lameness of his left leg worsened for a while, but this was only temporary.

Late photographs show the typical position of the hand and arm after a left-sided stroke (fig. 6), but his wife confirmed that he was able to use his weakened left hand to press the copper sheet against his body while he was etching. "After the illness, the movements of his left hand remained awkward, although he was able to carry them all out. He never mentioned this handicap—he simply took up his work again." And later: "This left hand was clumsy when he had to make intricate movements, such as opening a tube or buttoning his collar, but he required no personal assistance. Only a little help from us in performing these small tasks from time to time."[39] According to Horst Uhr, however, she helped him tremendously in his struggle to return to art. She laid out the paints for him, placed the palette and brush in his weakened left hand and removed them from his stiff, swollen fingers as soon as he was finished with a painting. When he was unable to hold his sketchbook, she helped him carefully and with great tact.[40] On the other hand, Charlotte Berend-Corinth reported elsewhere that "After Corinth's illness, I no longer got much support from him.[41] According to Thomas Corinth, "This [lameness] satisfactorily receded to a large degree after the attack in 1911. However, it remained distressing enough for the suffering artist."[42]

Fig. 6
Photograph of Lovis Corinth at the age of sixty (1918). The painter holds his left upper extremity, lame as a result of his stroke, pressed against his body; his hand is clutched in a fist.

Artistic Production in the Year after the Stroke

Unexpectedly, Corinth's productivity actually increased in the post-1912 years after the stroke. Almost 500 paintings and more than 800 prints, watercolors and drawings—more than half of his total output—date from this period. Naturally, the artist did not produce everything for the public, although today's public does not take this into consideration. It is interesting that the dating of the works from precisely this time is often not quite clear. Corinth occasionally corrected datings from 1911 to 1912 and vice-versa. The contemporary biographies, including the one by Biermann, also include imprecise or erroneous dates. In the phase following the stroke, Corinth concentrated on self-portraits, portraits of members of his family, and landscapes and produced large series of lithographs and etchings, partially as book illustrations. The first attempts at artistic production after the stroke are fascinating. As Charlotte Berend-Corinth reports in her memoirs, she accompanied her husband when he returned to his studio for the first time (in February 1912, around 8 weeks after the acute event). Still wearing pajamas, Corinth created a self-portrait after studying himself for a long time in the large mirror he knew so well.

In her diary-like notes, she writes "[Corinth went] casually, although with difficulty, step by step … He complained repeatedly, dark premonitions assailed him, and the depression he was prone to had been churned up by the illness. I had no idea of how to console him … . Suddenly, he started looking for his paints and palette, sat down in front of an easel and painted, in the shortest possible time, this first, anguished, self-portrait."[43] In a description of this self-portrait she states "The sacrifice has still not been compensated for by success."[44]

The self-portraits display an ongoing confrontation with the effects of a decline in his physical condition and often show his frailty and psychologically unstable condition.

In February 1912, Corinth used the vernis-mou technique to create a small etching showing the suffering painter as Job with his Friends (fig. 7). His son Thomas recalls that, at the time, Hermann Struck, one of Corinth's friends and also a painter, helped him prepare the plate for printing. "I saw him drawing on a kind of tissue paper in his sick room."[45] Stuck had introduced Corinth to the uncomplicated technique of etching with the dry point and vernis mou.[46]

This picture depicts Job sitting cross-legged on the ground. His right hand is placed on his right foot, the thin, lame left arm lies on the ground with the palm upwards and his left leg is turned inwards. Job is wearing the cap that Corinth had worn in several of his earlier self-portraits. There is a small error in the title of the etching on the plate—the "&" sign is reversed. This etching was more intended for private purposes than for the public: only five prints were made from the plate. Corinth traveled with his wife to Bordighera on the Italian Riviera to recuperate from his illness in the spring of 1912. There, he drew a small self-portrait that has considerably less resemblance to the artist than all of those created before 1912. Above all, the proportions of the nose, mouth and area around the eyes are irritating.

Several comparable studies made at the same time demonstrate a left-sided neglect with a missing sense of depth on the right-hand side of the face (fig. 8).

In a modest pencil sketch of his daughter Wilhelmine from this period, the considerably more developed sense of depth of the right side of her face and the more precise depiction of her hair with a braid on the right are particularly striking. On the other hand, the left half of her face is markedly neglected.

A pencil drawing of his wife that was also created in Bordighera shows a lack of depth: her dress seems without life, there is a lack of anatomical plausibility, and she appears strangely distorted.[47] In contrast to this, there is a very charming scene of his wife opening a small parasol on the balcony of their hotel room in Bordighera (cf. fig. 5). According to Horst Uhr, the correct perspective is missing from this painting, the hotel seems to be toppling to the left and its vertical lines do not tally.[48] However, other paintings from the time in Bordighera are evidence of progress in the recuperation process. Von der Osten describes the young woman as "strangely at the mercy of the outside world," describes the face as "formally torn," the balcony railing as "misshapen," "somewhat vague and displaced [...] the coexistence of our beautiful world."[49]

The beginnings of the lines in the letters that have been preserved from the period after the illness are very often moved to the right (fig. 9). This phenomenon cannot be observed before the stroke.

The first large painting from 1912 shows the blinded Sampson (fig. p. 35).

Sampson is a martyred, desperate figure reaching out in the direction of the viewer; he appears unsure and obviously still without faith in his strength returning.

The biblical figure is grotesquely distorted in a preparatory pencil sketch for this painting (fig. 10).

A small, pencil study of his wife created in October 1912—only 11 months after the stroke –was reproduced in Corinth's 1926 autobiography and shows an obvious symptoms of neglect, with sections of the contours of the left side of the face missing. It is interesting that this sheet was incompletely printed in Corinth's autobiography; the left side was simply cut off (fig. 11).

According to the neurophysiologist Richard Jung, Corinth's neglect was compensated for in the landscapes painted after 1913. Jung does however describe a certain insecurity in the depiction of the left half of the face in some self-portraits.[50] To produce these self-portraits, the artist sits in front of a mirror and focuses keenly on his own face. Here, Jung speculates on a loss of the left-sided range of parafoveal vision—directly adjacent to the point of sharpest vision. That might provide an explanation of the difficulty he had in finding the beginning of a line. Interestingly—and in contrast to his famous colleagues—Corinth never corrected the mirror effect in his self-portraits so that they always show the right-handed painter with his brush in his left hand, just as he did before the stroke (cf. fig. 8 and 9).[51]

Fig. 7
Job and his Friends, 1912
Etching, 34 x 23.8 cm
Staatliche Museen zu Berlin,
Kupferstichkabinett

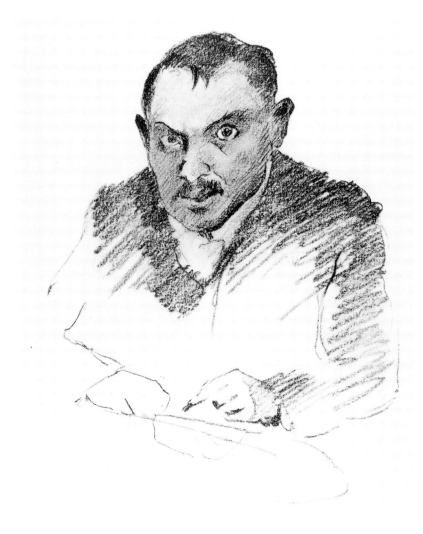

Fig. 8
Self-Portrait, 1912
Pencil on vellum, 34 x 28 cm
Detroit Institute of Arts

The Painter Corinth after his Stroke: Descriptions of Sittings by those he Portrayed

The accounts given by the contemporaries who sat for the master late in his life are particularly revealing.

Regarding a portrait done in 1924, Rudolf Grossmann noted, "When he works, his eyes nearly pop out of his head, he is seized by a rage, as he says, his features become tense, his nostrils flare—he is so obsessed with the impression that everything else around him disappears. He knows how to take advantage of the fact that that his motions are now impaired; there is no longer any trace of the nimble brushstrokes of his earlier, often somewhat Academic, pictures. His hand gropes around in the palette, gradually becomes madder red, while he paints me. The other one often comes to help, trembling, like a mahlstick, to form a particular tone more precisely, he frequently moves back and forth to get zinc white from his paint box. ... At the end, after two and a half hours of working non-stop—I had to stand and watch the whole time—his hands sank, blood red, as if he had been burrowing into my insides."[52]

In 1918, he painted the writer Carl Bulcke. In 1930, Bulcke sent a letter to Charlotte Berend-Corinth saying that "Corinth's studio was hardly heated, I froze terribly. The stoke patient comforted me: 'It's easier for me. When I freeze, I only freeze on one side.'" Later, "He painted standing in front of me but with his back turned. He sat

Fig. 9
Facsimile of a letter dated 29 June 1919
Illustration from Lovis Corinth, *Gesammelte Schriften*, Berlin 1920

111

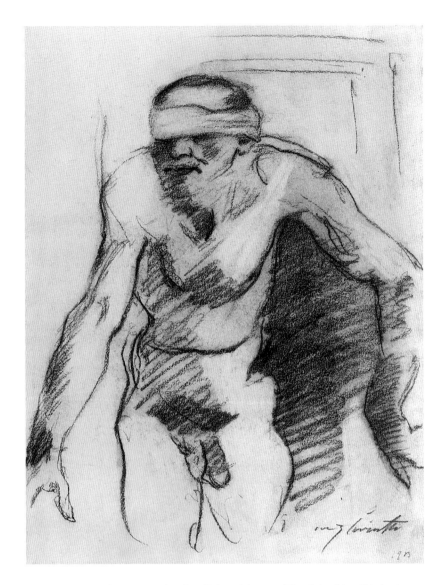

Fig. 10
The Blinded Sampson, 1912
Black crayon on vellum, 46.6 x 34 cm
Staatliche Museen zu Berlin,
Kupferstichkabinett

Fig. 11
Charlotte (detail of a sketch)
Technique and measurements unknown
Illustration from Lovis Corinth,
Selbstbiographie, Leipzig 1926

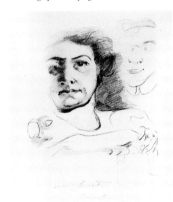

diagonally across from me, only a hand's breadth away. The right side of his body was greatly handicapped. His hand, his head and his upper body were always in motion. Not only the right hand: the left one too. The right hand held the brush horizontally; it looked like he was taking aim like a hunter. The right hand floated in the air for a few seconds, it hesitated. Then the left hand came to its aid, grasped the right wrist and carefully, with great caution, the brush started to paint."[53]

A final report comes here from Julius Meier-Gräfe. "He tortured himself. Although I remained completely still, it seemed as if he was hunting for something fleeting around my face that he could not capture. ... He began immediately as if compelled to do so. Several canvases had to take the brunt. Once he stopped, took a copper plate, said something about it, tried to make an etching and pulled my face so close to the plate that I started to feel a little uneasy."[54]

Stylistic Change—Psychological or Physical After-Effect of the Stroke?

Hans-Jürgen Imiela calls "the necessity to complete something under altered creative conditions and, ultimately, the capability of making an achievement that continues with that already undertaken and goes even further to produce incomparable formulations of new artistic insights" a purpose in life.[55] Several biographers describe the experience of being close to death and the mortal fear experienced during and after the stroke as the key to Corinth's stylistic change. According to Horst Uhr, all the works created after the stroke are, in a certain manner, evidence of this occurrence.[56] He describes the stroke as "an experience that ultimately led to a new freedom of expression." Many art experts agree that Corinth's art underwent a stylistic change and also feel that this was entirely due to psychological factors such as depression, a more intense consciousness of the transience of life, and an increased preoccupation with death. In the foreword to a major comprehensive exhibition of his works in 1913, Lovis Corinth himself explained "My last pictures… were difficult for me because of my annoying illness, but I hope that I have overcome this handicap and want to continue along my path."

Fig. 12
Self-Portrait with Straw Hat, 1913
Drypoint etching, 29.1 x 21.9 cm
Von der Heydt-Museum, Wuppertal

In his foreword to the catalogue for a major retrospective exhibition held in 1966, Christoph Vitali expresses doubts that the stroke had a decisive influence "that led to his painting technique once again changing fundamentally and a radicalization of his style. Describing this metamorphosis purely from a physiological viewpoint is clearly much too simple … . The nearness to death and the illness may have accelerated and intensified this development, the foundation of which had been laid in the previous work, but they did nothing more than that."[57] Alfred Kuhn gives a more detailed description of the change in style: "The contours disappear, the bodies often appear to be torn apart, deformed, disappear into the surface. The realism of the portraits almost completely disappeared and they relinquished all manner of fidelity to detail. The person is captured in his entirety with broad brushstrokes. Characterizations are exaggerated, often going as far as a caricature. Models, no matter what their background, were simply objects to be painted."[58] Later he says, "Corinth always seems to be painting a picture behind the picture, one only he alone can see." The observation he made while sitting for his own portrait in 1923 is particularly interesting: "When one sat opposite him and talked to him in recent years, one had the feeling that he was not at all interested in conversation, that the tense glance that was focused on the sitter was not aimed at the person himself, and it could happen that, suddenly, words such as 'Stay in that position, the yellow forehead intrigues me' or 'Your eyes have a really strange color right now' came out of Corinth's mouth."[59]

Of course, the evaluation made by an art critic or historian who is used to interpreting stylistic changes in an artist's life will be different from those made by a neurologist who is familiar with damage done to the right side of the brain, but the resulting controversy should be handled cautiously by all of the parties involved. An artist naturally reacts to a dramatic stroke with thematic changes and will possibly move on to stylistic variations. However, just how fluid the transition between the—supposedly so opposing—positions is, is shown clearly in Charlotte Berend-Corinth's made a noteworthy comment on the creation of the self-portraits, "After the stroke, after he had experienced the metaphysical horror and (as he noted in his diary) had 'seen nothingness,' he appeared to see more of the visually perceptible than the mirror could show him."[60]

Richard Jung was the first to describe the typical signs of hemispatial neglect in Corinth's late work from the point of view of a neuro-scientist.[61] Howard Gardner later made a systematic investigation of left-sided neglect, for which he believed Corinth was able to compensate to a large degree within a matter of a few months (he mentions that the portrayed person is occasionally placed in the right half of the picture and that, in some works, the left half of the picture is less precisely executed).[62] Interestingly, descriptions of several of Corinth's works from after the stroke, by art

historians, contain different findings typical for damage to the right side of the brain. This applies, for example, to Horst Uhr's description of the painting *Interior in Front of the Mirror* (1912): "This painting quotes a painting from 1911 showing Charlotte Berend in her bedroom being visited by a hairdresser. The later work shows a striking alteration. The light coloration of the earlier picture is replaced by colder tones with greater opacity; colored fields are separated by large, black areas; the brushstrokes are broad, with less variation in accentuation and direction... the details of the two faces are so generalized that the two figures appear to be absolutely faceless. This leads to a noticeable psychological distance, particularly in comparison with the earlier, erotically charged, double portrait."[63]

From that point of view, there is proof of the typical signs of damage to the right side of the brain in small-scale graphic works, as well as in the large oil paintings, in Corinth's late œuvre:

• Omissions on the left side—affected by neglect—of a drawing or painting (sketch 1912, see above). Omissions in this pronounced form can only be observed in Corinth's art in the first year after the stroke.

• Relocation of the centre of the representation in the right half of the picture (e.g. in *Susanna and the Two Elders* from 1923. There are many examples of this kind of repositioning of the centre of the picture in Corinth's late period. In this picture, we can also observe an oversimplification of the contours and a "neglect" of the lower left corner of the picture).

• Omissions on the left side within the depiction of the individual objects in a drawing or portrait (for example, the right lower leg is clearly missing in the 1923 etching of his friend Leo Michelson, fig. 19).

• Changes in the form in the depiction of objects and persons (e.g., sketch for *Sampson*, 1912, see above, fig. 10).

• Loss of clear contours in separating the object and background; e.g. in the oil painting *Hiller's Grocery Shop* from 1923, in *Portrait of the Painter Bernt Grönvold* of 1923 (fig. 17), and *Susanna and the Two Elders* from the same year (see above) or *Abduction of the Women* from 1918).

• Loss of plastic depiction, disappearance of spatial depth, especially on the left side of the picture, e.g., *Self-Portrait* from 1920/1921 (cf. p. 4).

• Placing details in the wrong position in the etching of *Franz the Farmhand* from 1919 who he shows with markedly asymmetric arms (fig. 18).

• Lack of emotional closeness and the resulting distinct stressing of distance; e.g. in the portrait of his son *Thomas with his Hat in his Hand* from 1922 (fig. 14).

• Increased subjectivity, e.g. in the last painting of his wife as *Carmencita*, 1924, as well as the neglected lower left corner of the picture (fig. 13) compared with a 1908 painting with a very similar motif *The Black Mask*.

• Missing similarity of familiar faces in portraits, e.g. in drawings of his wife compared with those made before the stroke in 1911.

• Conspicuously often asymmetric and distorted depictions of faces—especially in the self-portraits (fig. 1).

As Rudolf Grossmann describes the phenomenon, "He repeatedly turns to the self-portrait. Without his wanting it, it often becomes larger than life, the head appears ready to blast the space open, becomes pear-shaped, pathological, usually dissimilar in the objective sense. There is a second Corinth, no longer the one we see objectively, a face, an interpretation of his inner life at the moment, that becomes his reality, that he forces on us. It is similar when he draws others. In one drawing he made of me, he captured something clown-like, and then I looked like a cleric, with thick, somewhat weak-willed, sensual blubber lips contrasting with my clear, watery, dreamy eyes, in another one."[64]

- The lack of correct perspective, e.g. in the 1912 (cf. fig. 15) painting *On the Balcony in Bordighera* (see above), *Berlin, Unter den Linden* from 1922 (fig. 15) and some floral still lifes.
- Anatomical peculiarities and missing anatomical exactness, e.g. *Study for the Blinded Sampson* 1912 (cf. fig. 10) and *Pieta* 1920. This is particularly noticeable in portraits. Von den Osten calls the forms for the depiction in the portrait of Otto Winter "dissociated" and "somewhat grotesque" and he writes that, in the portrait of Fritz Thiemes from 1919 "A few large forms of the face are stressed, made dominant, others simplified or omitted" and, finally, calls the standing figures in the later double portraits "disproportioned" and describes "long, thin men's legs … and outsized heads.[65]

Fig. 13
Carmencita (The Artist's Wife), 1924
Oil on canvas, 130 x 90 cm
Städel Museum, Frankfurt am Main

This list of examples could be lengthened considerably. However, there can be no doubt that a major portion of his late œuvre—even seen from the prejudiced viewpoint of the neurologist and pathographer—consists of magnificent works by a remarkable artist that do not provide any evidence of changes resulting from the illness. On the other hand, Corinth's enormous number of artworks makes a detailed study of the extremely subtle consequences of his illness possible.

In the debate on the question of a purely psychologically-based stylistic change versus one associated with neglect, which has now lasted for close to 100 years, we can find no evidence to support the one or other theory. However, it must be noted that not all aging or ill artists undergo a stylistic change; but there are comparable cases of artists who have suffered a stroke to the right side of the brain demonstrating similar changes to those seen in Corinth's work. The works of Otto Dix (1891–1969) after a stroke to the right side of the brain in 1967 and especially the magnificent series of self-portraits made by Anton Räderscheidt (1892–1970) lead to similar interpretations.[66]

In the memoirs written in the last year of his life, Lovis Corinth states, "I discovered something new: real art is practicing unreality. The absolute supreme!"[67] If we agree with Horst Uhr, Corinth had "long before, given up the conventional notion of realism" and, therefore, Corinth's new understanding was probably not founded on purely technical aspects but was more a conceptual matter. When Corinth approached abstraction in his late work—although he "never strived for it"—this knowledge came to light.[68] Together with the maxim "drawing means leaving out"—a saying originally attributed to his friend Max Liebermann and which Corinth repeated in the same place in his memoirs—we are suddenly in the position of being able to interpret these principles in the context of Corinth's stroke and its after-effects. At the end of his biography, von der Osten writes, "The sensual alone is [Corinth's] bridge to the supernatural. Beginning with the visible things of this world is essential for him; but he is able to say more than can just be seen."[69] One could conclude that Corinth discovered a new artistic principle as a result of his left-sided visuospatial neglect. Or, to put it differently, this means that Corinth was ultimately successful in transforming a "deficiency" in physiological perception resulting from his illness to develop his true art. It is our aim to open a discussion on this new argument in the interpretation of the works of the "late" Lovis Corinth.

*This article is based on a suggestion made by Prof. Dr. Michael Hennerici, Director of the Neurology at the University Hospital in Mannheim.

1 Gert Von der Osten, *Lovis Corinth*, Jahresgabe Kunstverein Hannover (Munich: F. Brückmann, 1955), p. 111.
2 Paul Westheim, "Lovis Corinth und die NS-Kulturgemeinde," *Pariser Tagblatt*, 1935, vol. 3, no. 593, p. 4.

3 Ibid, 4.

4 Richard Jung, "Neuropsychologie und Neurophysiologie des Kontur- und Formsehens in Zeichnung und Malerei," *Psychopathologie musischer Gestaltungen,* ed. by Hans Heinrich Wieck (Stuttgart, New York: Schattauer, 1974), pp. 29–88.

5 Thomas Corinth (ed.), *Lovis Corinth. Eine Dokumentation. Zusammengestellt und erläutert von Thomas Corinth* (Tübingen: Wassmuth, 1979), p. 157.

6 Charlotte Berend-Corinth, *Lovis* (Munich: A. Langen and G. Müller, 1958); Charlotte Berend-Corinth, *Mein Leben mit Lovis Corinth* (Munich: P. List, 1958).

7 Wilhelmine Corinth, *Ich habe einen Lovis, keinen Vater. Erinnerungen,* recorded by Helga Schalkhäuser (Munich: Langen Müller, 1990).

8 Lovis Corinth, *Selbstbiographie* (Leipzig: Hirzel, 1926) p. 185.

9 Claudio Luzzatti Bisiach Edoardo, "Unilateral neglect of representational space," *Cortex,* 14, 1978, pp. 129–133.

10 Peter Halligan and John Marshall, "Graphic Neglect—More than the sum of parts," *NeuroImage,* 14, 2001, pp. 91–97.

11 Ibid., p. 93.

12 Günter Herzog, *Anton Räderscheidt, (*Cologne: DuMont, 1991), p. 133.

13 Von der Osten 1955 (see note 1), p. 132.

14 Berend-Corinth, *Leben,* 1958 (see note 6), p. 54.

Fig. 14
Thomas with his Hat in his Hand, 1922
Oil on canvas, 90 x 75 cm
Private collection, Switzerland

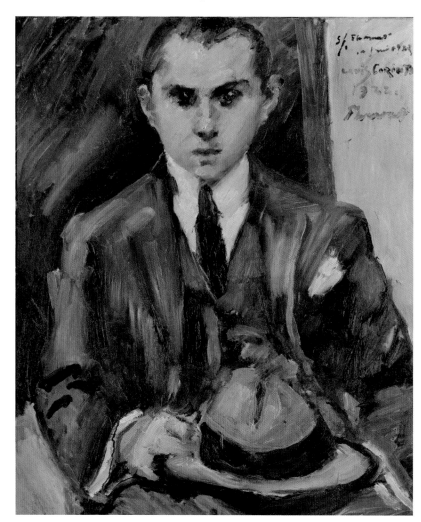

Fig. 15
Berlin, Unter den Linden, 1922
Oil on canvas, 70 x 90 cm
Von der Heydt-Museum, Wuppertal

15 Corinth 1979 (see note 5), p. 238.

16 Ibid., p. 238.

17 Corinth 1926 (see note 8), p. 123.

18 Berend-Corinth, *Leben,* 1958 (note 6), pp. 107–108.

19 Corinth 1979 (see note 5), p. 152.

20 Ibid., p. 152.

21 Ibid., p. 100.

22 Alfred Kuhn, *Lovis Corinth* (Berlin: Propyläen, 1925), p. 100.

23 Ibid., p. 100.

24 Berend-Corinth, *Leben,* 1958 (see note 6), p. 63.

25 Corinth 1979 (see note 5), p. 152.

26 Ibid., p. 155.

27 Ibid., p. 157.

28 Berend-Corinth, *Leben,* 1958 (see note 6), p. 63.

29 Corinth 1979 (see note 5), p. 161.

30 Ibid., p. 238.

31 *Lovis Corinth*, exhibition catatalogue (Munich, Haus der Kunst; Berlin, Nationalgalerie; Saint Louis, The Saint Louis Art Museum; London, The Tate Gallery), (Munich, New York 1996), p. 168.

32 Berend-Corinth, *Leben,* 1958 (see note 6), p. 25.

33 Corinth 1979 (see note 5), p. 232.

34 Ibid., p. 239.

35 Berend-Corinth, *Leben,* 1958 (see note. 6), p. 36.

36 Ibid., p. 36.

37 Corinth 1979 (see note 5), p. 246.

38 Berend-Corinth, *Leben,* 1958 (see note 6), p. 135–136.

39 Ibid., p. 135–136.

40 Horst Uhr, *Lovis Corinth* (Berkeley, Los Angeles, Oxford: Berkeley UP, 1990), p. 196.

41 Berend-Corinth, *Leben,* 1958 (see note 6), p. 72.

42 Corinth 1979 (see note 5), p. 321.

43 Berend-Corinth, *Leben,* 1958 (see note 6), p. 103.

Fig. 16
Otto Dix
Small Self-Portrait, 1968
Lithograph, 27 x 17.8 cm
Courtesy Galerie Nierendorf, Berlin

117

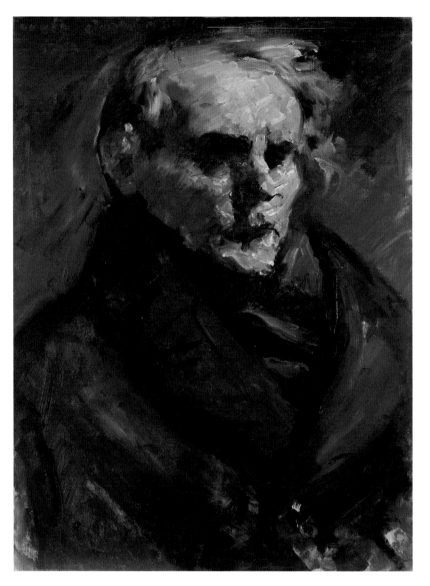

Fig. 17
Portrait of the Painter Bernt Grönvold, 1923
Oil on canvas, 80 x 60 cm
Kunsthalle Bremen—Der Kunstverein
in Bremen

44 Von der Osten (see note 1), p. 159.

45 Corinth 1979 (see note. 5), p. 156.

46 Ulrike Lorenz, "Lovis Corinth in Bildern und Dokumenten," *Lovis Corinth und die Geburt der Moderne*, exh. cat., Leipzig, Museum der bildenden Künste; Regensburg, Kunstforum Ostdeutsche Galerie, Paris, Musée d'Orsay (Bielefeld: Kerber Art, 2008), pp. 20–51, here p. 40.

47 Uhr 1990 (see note 40), p. 198.

48 Ibid., p. 198–199.

49 Osten 1955 (see note 1), pp. 118–119.

50 Jung 1974 (see note 4), p. 77.

51 Olaf Blanke, "Visuospatial Neglect in Lovis Corinth's Self-Portraits," *International Review of Neurobiology*, ed. by Ronald J. Bradley, Adron R. Harris and Peter Jenner, Bd. 74, (New York: Academic Press, 2006), p. 193–214, here p. 205–206.

52 Rudolf Grossmann, "Besuch bei Corinth," *Kunst und Künstler* 23, 1925, pp. 268–271, here pp. 169–170.

53 Charlotte Berend-Corinth, *Lovis Corinth. Die Gemälde. Werkverzeichnis*, revised by Béatrice Hernard (Munich: F. Bruckmann, 2nd revised edition 1992), p. 224.

54 Ibid., p. 223.

55 Ibid., p. 37.

56 Uhr 1990 (see note 40), p. 227.

57 Munich/Berlin 1996 (see note 31), p. 9.

58 Kuhn 1925 (see note 22), p. 107.

59 Ibid., p. 107.

60 Berend-Corinth, *Lovis,* 1958 (see note 6), p. 81.

61 Jung 1974 (see note 4), p. 58–59.

62 Howard Gardner, "The pathology of art," Howard Gardner, *The Shattered Mind* (London: Knopf, 1977), pp. 291–349, here p. 324.

63 Uhr 1990 (see note 40), p. 205.

64 Großmann 1925 (see note 52), p. 270.

65 Von der Osten 1955 (see note 1), pp. 144, 149.

66 Hansjörg Bäzner and Michael Hennerici, "Stroke in painters," *International Review of Neurobiology*, ed. by Ronald J. Bradley, Adron R. Harris, Peter Jenner, vol. 74 (New York: Academic Press, 2006), pp. 165–191; Anna Mazzucchi, Giovanna Pesci, Dario Trento, *Cervello e pittura. Effetti delle lesioni cerebrali sul linguaggio pittorico*, Rome: Filli Palombi, 1994.

67 Corinth 1926 (see note 8), p. 185.

68 Uhr 1990 (see note 40), p. 295.

69 Von der Osten 1955 (see note 1), p. 178.

Fig. 18
Franz the Farmhand, 1919
Sheet 12 from the portfolio:
At the Corinthians
Drypoint etching, 32 x 24.7 cm
Hamburger Kunsthalle

Fig. 19
Michelson on the Shore of Walchensee, 1923
Etching, 19.5 x 14.5 cm
Courtesy Galerie Nierendorf, Berlin

Erhard Stöbe

Comments on Lovis Corinth's Painting Technique

The ten paintings in the Belvedere's Corinth collection provide an excellent overview of Lovis Corinth's working methods from the time of his first mastery until the last years of his life. The pictures range from the *Slaughtered Calves* of 1896 to the second portrait of *Herbert Eulenberg* from 1924. The Belvedere's holdings are also representative in terms of Corinth's favored subjects and make it possible for us to experience the differences in the master's painting methods. In the following essay, an attempt will be made to approach the way Corinth practiced his craft as a painter by examining his colossal work from various viewpoints; for this, the organization according to technical criteria and characteristic features appears suitable. Therefore, the following categories will be investigated:
1. Support and grounding,
2. Media, including palette and brushes,
3. The position and movement while painting and their results,
4. The composition of the palette (choice of colors) and their use, and finally
5. The structure of the color pastes that become the surface of the painting.
The investigation of the paintings was carried out with the naked eye, magnifying glasses and with the help of UV light.

Support

Corinth's preferred support for his painting was canvas. He usually works on fairly tightly woven light linen and the type chosen seems to remain constant throughout most of his creative period, although the earliest picture from 1896 is painted on somewhat sturdier cloth. An examination shows thread counts of 18:19 to 20:21. The portrait of *Herbert Eulenberg* is the only investigated canvas with a Panama weave, called "Roman linen" at the time, with a double-threaded count of 14:12.
The canvases are prepared professionally and not grounded by the artist himself. This is made apparent by the fact that the grounding is clearly applied by a machine and not brushed on by hand. Most of the canvases are cut to size from large, pre-grounded lengths of cloth and stretched onto the frames.

Grounding

The grounds are either oil-based, which can be recognized in the craquelure, or half-oil grounds, which are less inclined to display this phenomenon. However, the fact that the investigated grounds are still sufficiently elastic and no craquelure can be seen on the paintings makes it possible for us to ascertain the superior quality of both the material used and its application. The collection in the Belvedere is made up entirely of paintings on canvas but Corinth also occasionally used wooden panels and cardboard.
For plein-air painting—especially for large-format works—Corinth used specially prepared canvases: the frames were hinged on the long side and could be folded in-

Fig. 1
The Herzogstand on Walchensee in the Snow
(detail), 1922
Oil on canvas, 78 x 98 cm
Belvedere, Vienna

wards; handles were screwed onto the short side to prevent the two folded halves of the painting from coming into contact with each other. Two cuts were made in canvases in the middle of the long side of the frame—where the picture was folded for transport—to prevent buckling when the frame was folded. A painting prepared in this manner had to be unfolded as soon as possible after returning to the studio in order to make corrections with the brush to any areas where paint may have been squeezed together in the crease. (fig. 1)

The ground was applied to the entire canvas, but in such a thin coat that the grain of the canvas remained visible and tangible; smooth grounds, applied with a palette knife, were already things of the past. However, the grounds Corinth used were conventional; the artist did not experiment with new methods, preferring instead to move within the given limits of a material while making the most of the possibilities of the medium available to him and, in this way, expanding its powers of expression.

Painting Material

Apart from all of the graphic techniques that the painter also mastered, Corinth's instruction had mainly been in the use of oil paints, and this was his preferred medium: Neither in Paris nor in Munich, were the artists of this period (with the exception of Arnold Böcklin and Hans von Marées) involved in technical experiments—they experimented within the framework of traditional techniques (think of Paul Cézanne, for instance) and did not go beyond the medium as later generations of painters (Paul Klee, for example) did. The masters of the past and of his own time who Corinth admired were concerned with the possibilities offered by painting in oil and the forms of expression it allowed, and he was always pleased when he discovered similarities to them. Like his favorite painters, Rembrandt and Frans Hals, he did not use paint to project an idea onto a prescribed surface; instead, each of them, in his own individual way, regarded working with oils as a confrontation with the material. The way of thinking of painters of this type covers a wide spectrum ranging from a confrontation with the material to transcending this in the creation of a picture. Once this has been achieved, one is referred back to the starting point by the wildly animated color pastes—especially if a close inspection is made. The strength of this kind of painting lies in the fact that the viewer can fall into it as if into an abyss and then, finding a hold on the strongly defined contours, can once again pull himself up into the representational.

The Herzogstand on Walchensee in the Sun of 1922 is a fine example of this. Everything that occurs on the surface of the picture can be understood concretely; there is an equivalent in reality for each brushstroke. However, if one frees oneself from the conventional form of observation, one can look past the subject, through the framework of dark lines and discover pure painting. This is especially stimulated by the slanting lines that make the picture appear unstable in comparison to the orthogonal parallelism of forest paintings by Ferdinand Hodler, Gustav Klimt and others.

The sun captured between the tree trunks on the upper left makes it clear just how different the coloration is between the dark, sloping strokes compared with the rest of the painting: The dominant white is used as a color and not as a lighting effect. The artist bids farewell to the "shoebox" space. Yet, in spite of the slanting trees, the picture appears completely cohesive. It is precisely the motif of the sloping elements that draws this picture close to Wassily Kandinsky's works—just think of the preliminary studies to the *Picture with White Border* from 1913. Here, as well as in Corinth's case, the dominating white is used as a color and not as a lighting effect.

The struggle with the paint itself placed great demands on Corinth, as can be seen from his own comments. He repeatedly commented on the difficulties of arriving at a clarification of the image from what he termed "a collection of smears," of reaching the point at which something objectively comprehensible emerges from the colored past that has congealed with a fury, without revealing its origin.

Fig. 2
Slaughtered Calves (detail), 1896
Oil on canvas, 68 x 88 cm
Belvedere, Vienna

Media

As many of his contemporaries, Corinth used painting media that were intended to liquefy the oil paint and make it more pliable. These painting media are mixtures of drying oils, resins and solvents and have an influence on the drying time and shine of the surface of a painting. The use of painting media often results in characteristic cracks that occur quite early in the drying process; for this reason, these fissures are called early shrinkage cracks or craquelure. (fig.2)

Some colors are particularly prone to these cracks; they are fine-corned pigments mixed with much oil such as viridian green, some brown tones and black, as well as red lacquers. Oil grounds, such as those Corinth frequently used, also trigger the formation of early shrinkage cracks. Grounds with a lower oil saturation, such as half-oil and distemper-gesso grounds, help to at least limit this phenomenon but they have other disadvantages. This means that the artist has to decide about what he intends to

Fig. 3
Slaughtered Calves (detail), 1896
Oil on canvas, 68 x 88 cm
Belvedere, Vienna

achieve before beginning his work. At any rate, shrinkage cracks can often be seen in Corinth's works and we must therefore assume that they are the result of the use of a combination of paint saturated with oil and high in bonding agents with an oil ground.

This phenomenon can already be clearly observed in the painting *Slaughtered Calves* from 1896. The organization of the composition appears to have been altered and reworked because one can see other layers of paint beneath the cracks. Pasty brushstrokes showing a different spatial situation can be seen through the color relief of the layer of paint that is now visible. (fig.3)

Painting Equipment (brushes and palette)

Corinth's painting equipment consisted of a rectangular wooden palette that the painter held in his hand and did not lay on a table next to him and a handful of brushes. This was how Corinth was always seen in front of his easel. The brushes are made of bristles and not of hair and, as one can see from the brushstrokes, he used flat brushes more frequently than round ones. In many pictures, it is apparent that he also used a palette knife or spatula (together with the brushes). The palette knife makes it possible to work with great speed, but the sensitivity for refining the tones of the colors suffers, as it is much easier to mix them using a brush. The brush is also more suitable than a knife for defining shapes. (fig.4) Occasionally, cuts are made into paint that is already on the canvas to create a detail or sharp line; however, Corinth integrated this artistic means into the flow of his work and did not use it as a stylistic method in the manner of Oskar Kokoschka and Max Oppenheimer. Scratching is carried out with the palette knife or shaft of the brush.

The Act of Painting

Corinth painted either standing or sitting depending on the size of the work in question. This is easiest to confirm when dealing with the self-portraits, but it is also possible to determine the position the artist assumed while working on the other paint-

ings. Movements made when standing are much more energetic than when sitting and can make their way more easily across the surface of the canvas to take greater advantage of the format. Standing, Corinth is able to keep the entire picture in his field of vision and to concentrate not only on the central motif (the head of the person to be portrayed, for example) but also on the brushstrokes not becoming more cursory towards the edges and corners (as one can observe with other painters such as Giovanni Boldini).

Corinth held the brush in the middle and usually approached the surface directly, almost horizontally: One often has the impression that he was stroking the surface with his brush full of paint. He ended his contact with the canvas just as abruptly as he began; that manifests itself in the streaks and strings of paint, like a preview of Informel, left by the attacks with the brush on the surface.

As one knows, long brushstrokes require an appropriately pre-painted grounding because the stroke would break off and start to falter on a dry surface instead of continuing in a flowing manner.

Two portraits from 1905, *The Singer Frieda Halbe* and *Frau Maria Moll*, are excellent examples of the way Corinth worked in this genre. Both paintings show around two-thirds of the body. This is the limit of what a painter can manage from a single position if he intends to complete a portrait as quickly as possible. When the whole figure is painted, the canvas must be moved up and down on the easel, in order to reach every place on the canvas, and this has a negative influence on the flow of work. Obviously, at least two sittings were necessary for the portrait of Frau Halbe. The corrections to the back of the model's head were made in the wet paint but, above her head, we can detect brushstrokes that hint at an arrangement with a curtain. This adjustment was made when the paint had already dried and, therefore, the brushstrokes beneath this are still visible on the surface.

The painter and his model stood opposite each other during the sittings. They play their roles on the same level. The painting is an exchange of ideas but we can only see one half. A Viennese Actionist could not have left us a better relic of an act of painting. The paint was in motion throughout the work and applied with care; nowhere, can one detect a decline in the painter's concentration. This invests the subject with a tangible physical presence. Corinth had an especially pronounced feeling for the physical, stressed by the fact that he only defined the textiles of the clothing to the extent necessary to be able to identify what he painted as having different properties. He was not concerned with the superficial charm of the material on which salon painting placed such importance. Corinth could depict the effects of transparent material wet-on-wet without varnishing. The differences in the materials were not presented in an illustrative fashion but in the turmoil of the changing texture of the brushstrokes. His widely swinging, graphic brushstrokes were completely suited to the format.

Embedded particles of pure colored paint can be detected in the background that appears to be gray to show what this tone was composed of. These particles of, not completely mixed, color can also be seen in the darkness of the portrait of *Frau Marie Moll*. The portrait of Frau Halbe is dominated by her physical presence, whereas the portrait of Frau Moll is characterized by the existence of memory; everything surrounding the portrayed woman points towards her and does not emanate from her. She sits—reminiscing—in memory. This effect is achieved by having the picture implode into its dark colorfulness. In contrast to this, the portrait of Frau Halbe radiates its vitality as brightness.

Corinth's Palette

Corinth's choice of color is in no way exceptional. He rarely succumbed to the charms of a specific tone, because it was neither the color nor its atmosphere that triggered a picture in him; color did not overpower the subject. A single color hardly ever domi-

Fig. 4
The Singer Frieda Halbe, 1905
Oil on canvas, 120 x 90 cm
Belvedere, Vienna

Fig. 5
The Singer Frieda Halbe, 1905
(detail)

nates a composition, it is usually all the hues pressed onto his palette that play a role in the creation of a painting. This results in the many optical gray tones, with many rudiments of their component colors shining out of them gem-like, in his pictures. Corinth had seen and recognized similar effects in the works of the Old Masters he admired so much. And, like them, Corinth was in no way afraid of black.

Corinth chose his colors in a completely traditional manner; he was not concerned with fashionable pigments. We find madder red and not the synthetic led lacquers that were all the rage at the time on his palette; his white was white lead; I could find no traces of zinc white under UV light.

Corinth often used white to create lighting effects—in this way, he was very "German". The picture *Slaughtered Calves* is still influenced by the medium-toned, uniform coloration, not broken by white, with which he had become acquainted in Paris. With its white highlights, the painting *Woman Reading near a Goldfish Tank* from 1911, on the other hand, is an example of German Impressionism—contrary to the practice in France, where artists were more intent on having white make itself felt as an autonomous color than a mixed component. They attempted to create lightin their pictures from an interaction of colors that ultimately led to divisionism. German painters uncompromisingly placed white among the colors when they wanted to reproduce reflections of light; with his hectic manner, Corinth—in particular—did not take the time to mix his colors on the palette. Julius Meier-Graefe pointedly remarked that "The modeling brush replaces the palette."[1] Insufficiently mixed white reduces their color value and stresses the darkness of a color in relationship to white, it intervenes in the connection of the colors to each other. This is the reason that some paintings, when seen from a distance, lose much of the vividness they have close up. On the other hand, the French technique leads to an increase in the general effect of color when viewed from a distance.

Corinth shows no tendency towards a specific "beautiful coloration" which, in many cases, this can only be reached contrary to the rules of "alla prima" painting (as a contrast, compare Kokoschka's Dresden paintings). The choice of color always appears completely natural and spontaneous; in no way planned. The palette was Corinth's vehicle leading towards a felt truth that can, sometimes, be confused with realism. His "truth" was neither stylized nor in conformity with any group (compare this with the French Impressionists whose common tool was Pointillism or the stylization of Viennese and Swiss painting at the beginning of the twentieth century).

Corinth's struggle for his "reality" was rooted in the naturalist-realist tendencies of the late nineteenth century but realism also reacted to certain parallels with Impressionism. In the theatrical world, Corinth's handling of color is described as being "direct"—its expression is not adapted to the theme or subject but taken from the practiced, the pertinent. However, it is astonishing that Corinth's painting is often described as being "virtuoso". He could paint very well, but "virtuosity" is something completely different. The search for truth in a picture and the struggle to find an appropriate form of expression brought his painting close to various contemporary styles and "isms"—but ultimately no label tallies completely; each is revealed as being a kind of crutch to help one pigeonhole the phenomenon.

Corinth's penchant for hatching large sections from the upper right to the lower left, which becomes increasingly noticeable in the later works, can already be observed in many of his pre-1900 drawings and only made itself felt in his painted works at a later date. Corinth probably placed emphasis on this process because hatching invested the freely dabbed, springing accents and marks with stability and, in this way, positioned what would have otherwise been difficult or impossible to interpret in the right place in the viewer's understanding. Here the opposition between the practiced (hatching) and the "direct" (inclusions) in Corinth's pictures comes to light.

Corinth's Surfaces

In addition to his comments on painting tools, the act of painting and his palette, it is necessary to consider his compositional construction. Corinth's restless color surface is one reason that one thinks more of meat than of skin when viewing his flesh tints. Comparing a painting such as his *Reclining Female Nude* from 1907 with works by Peter Paul Rubens makes it clear that Rubens—contrary to widespread opinion—painted the skin and its glow. He evened out the colored surfaces in such a way that the smoothness of the skin was imitated in the act of painting. Corinth's nude, on the other hand, is far removed from the sculptural ideals of classicism; the painting boldly pushes the relief thoughts of the "paragone" aside and creates a figure of flesh out of the interaction between cold and warm tones. There are suggestions of warmth, odor and weight. The brushstrokes are always applied effectively without smoothing over. The lightly applied shimmer of the white sheet under the nude creates a complete contrast to the concentrated carnality of the naked body.

On the other hand, in his portrait of *Herbert Eulenberg*, Corinth's brushstrokes succeeded in everything a naturalist could also aim at—without being naturalist. The structure of the skin and flesh of the face, the grasping hands each stroke and blow with the brush defines something concrete. Despite their tempestuous style, Corinth's paintings do not make the carnality of the subject's face take second place to its expression and importance. Here, the "artistic tightness"[2] that Cézanne's apostles strove for comes "galloping" onto the scene.

Corinth's attitude towards the surface of a painting, which is so far removed from Cézanne's position, can be seen in the *Tyrolean Landscape with Bridge*. The picture was painted *en plein air*, probably folded for transport, and almost certainly completed in a single session. First of all, the darkness of the forest was created in thinned, dark green and then—in a tour-de-force of rapid brushstrokes—Corinth created a more precise characterization of the individual trees on this. The entire picture is rather mid-toned as a result of the wet-on-wet painting. In addition, Corinth kept on using the tones he had mixed on his palette for as long as possible in order not to interrupt the process of painting (in complete contrast to Cézanne's method). Brushstrokes set the entire surface in motion and it appears to be virtually torn asunder. The sky is also worked violently, different from older styles of painting that attempted to stress the contrast between the sky and horizon by using different means in order to create a greater feeling of depth.

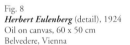

Fig. 8
Herbert Eulenberg (detail), 1924
Oil on canvas, 60 x 50 cm
Belvedere, Vienna

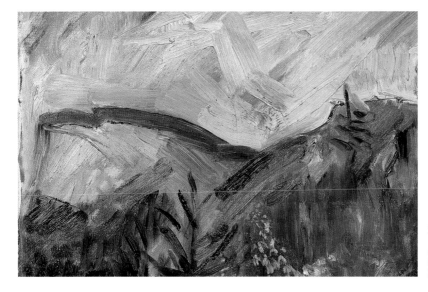

Fig. 9
Tyrolean Landscape with Bridge
(detail), 1913
Oil on canvas, 95.5 x 120.5 cm
Belvedere, Vienna

The *Still Life with Chrysanthemums and Amaryllis* from 1922 is noteworthy for its particularly turbulent style. In an essay, the botanist Wilfried Morawetz once described blossoms as the orgasms of plants and defined them as expressions of vegetal sexuality. Corinth captured this wild tumult in a delirium of color.

It is rather easy to interpret what appears to grow up in an orderly fashion from the lower edge of the painting, but in the upper sections it expands into an orgiastic dance with traces of the brush and palette knife preserved in the semi-liquid paint. This leads to the justified conclusion that the painting was executed from bottom to top. The uppermost chrysanthemums relinquish their floral qualities and topple into an expression of indefinite grotesqueness. This is a result of the attempt to rid the petals of their usually tangible softness. The forms are positioned in a sphere of vagueness from where they can be interpreted in various ways in the fusiform gyrus of the brain. It is typical for Corinth that the step to the abstract occurred during the furor of painting and was not coolly calculated.

It is not without reason that the wildness of this style reminds one of Richard Gerstl's paintings; the fact that the Viennese painter was attracted to certain aspects of Corinth's painting has received too little attention. The bridge between Corinth and Gerstl is somewhat fragile but maybe it is strong enough. Could Lovis Corinth have been one of Richard Gerstl's artistic models?

Gerstl worked his way through a wide repertoire of what was available at the time: Edvard Munch, Vincent van Gogh, the Pointillists, etc. This was a period of maturing, of understanding other experiences, of selecting what was suitable for his own art from the work others had done the groundwork for.

In his Berlin period, Corinth was a famous painter, his pictures were illustrated in esteemed art journals and it is possible that original works were displayed in Vienna; there are apparently records that the *Self-Portrait as a Howling Bacchant* was shown in Vienna in 1906.[3] Gerstl's *Laughing Self-Portrait* from 1908 (fig. 5) follows this example in its radicalism, if not in its atmosphere. Here, Corinth and Gerstl are on common ground. I also believe that I have been able to trace hints of Corinth in some of Gerstl's other portraits: The *Prillinger Portrait* appears as if Gerstl had played with the idea of painting a head like a Corinth self-portrait and he found his inspiration for this in his innkeeper on Traunsee. For the two last portraits Gerstl painted—of his mother and an anonymous woman (fig. 6,7)—we can, once again, make a comparison between works by Corinth and Gerstl's methods. Schönberg reported on Gerstl's admiration for Max Liebermann's painting that served as a model for his *Portrait of a*

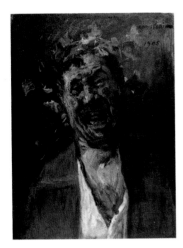

Seated Man in the Studio from 1907. However, Gerstl then settled on a more passionate style similar to that displayed in Corinth's painting.

There is no foundation in art history for any other connection between the two painters as there is no proof of the two having had any direct knowledge of the other's tendency towards the "wildness" that I previously mentioned. Both had a predilection for dealing intensely with the color paste and both followed this—albeit at different speeds. The personal crisis in which Gerstl found himself in 1908 accelerated this development and led to him throwing himself into an intensity that was unparalleled at the time. The young painter was almost overpowered by the paint. In terms of violence, Gerstl left Corinth far behind him even when one takes the late, almost informal, works of the older painter into consideration. The violence in Corinth's work increased continually to the end of his life. Corinth displayed his radicalism not in toto, as with Gerstl, but flaring up in individual spheres time and time again. (Cf. the red cloth in Corinth's *After the Bath* from 1906 with Gerstl's *Schönberg Family* from 1907.)

Fig. 10
Self-Portrait as a Howling Bacchant, 1905
Oil on canvas, 67 x 49 cm
Stiftung Insel Hombroich, Neuss

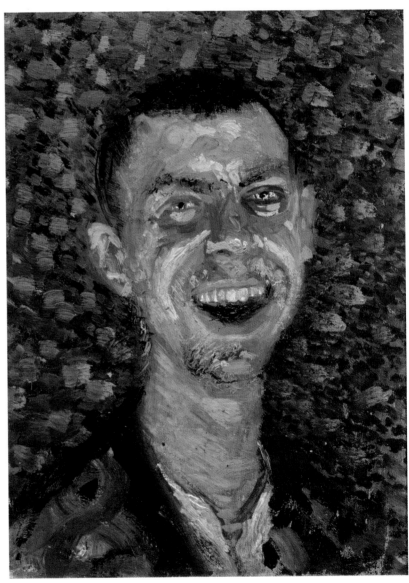

Fig. 11
Richard Gerstl
Laughing Self-Portrait, 1908
Oil on canvas, 39 x 30.4 cm
Belvedere, Vienna

Gerstl, however, was forced to descend from the summit of detachment and, once again, found himself in the company of Corinth; no other painter of the time painted faces the way he did; neither Slevogt nor Liebermann—and definitely not the French. The *Smiling Self-Portrait* and the two female portraits (fig. 6, 7) from 1908 can be traced to the style of a painter like Corinth. In the case of any appropriation, the question always arises of "What should I appropriate from all that, what can I make use of?" All of Gerstl's attempts to come to grips with the working processes of other painters were not imitating, as is often the case, because that would not have fitted in with his striving for independence. But, like any other young artist, he needed to use the ladders that already existed in order to climb up to the heights. And so, he attempted to penetrate into new ideas to achieve something for himself. In these attempts, Lovis Corinth's was the most suitable of all the known positions of the time as this recommended treating the color material violently.

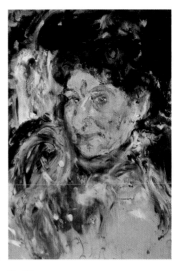

Fig. 12
Richard Gerstl
Portrait of his Mother Marie Gerstl, 1908
Oil on cardboard, 49 x 35 cm
Private collection

1 Julius Meier-Graefe, *Entwicklungsgeschichte der modernen Kunst*, vol. 2 (Munich: Piper, 1920), p. 366.

2 Sir Ernst Gombrich used this expression in connection with the Austrian Cézanne follower Gerhard Frankl in the catalogue to the artist's retrospective exhibition at the Hayward Gallery, London 1970/71. It means that painting provides optical support and does not let the view fall into emptiness.

3 Klaus Albrecht Schröder, *Richard Gerstl: 1893–1908*, exhibition catalogue, Vienna, Kunstforum der Bank Austria, 1993, and Kunsthaus Zurich, 1994 (Vienna: Kunstforum der Bank Austria, 1993), p. 166.

Appendix

Biography

Franz Heinrich Louis, called LOVIS CORINTH

21 July 1858	Born in in Tapiau, East Prussia (now Gwardeisk, Kaliningrad Oblast). Childhood in Tapiau, a small town near Königsberg (Kaliningrad). After marrying his cousin Amalie Wilhelmine Buttcher, his father, Franz Heinrich Corinth, took over her tannery and achieved a certain prosperity making it possible for his son to study painting at the academy in Königsberg. His mother died in 1873.
1876–1880	Student at the Königsberg Academy.
Summer 1880	Moves to Munich, studies under Franz Defregger.
1880–1884	Studies in Wilhelm Löfftz's painting school and at the Munich Academy.
1884	Three months in Antwerp.

The Complot (Berend-Corinth no. 17) is awarded a bronze medal in London and shown at the 1885 Paris Salon

Birth house in Tapiau

At a costume party, Königsberg, 1876

At the age of 29, Paris, 1887

1884–1887	Studies at the Académie Julian, Paris.
1887	Returns to Königsberg as a free-lance painter.

Portrait of his Father Franz Heinrich Corinth (Berend-Corinth no. 51)

October 1887	Berlin: Corinth attends life drawing sessions held by the *Nasser Lappen* (Wet Rags) artists' association and becomes a member. He becomes acquainted with Walter Leistikow.
1988	Adopts the name Lovis.

January 1889	Death of his father. Corinth rents a studio in Königsberg. Friendship with Walter Leistikow who is also in Königsberg and wants Corinth to move to Berlin.	
1890		*Pietà* (Berend-Corinth no. 61) is accepted for the Paris Salon and receives a *mention honorable*.
1891	Corinth moves to Munich. His picture *Diogenes* receives mixed reviews in the press.	*Susanna in the Bath* (Berend-Corinth no. 74) is shown at the Paris Salon
1892	Corinth travels to Kraiburg am Inn, Upper Bavaria, where he paints in a slaughterhouse. Founding of the Munich Secession (with Max Liebermann, Wilhelm Trübner, Otto Eckmann, Hans Thoma and others).	*Slaughtered Calves* Exhibition of the Munich Secessionists at Edouard Schulte's gallery in Berlin
1893/94	Founding of the *Freie Vereinigung* (Free Association) and expulsion of the members of this group from the Munich Secession (in addition to Corinth, Wilhelm Trübner, Max Slevogt, et al.).	Members of the *Freie Vereinigung* exhibit at Fritz Gurlitt's gallery in Berlin
1895		*Descent from the Cross* (Berend-Corinth no. 125) wins the 2nd gold medal in the exhibition at the Munich Glaspalast
1996	Corinth teaches (pupils include Josef Ruederer).	*Slaughtered Calves* (Belvedere Collection)

Königsberg, 1880

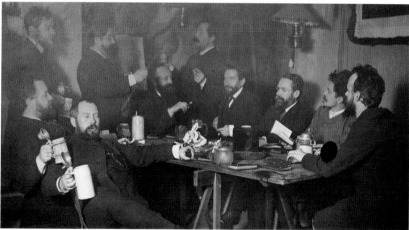

At the artists' table, Berlin, 1887

1897	Corinth makes his first substantiated sales (*Temptation of St. Anthony* and *The Witches*—both to private collections in Leipzig).	
Dec. 1898– Oct. 1901	Corinth commutes between Munich and Berlin, undecided on whether to accept Leistikow's proposal or not. He becomes a founding member of the Berlin Secession and establishes social contacts. He subsequently takes part in the Secession's exhibitions. First portrait commissions and participation in the social life of the Berlin salons.	Participation in the First Berlin Secession Exhibition in 1899; shows *Salome* (Berend-Corinth no. 171) there in 1900. 1900: Corinth Exhibition in Paul Cassirer's gallery, Berlin 1901: International Art Exhibition Dresden

October 1901	Corinth opens his painting school in Berlin; Charlotte Berend is his pupil.	December: second Corinth exhibition at Cassirer's gallery
1902	Corinth is elected to the board of the Berlin Secession. Begins a lengthy, but sporadic, collaboration with Max Reinhardt. Secret marriage to Charlotte Berend.	Despite a police ban, Max Reinhardt produces Oscar Wilde's *Salome*. Sketches for the costumes and set partially by Corinth
1903	Their son Thomas is born in October. Further collaboration with Max Reinhardt as an artistic adviser of the Neue Theater and by providing designs for the Kleine Theater. Founding member of the *Deutscher Künstlerbund* in Weimar (together with Count Harry Kessler, Max Liebermann, Max Klinger, Alfred Lichtwark, et al.	Corinth exhibition at Cassirer's gallery
1904	Conversion of the studio on Klopstockstraße into a flat.	Corinth exhibition at Cassirer's gallery
1905	Corinth is firmly established, artistically and socially. Yet, despite increased portrait commissions and some sales, he derives most of his income from his painting school and by correcting for other schools. In addition, Corinth begins writing theoretical and autobiographical works.	*Frau Marie Moll,* (Belvedere Collection) *The Singer Frieda Halbe,* (Belvedere Collection)

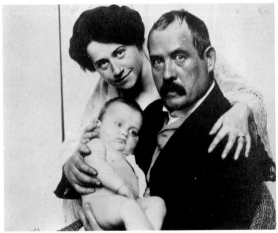

With Charlotte and son Thomas, Berlin 1905

With Charlotte, 1914

1907		*Reclining Female Nude* (Belvedere Collection)
1908	Death of Walter Leistikow—Corinth starts working on a manuscript on the life of his friend.	*Das Erlernen der Malerei* (Studying Painting), published by Paul Cassirer, *Legenden aus einem Künstlerleben* (Legends from an Artist's Life), published by Bruno Cassirer *Portrait of the Poet Peter Hille* (Berend-Corinth no. 237) is purchased by the Kunsthalle in Bremen
1909	Birth of the daughter Wilhelmine; purchase of the second floor of the same house, Klopstockstraße 48.	

| 1910 | | *The Weapons of Mars* (Belvedere Collection) |
| | | Corinth exhibition in Königsberg |

| 1911 | Corinth is elected president of the Secession in January. It is a year of intensive work with more than 60 paintings, teaching and correcting, as well as the participation in several exhibitions. Holidays in St. Ulrich, Gröden Valley in South Tyrol In December, Corinth suffers a stroke. | *Harem* (Berend-Corinth no. 299) is shown, without passing the jury, in Leipzig *Woman Reading near a Goldfish Tank* (Belvedere Collection) |

| 1912 | The year is one of convalescence: a three-month stay at the health resort of Bordighera on the Italian Riviera improves the state of Lovis Corinth's health. The general assembly of the Secession elects Paul Cassirer president, leading to a split in the Secession. | Corinth's exhibition of new works in the Berlin Secession is a great success |

| 1913 | Split in the Secession: the minority opposed to Cassirer's presidency refuses to resign; thus, the majority, including Liebermann and Slevogt, leave the Secession. Corinth's decision to remain leads to a break with Cassirer. | *Tyrolean Landscape with Bridge* (Belvedere Collection) |

| 1914 | Outbreak of the First World War and destruction in Tapiau (Corinth's *Entombment* is destroyed) The third floor on Klopstockstraße is purchased | |

Corinth room at the Berlin Secession, 1907

Jury of the Berlin Secession, 1915

| 1915 | Corinth is, once again, elected president of the Berlin Secession. New members and sponsors strengthen the institution. There is a new exhibition hall as the contract on the old building had expired. | |

| 1917 | Corinth meets Herbert Eulenberg, who publishes the book *Corinth, ein Maler unserer Zeit* (Corinth, A Painter of Our Time). Corinth is confirmed as the president of the Secession, but intrigues within the board lead to Corinth's gradual withdrawal. | |

1918	Charlotte finds a site for a second home in Urfeld on Walchen-see, Upper Bavaria—in the hope that Corinth, who is now 60 years old, will find peace there.	First portrait of *Herbert Eulenberg* (Berend-Corinth no. 732)
	Corinth's plans to paint Karl Liebknecht are thwarted by his murder in January 1919.	
	Corinth becomes a member of the Academy of Arts in Berlin.	
1919	Private ball in Urfeld on Walchensee. Subsequently, the Corinth family spends extended periods there every year. Walchensee becomes a central motif in Corinth's œuvre.	

In his studio in front of *Harem,* 1911

In his studio in front of *Self-Portrait with Palette,* 1924

1920	Film production in Babelsberg, where Corinth meets Eulenberg again. He illustrates proposal for a film *Anna Boleyn* (published by Fritz Gurlitt Verlag, Berlin).	
1921	Corinth is named honorary doctor of philosophy and master of liberal arts at the University of Königsberg. Two books on Corinth's graphic works are published.	Invitation to exhibit at the Art Institute of Chicago
1922	Hans Cürlis makes a film on Corinth as part of the series *Schaffende Hände* (Creative Hands), which ultimately included film portraits of 87 artists, produced from the 1920s through to the 1960s.	*The Herzogstand on Walchensee in the Snow* (Belvedere Collection) *Still Life with Chrysanthemums and Amaryllis* (Belvedere Collection)

| 1923 | Corinth receives an invitation, along with other artists, from the President of the Reich Friedrich Ebert. | The National Gallery in the former Crown Prince's Palace shows a Corinth exhibition with 170 works from private collections |
| 1924 | | Corinth exhibition in Königsberg; the lord mayor awards him the city's medal of honor Second portrait of *Herbert Eulenberg* (Belvedere Collection) Corinth exhibition in Bern |

With Charlotte at the country house in Urfeld, 1921 Corinth painting *Garden in Berlin-Westend*, 1925 Last photograph, 1925

| 1925 | Corinth is named honorary member of the Bavarian Academy of Fine Arts in Munich.
Corinth completes his autobiography, which is published posthumously.
Visit to Amsterdam. Falls ill in June.
Corinth dies in Zandvoort on 17 July. | Corinth exhibitions in various German cities (while still alive) |

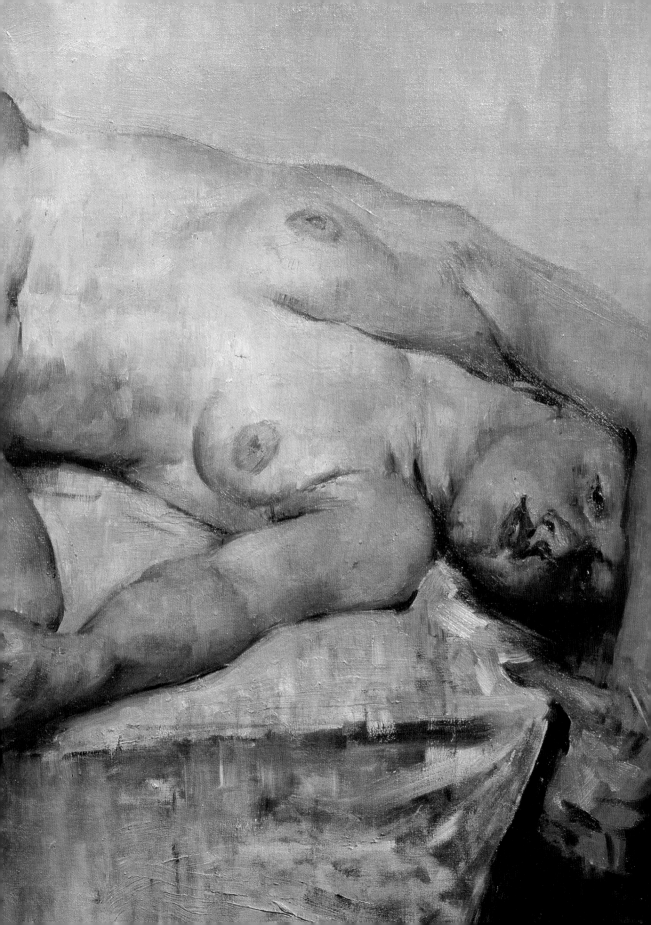

Corinth in the Belvedere

Slaughtered Calves, 1896
Oil on canvas, 68 x 88 cm
Signed, lower right: LOVIS CORINTH
Belvedere, Vienna, inv. no. 3793
Wilhelm Trübner, Karlsruhe; Walter Louran, Berlin; Dr. Rosin, Berlin; Max Böhm, Berlin; auction of the Max Böhm Collection by Rudolph Lepke, Berlin 1931 and 1932, auction by Dr. Ernst Mandelbaum & Peter Kronthal 1935 from "Property B." (= Max Böhm); 1940 purchased on Berlin art market (Carl Nicolai)
Literature
Berend-Corinth 1992, cat. no. 128

Frau Marie Moll, 1905
Oil on canvas, 120.5 x 101.3 cm
Signed and dated, upper right: LOVIS CORINTH / 1905 März
Belvedere, Vienna, inv. no. 3915
Dr. Fritz Moll (Marie Moll's son), Königswalde/Neumarkt; 1942 purchased from Dr. Alice Moll (Marie Moll's daughter-in-law), Königswalde/Neumarkt
Literature
Berend-Corinth 1992, cat. no. 317

The Singer Frieda Halbe, 1905
Oil on canvas, 120 x 90 cm
Signed and dated, upper right: LOVIS CORINTH / 1905 pinxit
Belvedere, Vienna, inv. no. 3837
Galerie Caspari, Munich; Heinrich Thannhauser, Berlin; Dr. K. Zitzmann, Erlangen; 1941 purchased on Berlin art market (Paul Roemer)
Literature
Berend-Corinth 1992, cat. no. 321

Reclining Female Nude, 1907
Oil on canvas, 96 x 120 cm
Signed upper left: LOVIS CORINTH.
Belvedere, Vienna, inv. no. 3809
Walter Rathenau, Berlin, Edith Andreae (Walter Rathenau's sister), Berlin; Maria Holzhausen (Walter Rathenau's niece); 1941 purchased on Salzburg art market (Galerie Welz)
Literature
Berend-Corinth, *Corinth*, 1992, cat. no. 345; *German Painting*, Collection catalogue, Vienna, Belvedere, 1992, p. 98-99; *Corinth*, exh. cat. Leipzig 2008, p. 174, cat. no. 3/8; Exh. cat. Paris, Corinth, 2008, cat. no. 46; Monika Mayer, "Anmerkungen zu zwei Erwerbungen aus der Sammlung Walther Rathenau. Lovis Corinths *Liegender weiblicher Akt* und Edvard Munchs Der Maler Paul Hermann und der Arzt Paul Contard," *Jahresbericht der Österreichischen Galerie 1998/99*, Vienna 2000, p. 107; Exh. cat. no. 3/8; Exh. cat. Paris 2008, cat. no. 46.

The Weapons of Mars, 1910
Oil on canvas, 141.5 x 181 cm
Signed and dated, lower centre: LOVIS CORINTH 1910.
Belvedere, Vienna, inv. no. 3792
Galerie Ernst Arnold, Dresden; Eduard Merzinger, Dresden; Karoline Merzinger (Eduard. Merzinger's widow), Dresden; 1940 purchased on Berlin art market (Scheuermann & Seifert)
Literature
Berend-Corinth 1992, cat. no. 413; exh. cat. Leipzig, *Corinth*, 2008, p. 122, cat. no. 2/20; *Corinth*, exh. cat. Paris 2008, cat. no. 29

Woman Reading near a Goldfish Tank, 1911
Oil on canvas, 74 x 90.5 cm
Signed and dated, upper centre: LOVIS CORINTH. 1911
Belvedere, Vienna, inv. no. 1829
1916 purchased on Berlin art market (Kunsthandlung Karl Haberstock)
Literature
Berend-Corinth, 1992, cat. no. 501; *German Painting,* Collection catalogue, Vienna,
Belvedere, 1992, p. 100-103; exh. cat. Leipzig, *Corinth,* 2008, p. 186, cat. no. 3/13;
Exh. cat. Paris, *Corinth,* 2008, cat. no. 52

Tyrolean Landscape with Bridge, 1913
Oil on canvas, 95.5 x 120,5 cm
Signed and dated, lower centre: LOVIS CORINTH / Tyrol 1913
Belvedere, Vienna, inv. no. 2885
1929, purchased from Charlotte Berend-Corinth, Berlin
Literature
Berend-Corinth, *Corinth,* 1992, cat. no. 581, Collection catalogue, Vienna 1992,
pp. 104–105

Self-Portrait, 1920/21
Etching, vernis mou, on Japan paper, 12 x 9.3 cm (plate)
Signed, lower right: Lovis Corinth
Belvedere, Vienna, inv. no. 9823
1987 Auctioned by Villa Grisebach, Berlin; 2009 purchased on Berlin art market
(Galerie Nierendorf)
Literature
Müller 1960, cat. no. 481

The Herzogstand on Walchensee in the Snow, 1922
Oil on canvas, 78 x 98 cm
Signed and dated, lower left: LOVIS CORINTH / 1922, Dezember 1922
Belvedere, Vienna, inv. no. 2377
1923 purchased from the artist
Literature
Exh. cat. Regensburg/Bremen 1986, pp. 157, 266, cat. no. 48; Berend-Corinth 1992,
cat. no. 876; *Corinth,* exh. cat. Leipzig 2008, p. 268, cat. no. 5/7; *Corinth,* exh. cat.
Paris, 2008, cat. no. 79

Still Life with Chrysanthemums and Amaryllis, 1922
Oil on canvas, 121 x 96 cm
Signed and dated, lower left: LOVIS CORINTH / 1922
(an earlier signature, upper left, partially painted over: Lovis Cor[....]/19[..]
Belvedere, Vienna, inv. no. 2446
1923 Purchased on Berlin art market (Hugo Perls)
Literature
Berend-Corinth 1992, cat. no. 854; Exh. cat. Munich 1996, p. 273, cat. no. 154

Herbert Eulenberg, 1924
Oil on canvas, 60 x 50 cm
Signed and dated, upper left: LOVIS CORINTH. / 1924; title, centre right: Herbert /
Eulenberg
Belvedere, Vienna, inv. no. 2884
1929 purchased from Charlotte Corinth, Berlin
Literature
Berend-Corinth 1992, cat. no. 952; Exh. cat. Munich 1996, p. 300, cat. no. 176;
Exh. cat. Leipzig, 2008, p. 252, cat. no. 4/37; Exh. cat. Paris, 2008, cat. no. 69

Ausgewählte Literatur

PUBLICATIONS BY CORINTH

Corinth, Lovis. *Das Erlernen der Malerei. Ein Handbuch*. Berlin: Cassirer, 1908.

Corinth, Lovis. *Gesammelte Schriften*. Berlin: Gurlitt, 1920.

Corinth, Lovis. *Selbstbiographie*. Leipzig: Hirzel, 1926.

CATALOGUES OF THE WORKS

Berend-Corinth 1992

Berend-Corinth, Charlotte. *Lovis Corinth. Die Gemälde. Werkverzeichnis*. Revised edition by Béatrice Hernard, with an introduction by Hans-Jürgen Imiela. Munich: F. Bruckmann, 2nd revised edition, 1992.

Müller 1960

Müller, Heinrich. *Die späte Graphik von Lovis Corinth*. Hamburg: Lichtwarkstiftung, 1960.

LITERATURE

El-Akramy, Ursula. *Die Schwestern Berend. Geschichte einer Berliner Familie*. Hamburg: Europäischer Verlagsanstalt, 2001.

Uhr, Horst. *Lovis Corinth*. Berkeley, Los Angeles, Oxford: Berkeley UP, 1990.

Paret, Peter. *Die Berliner Secession. Moderne Kunst und ihre Feinde im kaiserlichen Deutschland*. Berlin: Severin und Siedler, 1981.

Corinth, Thomas (ed.). *Lovis Corinth. Eine Dokumentation. Zusammengestellt und erläutert von Thomas Corinth*, Tübingen: Wassmuth, 1979.

Doede, Werner (ed.). *Die Berliner Secession. Berlin als Zentrum der deutschen Kunst von der Jahrhundertwende bis zum Ersten Weltkrieg*. Frankfurt am Main, Berlin, Vienna: Propyläen, 1977.

Von der Osten, Gert. *Lovis Corinth*, Munich: F. Bruckmann, 1955 (Jahresgabe Kunstverein Hannover).

EXHIBITION CATALOGUES

Exh. cat. Leipzig/Regensburg 2008

Lovis Corinth und die Geburt der Moderne (exh. cat. Leipzig, Museum der bildenden Künste; Regensburg, Kunstforum Ostdeutsche Galerie; Paris, Musée d'Orsay), Bielefeld: Kerber Art, 2008.

Exh. cat. Paris 2008

Lovis Corinth (1858–1925). Entre Impressionnisme et Expressionnisme. Paris: Reunion des musees nationaux, 2008.
(revised edition of the exh. cat. Leipzig/Regensburg 2008 for the exhibition in Paris, Musée d'Orsay)

Exh. cat. Munich/Berlin 1996

Lovis Corinth. Retrospektive (exh. cat. Munich, Haus der Kunst; Berlin, Alte Nationalgalerie; Saint Louis, The Saint Louis Art Museum; London, The Tate Gallery). Munich, New York: Prestel, 1996.

Exh. cat. Regensburg/Bremen 1986

Timm, Werner (ed.), *Lovis Corinth, die Bilder vom Walchensee. Vision und Realität* (exh. cat. Regensburg, Ostdeutsche Galerie; Bremen, Kunsthalle Bremen), Regensburg 1986.

Exh. cat. Essen/Munich 1985

Lovis Corinth. 1858 - 1925, (exh. cat. Museum Folkwang, Essen, Kunsthalle der Hypo-Kulturstiftung, Munich). Cologne: DuMont, 1985.

Collection catalogue Vienna 1992

Koja, Stephan (ed.). *Von der Romantik zum Impressionismus. Meisterwerke deutscher Malerei des 19. Jahrhunderts aus dem Bestand der Österreichischen Galerie Belvedere*. Vienna: W. Fischer, 1992.

Credits

This publication is released on the occasion of the exhibition

Lovis Corinth—A Feast of Painting
In the series
Masterpieces in Focus

Belvedere Vienna
25 March—19 July 2009

Director
Agnes Husslein-Arco

Curator
Stephan Koja

Curatorial assistance
Dietrun Otten

Belvedere
Prinz Eugen-Straße 27
A–1030 Vienna
www.belvedere.at

THANKS to
Ulrike Lorenz, Gerhard Leistner
Kunstforum Ostdeutsche Galerie Regensburg
Stella Rollig, Elisabeth Nowak-Thaller
Lentos Kunstmuseum Linz
Klaus Albrecht Schröder, Maria Luise Sternath
Albertina, Vienna
Johannes Melbinger
Architekturbüro Melbinger

PUBLICATION

Editors
Agnes Husslein-Arco and Stephan Koja

Editorial assistance: Maureen Roycroft Sommer
Translation into English: Robert McInnes
Design and layout: Peter Baldinger
Picture processing: Rudolf Hemetsberger
Project management: Anja Besserer and Sabine Gottswinter
(Prestel), Julia Heine (Belvedere)
Production: Simone Zeeb (Prestel)

Printed and bound by: TBB, Banská Bystrica, Slovakia
© 2009 Belvedere Vienna
Prestel Verlag, Munich · Berlin · London · New York,
and the authors

All rights reserved.

Prestel Verlag
Königinstraße 9
D–80539 Munich
www.prestel.de

Prestel Publishing Ltd.
4 Bloomsbury Place
London WC1A 2QA

Prestel Publishing
900 Broadway, Suite 603
New York, NY 10003
www.prestel.com

The Deutsche Nationalbibliothek holds a record of this
publication in the Deutsche Nationalbibliografie; detailed
bibliographic data can be found under: http://dnb.ddb.de.

ISBN 978-3-901508-64-6 (English museum edition)
ISBN 978-3-7913-4378-5 (English trade edition)

List of illustrations
The numbers indicate the pages; the illustrations were provided
by the museums and institutions named in the captions, the
archives of the Belvedere, private persons, as well as:
b p k Bildagentur für Kunst, Kultur und Geschichte: 24, 30, 35,
63 (© Photo: Jörg P. Anders), 64, 110, 112, 119.
Artothek: © Christie's London: 15, 84; © U. Edelmann: 93,
115; © Blauel/Gnamm: 10, 54, 116; © with the cited museums:
19, 32, 45, 70.
Akademie der Künste, Berlin: 134 centre and right, 135 right,
136 right.
Kunstarchiv des Germanischen Nationalmuseums Nuremberg:
134 left, 136 left, 138 left, 139 right.
Landeshauptstadt Düsseldorf, Heinrich-Heine-Institut,
Rheinisches Literaturarchiv, Nachlässe und Sammlungen: 86, 89.
Lovis Corinth, *Selbstbiographie*, Leipzig, 1926: 111.
Lovis Corinth. Dokumentation, Tübingen 1979: 76, 85, 92.
Horst Uhr, *Lovis Corinth*, Berkeley 1990: 130.
Exh. cat. Essen/Munich 1986: 132, 135, 135 left, 137, 138
right, 139 left and centre.
Lovis Corinth (exh. cat. Vienna, Kunstforum der Bank Austria;
Forum des Landesmuseums Hanover) Munich 1992: 34 above, 42.
Richard Gerstl (exh. cat. Vienna, Kunstforum der Bank Austria)
Vienna 1993: 131.
Exh. cat. Munich/Berlin 1996: 21, 26, 27, 30, 34 below, 39, 77,
96, 117.
Every effort has been made to locate all the owners of the copy-
rights for the illustrations in this book. Should this have not
been possible and, inadvertently, the correct acknowledgement
not been given, we would ask those claiming legal rights for their
understanding and request that they contact us.

Cover illustration:
Lovis Corinth, *Herbert Eulenberg*, 1924, Belvedere, Vienna

Partner of the Belvedere

CONSTANTIA PRIVATBANK
AKTIENGESELLSCHAFT